# PRAYERS IN STONE

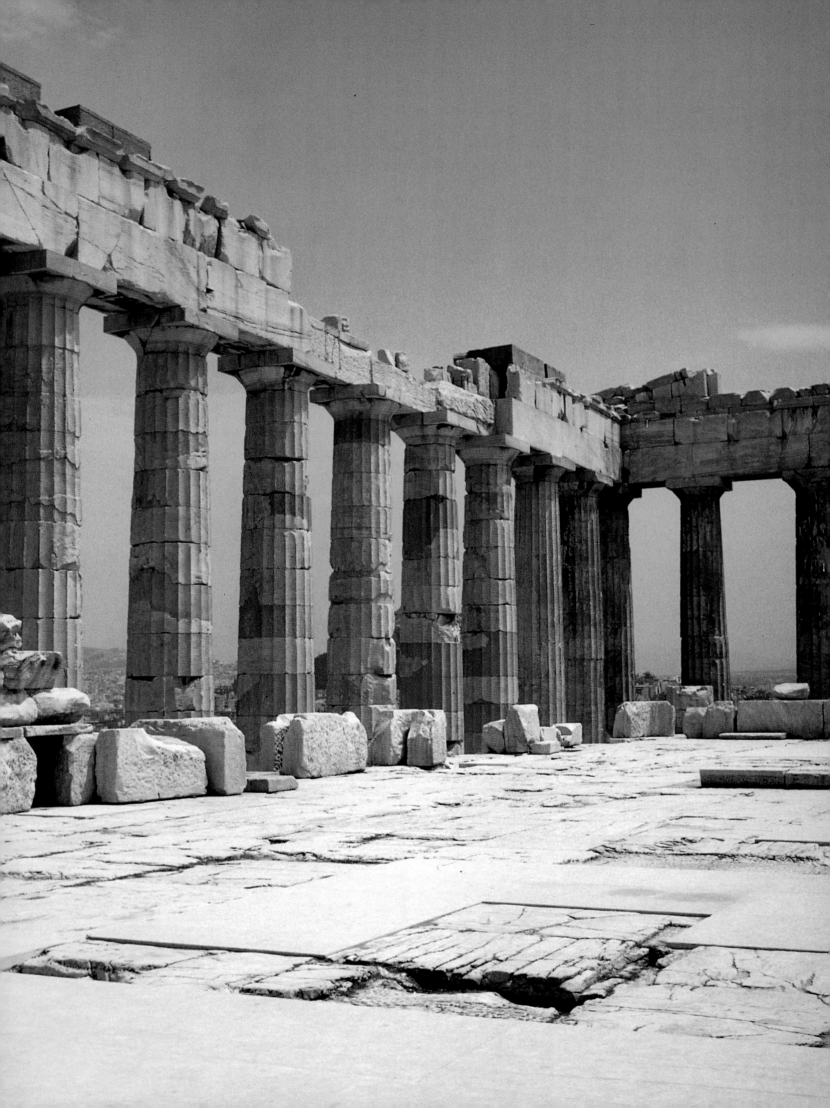

# PRAYERS IN STONE

PHOTOGRAPHS AND COMMENTARY
BY ALEXANDER LIBERMAN

Historical Essays by Diane Kelder

Designed by Crosby Coughlin

Random House
New York

For Victoria and S. I. Newhouse, Jr.

# CONTENTS

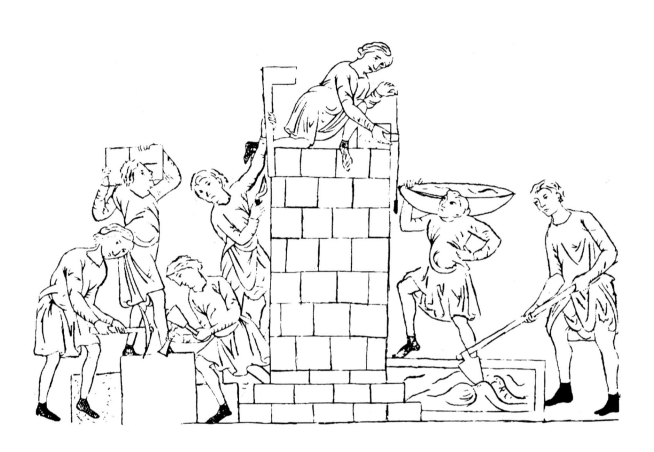

# Introduction

One of my earliest memories is of discovering a massive building on a small elevation near the river Moskva, not far from where we lived in Moscow. I must have been about seven or eight. It was just after the Revolution, and I was pretty much alone in the daytime. Both my mother and my father were very busy, and I was used to being in the street. I would play or, from time to time, fight with other little boys in the same situation. One day, on a solitary walk, I wandered into a huge unguarded stone space that seemed to me like an incredible cavern, with all the mystery an unexplored place has for a child. I later learned that this was the Cathedral of Christ the Savior. It had been erected in memory of the Russian victory over Napoleon. Many years later still this magnificent stone structure was destroyed on Stalin's orders and in its place a gigantic swimming pool was built. Now the Russian authorities have decided to rebuild the cathedral in concrete.

The awe I felt as a small boy standing in this colossal structure was unforgettable. It was my first experience of the majesty of a religious building, a house of the Lord in which

*Opposite page:* Twelfth-century drawing of masons and stonecutters at work.

believers are meant to feel small and barely worthy. On one of the monumental walls there was a giant head of Christ. I think it was painted. The eyes seemed at first to gaze straight ahead, but as you walked around you realized that wherever you went the eyes followed you. This is an old Byzantine method of impressing and mystifying the flock. For a small boy, the height, the volume, the mystery of this building were almost overpowering. Although I did not realize it at the time, the impact of this first close encounter with religious architecture would stay with me throughout my life.

In making this book, I have not tried to convey the precise differences among the buildings I have photographed, as one would in a serious architectural documentary. Nor have I attempted to cover the world: there are many extraordinary buildings that I have never seen. I have sought, rather, simply to capture some of the power of those that I have encountered in my travels. I've always felt that an exploration of the wonders of any city is best begun in its churches. One can go at any time of day, for these buildings are extraordinary in any light. They embody the highest levels of creativity of their respective cultures.

In the fourteenth century, Cennini Cennino advised those who wanted to practice the noble art of painting to "put on your most beautiful vestment, and then you are ready to do the work of the Lord." History is full of examples of artists who desired to reach up and glorify the Supreme Being. It is no accident, for quite practical reasons, that the greatest masterpieces were first offered to God. From very early on the priesthood or the royal establishment had the financial means to support artists, and the political establishment accepted the importance of worship and of celebrating the glory of God. What I have been drawn to in this book is in a way obvious, but that is because these works are by their nature the very greatest of civilization's achievements.

It is impossible to convey the mood of a cathedral interior through the technical means available to me. When you walk through the portals of Chartres, you are enveloped in an extraordinary aura that no photograph can truly render. In a curious way, some of the out-of-focus photographs in this book seem to me to best impart the mysterious, impalpable, unseizable quality that precise documentary pictures are not able to give. The good documentary picture will map out, identify, clarify, and explain a fresco or a sculpture or an architectural detail, and that is all to the good, for it is knowledge that we must have. But is that what we remember from a visit to a great temple or cathedral? I think not. Our memories are not so precise. They are emotional, closer maybe to Monet's impressionist views of the cathedral of Rouen. In breaking away from classic photography I am trying to communicate this kind of light and feeling. These images are a free association between my eye and the things that have felt significant to me in each place of worship. Many of the photographs show details and fragments of paintings and sculptures and structures in the hope that they will kindle the memory, much as the taste of a madeleine did for Proust. At the moment we experience them, Giotto's frescos in Assisi seem to have been already engraved in the mind. But in fact there are limits to what we can retain of all the carefully worked-out details and nuances of such masterpieces. If it is impossible to totally re-create what we see and experience, perhaps the photograph of a striking detail can stimulate the memory and call the whole into the mind's field of vision.

I have always been fascinated by the relationship between worship and artistic creativity. Many years ago I traveled to Greece, the cradle of western civilization, for a book I was preparing, *Greece, Gods, and Art*. I visited the earliest manifestations of man's desire to reach out to a deity. The columns of the Greek temples, erected in rhythmic repetition, are the embryos of Western European places of worship. Repetition is

one of the ways human beings try to touch the holy and remember. What the eye and the camera see is the surface of the magic that the temples and altars commemorate. And perhaps by immersing oneself in these haunting creations, one can achieve an understanding of what the prayers were meant to express. The experience of walking on the pavement of a centuries-old temple, of climbing the steps to the Acropolis, of kneeling on ancient floors is sublime. Whenever I do these things I feel that I am physically a part of the continuity of civilization. Just as in past times the grand tour was an obligation for any young, aspiring, thinking person, so today we should encourage bodily and mental contact with these prayers in stone. It is an essential duty to civilization. And today, with the speed at which we can travel, the plunge into the eternal story of humanity can be accomplished almost miraculously.

Working in stone has been from the beginning, from the days of monoliths and menhirs, the way to achieve permanence. Stone is humble, earthy, just solidified mud, yet of all the materials available to the artist it is the most resistant to destruction. And as such it is the safest element through which to transmit a society's beliefs and aspirations. I have always wondered what went on in the minds of the builders of religious monuments. Are those alignments of unsculptured stones at prehistoric Carnac simple or not so simple? The one principle that seems clear to me as a painter and sculptor and student of architecture is the principle of erection: building upward. Verticality is mysteriously connected with the concept of worship. With increasing understanding of structural laws and the capabilities of materials, with new techniques

and inventions man has been able to raise his buildings higher and higher into the sky. Today, new materials and new methods of construction have created secular buildings that are even taller and more imposing than the cathedral spires and temples of the past. But all the pride of commercial achievement cannot equal what was created by people who were making what their souls believed was right. They had a sacred task to which they applied their talents, their craftsmanship, their genius, and their faith. Their work in many cases involved a sacrifice, and one thinks that their lives were happier for their having given their sweat and in some instances their lives for something so profound.

It is very moving that a great master of our own time, Matisse, got up from his sickbed and created as his final visual testament the chapel for the Dominican Sisters at Vence. He reached the summit of his genius there, creating optical magic with stained-glass windows and graphic marks on tile, and a stenography of pain in *The Stations of the Cross*. Working with new materials, Matisse discovered forms in which prayer can be translated. Even if his chapel is not in a literal sense a prayer in stone, it takes a rightful place among the other monuments that remind us of the incredible power that enables an artist to transform simple materials into a moving act of worship.

The Scripture says, "Give, and thou shalt receive." And I think of all those who offered up their strength, physical and emotional, to glorify through their art the Supreme Giver of those sacred words. For a reward on this earth perhaps, but surely in the existence beyond. —ALEXANDER LIBERMAN

# Carnac

That stark stones could serve a religious purpose had not been obvious to me before I encountered the menhirs of Carnac. These standing stones, elevated and aligned in long, unexplained rows, are at once mysterious and reverent. Some of the stones are carved. The meaning of their markings and the symbolism of the stones themselves have been lost to time, but the alignments seem to be striving to convey something like a prayer.

There are no triumphal routes to the modest fields in which the stones stand, but the local people know where to look and they can take you to them. We came upon them on an automobile journey from Brittany to Paris. My wife and I had decided, after an exhausting trip through Italian museums, that it would be good for us to rest in Brittany. My daughter said, "Oh, Brittany is cold, you must take sweaters." We took the sweaters, but when we arrived, there was an incredible heat wave and I could not sleep. There was no air-conditioning. Brittany doesn't expect these heat waves, especially in early June. So we decided to leave for Paris. Our driver asked, "Have you ever been to Carnac?" I hadn't, but I wanted to go. And there is literally where this book took form. Perhaps nothing that follows has moved me more than the inexplicable majesty of these testaments to human yearning. —A.L.

During the Neolithic period (4000–2300 B.C.), people in northern and western Europe erected tombs and ceremonial monuments from huge stones that they often transported over great distances. The descriptive term for these constructions is *megalithic,* which derives from the Greek words for large (*mega*) and stone (*lithos*). They testify to the existence of a well-organized society with an apparently large and disciplined work force directed by skilled men. The scale of the monuments and the attention given to the placement of the stones suggest that they were part of a concerted effort by Neolithic people to mediate between themselves and what was surely a dangerous and frightening environment.

The southern coast of Brittany contains the largest number of megalithic monuments in continental Europe. The district encompassing the parishes of Carnac, Ménec, and Locmariaquer offers amazing assemblages of stones that have withstood the assaults of a harsh climate and vandalism for about six thousand years. More than three thousand vertical stones that the Bretons called menhirs still stand in a two-mile area. It is likely that over the centuries an equal number of the stones were destroyed or used to construct dwellings or walls. While some of the stones were arranged in circular patterns known as cromlechs, the majority were placed in straight rows. The most striking of these arrangements is comprised of twelve rows of more or less equally spaced stones, the height of which graduates from about three feet at the eastern end to over thirteen feet toward the west. The east-west orientation of the rows has persuaded some scholars that the people who erected them were referring to the movement of the sun. Others think that the isolated menhirs may have served as markers for celestial observation.

The monuments were probably the work of the Bretons' Celtic forebears, whose prehistoric migrations took them from Asia, across the Mediterranean, and over much of Europe before they settled along the shores of the Atlantic. Indeed, the surviving language of the Bretons closely resembles Welsh, Irish, and Gaelic. Although they abandoned their primitive religious beliefs and fervently embraced Christianity, the Bretons preserved legends and superstitions associated with the ancient monuments. Tales of eerie sounds emanating from the menhirs and of nocturnal encounters with strange animals are still common. One persistent local legend maintains that when a defeated army retreated to the coast and found no ships to carry them to safety, they turned to face their enemy and were instantly petrified. Another claims that a Christian missionary named Cornely miraculously transformed a group of Roman soldiers into stone when they threatened him with death. —D.K.

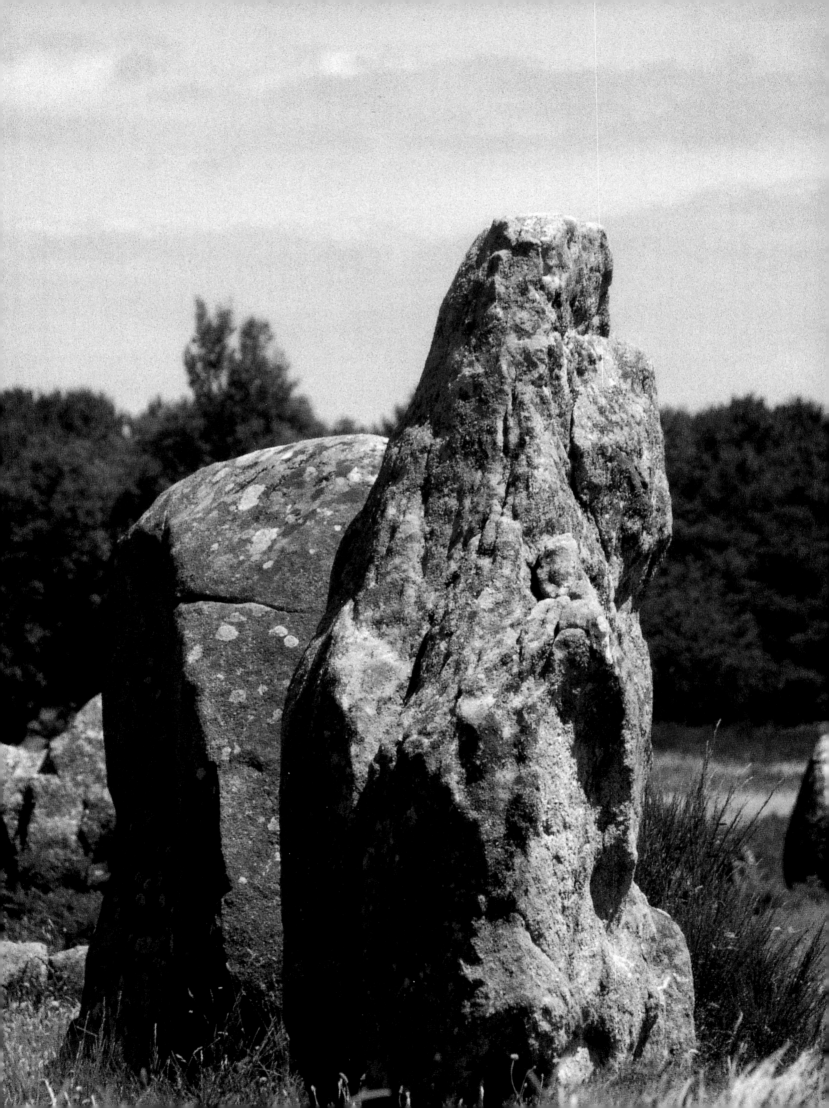

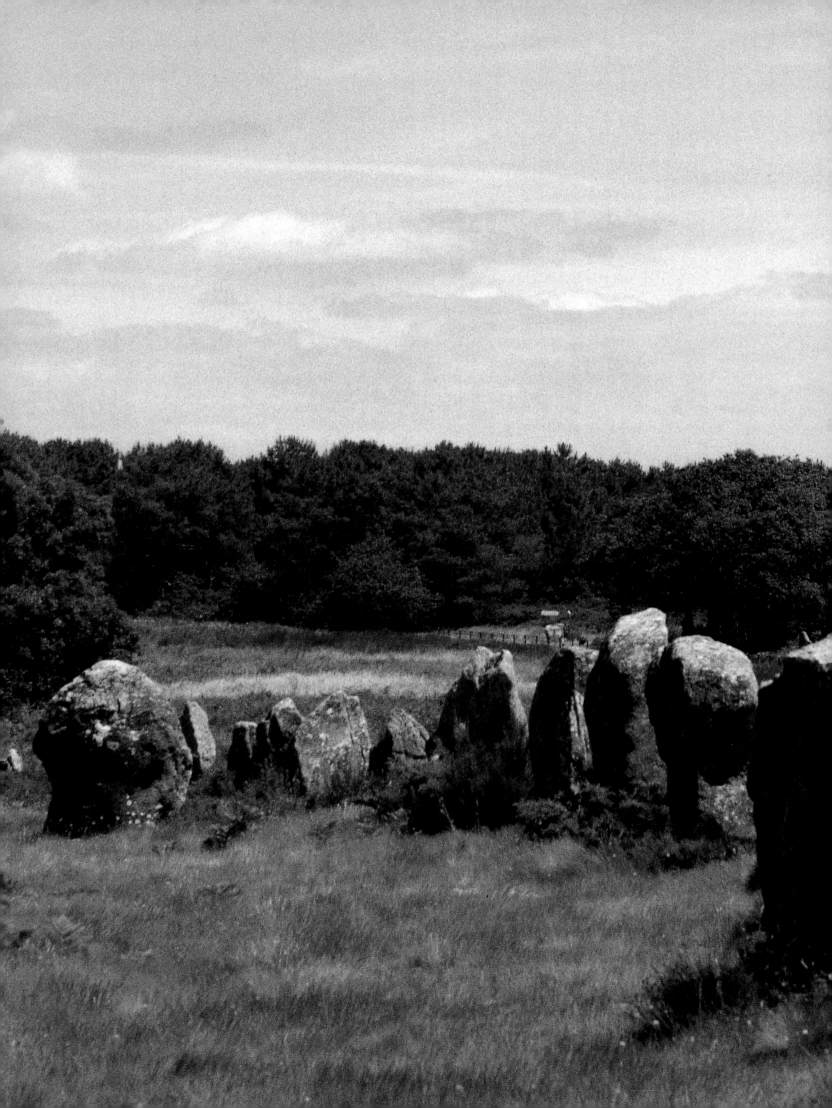

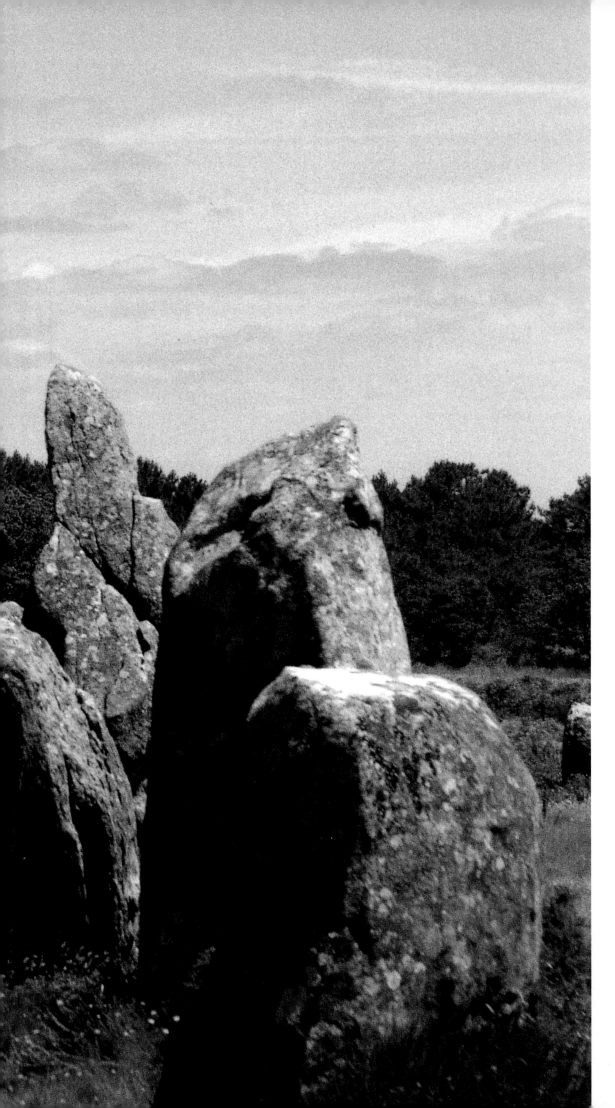

The menhirs near
Carnac are usually dated
from between 4200 and
3750 B.C. The monumental
alignments are comprised
of some three thousand
standing and fallen
pieces, many of which
have been upended and
broken up to be used
as building materials.

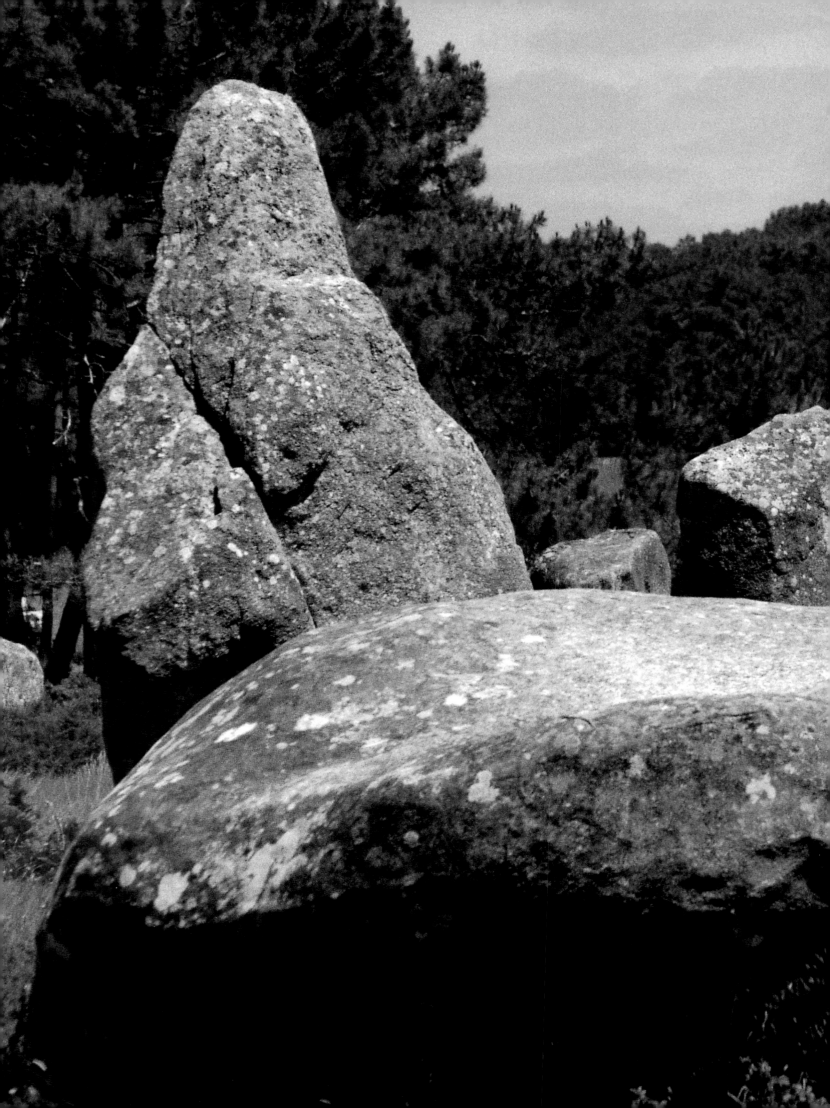

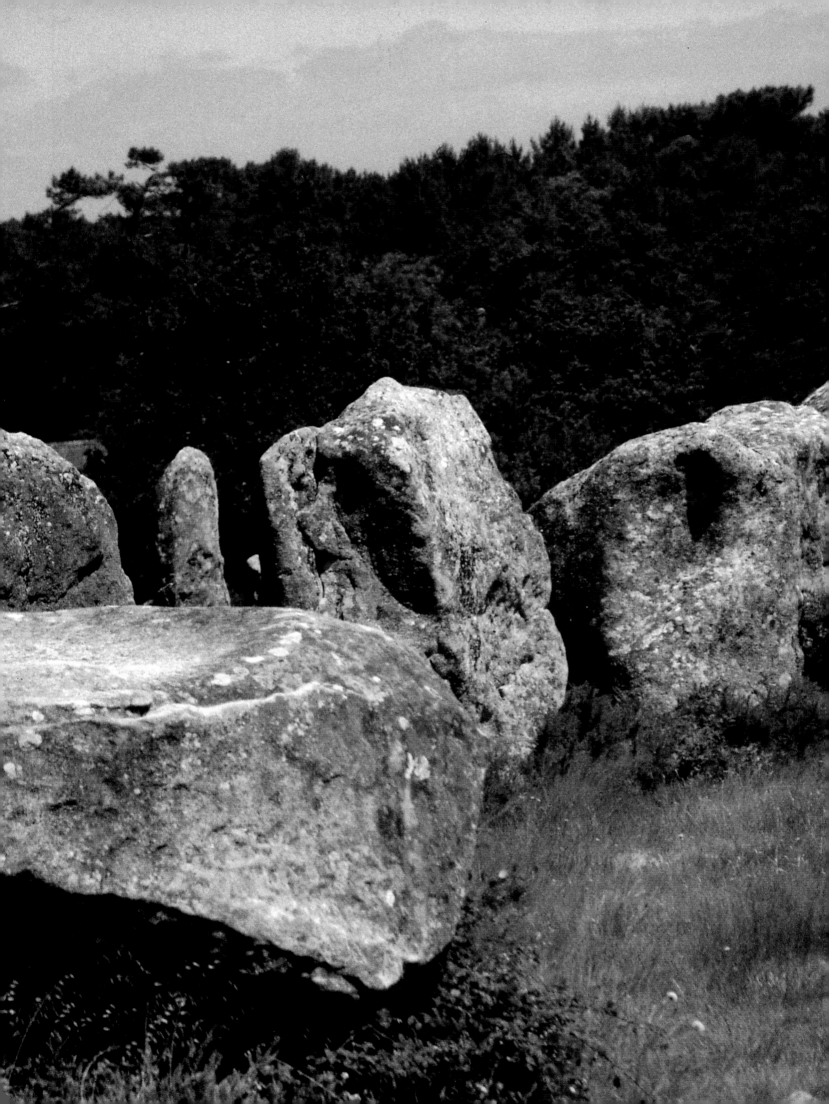

# Paestum

With the great civilizations of Athens and Rome came the building of temples, colonnades, domes, cupolas. The striking purity of early Greek religious architecture is unequaled by that of any other culture. These buildings now stand in ruins, their painted surfaces erased by time and exposure, but the full nobility of their concept is still apparent.

As you travel through the countryside in those parts of the Mediterranean world that came under the sway of ancient Greece, you sometimes suddenly encounter the rhythmically spaced columns of an abandoned temple, emanating the aspirations and memories of its creators. The three great temples of Paestum appear this way when you come onto a marshy plain after driving through rugged, arid mountains and deserted villages south of Naples. Mosquitos and malaria chased away settlers and intruders, and the temples stand majestic and vast in isolation.

Like all the examples of Greek architecture that I find most powerful, the temples of Paestum are in the Doric style, just as the Parthenon is. Ionic and Corinthian columns seem to me to have a certain decorative weakness. The Doric column makes a statement of majesty and grandeur. To stand and study the subtle rhythmic alignment of the columns in the peristyles of these temples is to contemplate one of the marvels of Greek architecture. The ruins of small cities have been uncovered here, along with extraordinary frescoes that were part of the temples.

When we visited Paestum we stayed in a small seaside village, Maratea, where you have to walk down hundreds of steps to reach the beach. Not the most comfortable experience, but worth it. And this arid, isolated region has unexpected delights. One day

*(continued from preceding page)* as we were driving back from Paestum on the forested mountain road, we suddenly saw at a turn a peasant girl, aged maybe ten, holding a big basket of wild strawberries. I have never seen such an abundance of these precious delicacies. The fragrance of the fruit, which was rare to us, kept us alert all the way to Maratea. We had arrived at Paestum at the end of an extraordinary voyage. A rich Greek friend had put at my disposal a yacht with thirty-two sailors and a Cadillac with a marvelous old-fashioned Greek chauffeur who took us to all the places where the boat could not go. The chauffeur was proud of his big car. Whenever I asked him, "Can you go through there, can you do it?" he would answer, "Me Cadillac."

Ancient Greece is the source of Western civilization and culture, and yet the world of the Greeks was vastly different from ours. For instance, when we read about the Greek wars we imagine vast fields filled with men. But when one visits the sites of the greatest battles, they seem puny and insignificant compared to the scale of the battlefields we are used to. Nonetheless, I don't think we can fully understand ourselves until we visit the monuments of that amazing civilization.

For a true cleansing of the mind, search out a temple like Bassae in Greece. Sit for an hour or two in the stony field surrounding it. Contemplate it. Learn to look. This is perhaps a modern form of prayer. Such contemplation imprints its image on the sensitive unexposed film of our memory.

I have been struck by the solitude of these monuments. They seem to stand aloof from bustling human centers. It reminds me how much isolation concentrates our perceptions. Alone, we can focus our thoughts and prayers on our most intimate beliefs. Perhaps some of these places were always hard to reach, demanding a real effort from those who wished to come closer. Isolation gives us a sense of privacy that we try to re-create when we enter a silent church to worship. In later civilizations, that quiet was ruptured by man's desire for glory. At Paestum, we can still respond like the early settlers of this place, and attempt communication through the stones. —A. L.

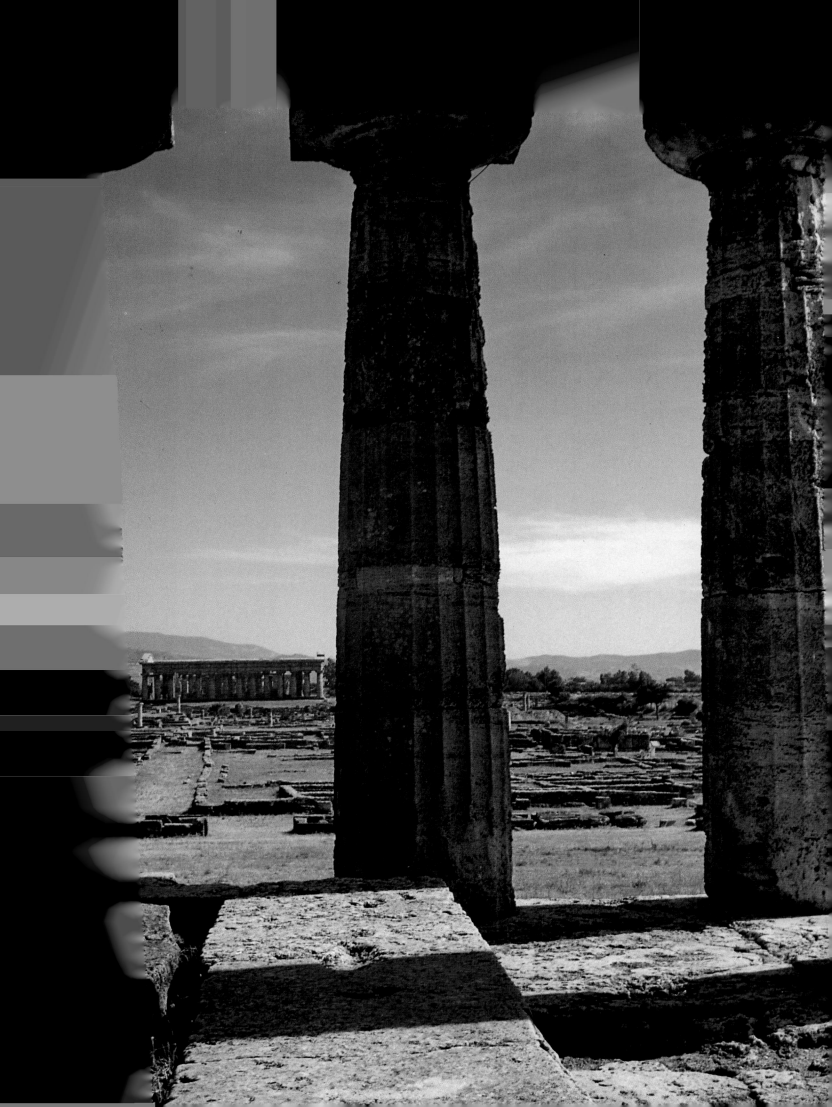

*Hail Poseidon, Holder of the Earth,*
*dark-haired lord! O blessed one,*
*be kindly in heart and help those*
*who voyage in ships!*

—HOMERIC HYMN XXII

During the eighth and seventh centuries B.C., Greece began to expand beyond the mainland and the islands of the Aegean. In the west, Sicily and southern Italy were especially attractive as areas for colonization since the soil was fertile, the climate temperate, and the resistance to occupation weak. The Greeks effectively hellenized the western Mediterranean, imposing their religion, culture, and laws on the indigenous population. This process ultimately brought to Rome what would be the basis of European civilization for more than two thousand years.

Paestum, a colony founded in the late seventh century B.C. some fifty miles south of the present-day city of Naples, was originally called Poseidonia, or city of Poseidon, but was renamed by the Romans in 273 B.C. When it was founded, the city overlooked the sea, but silt from the nearby river Sele accumulated to the extent that the surviving ruins sit in a vast plain. The site offers three rare examples of Doric temple construction that date from the early sixth through the mid-fifth centuries B.C. While the temples generally follow models on mainland Greece, they display a singular robustness and massiveness that may be a reflection of their colonial setting and of the diverse sensibility of the native population.

Scholars have long agreed that one of the temples, dating from c. 550 B.C., was dedicated to Hera, the wife of Zeus, and the goddess of marriage. The temple is a large, rectangular stone structure set on a stepped foundation. It has a single peristyle, or row of columns. There are nine columns at the east and west ends, and sixteen on the north and south sides. The elevation appears to be a local variation of the Doric order: the fluted columns have decisive Archaic profiles with a pronounced tapering in the shaft. In some, the undersides of the boldly rounded element of the capital display traces of carving. Other distinctive features of the plan *(continued on page 16)*

*(continued on page 16)*

Detail of a fluted Doric column from the Temple of Athena, which was built on the highest elevation of the city about sixty years before the second Temple of Hera was constructed in the fifth century B.C.

*Preceding page:* View through the columns of the Temple of Athena. The second Temple of Hera is in the distance.

*Following pages:* In this unusual view, two temples seem to be superimposed. In the foreground is the peristyle of the first Temple of Hera, which was built around 550 B.C. The second Temple of Hera is visible at the left.

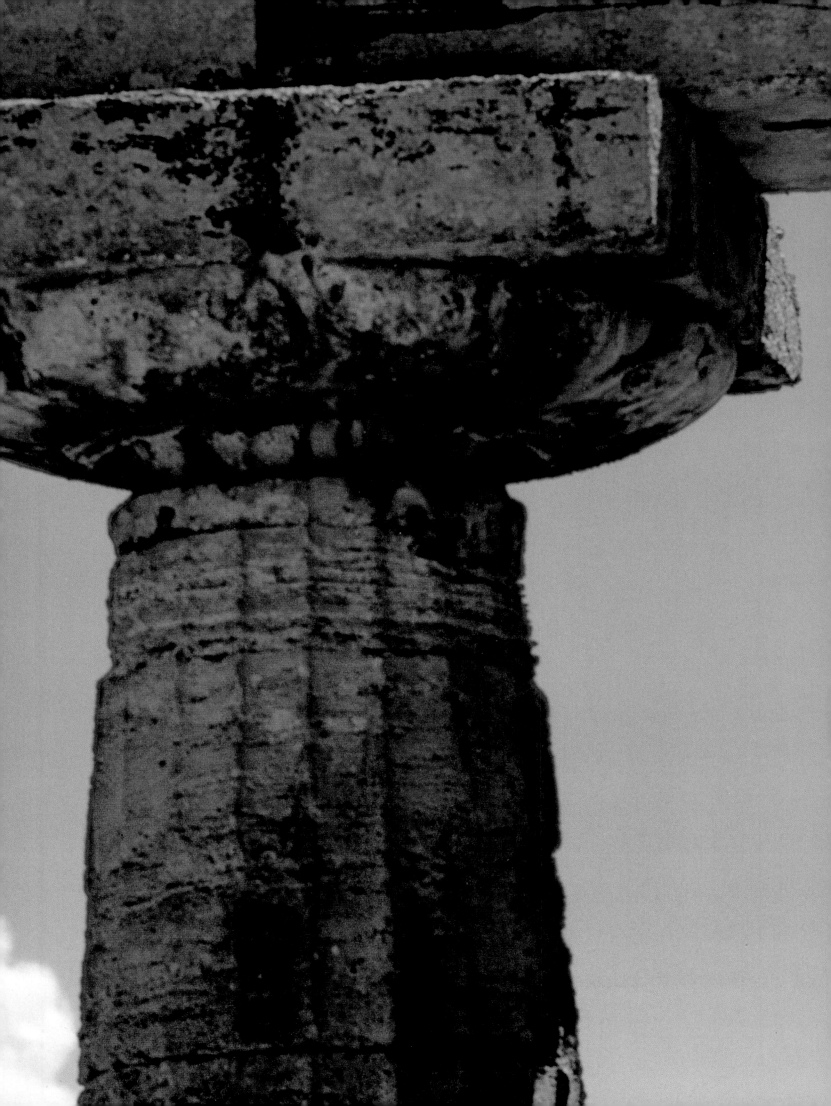

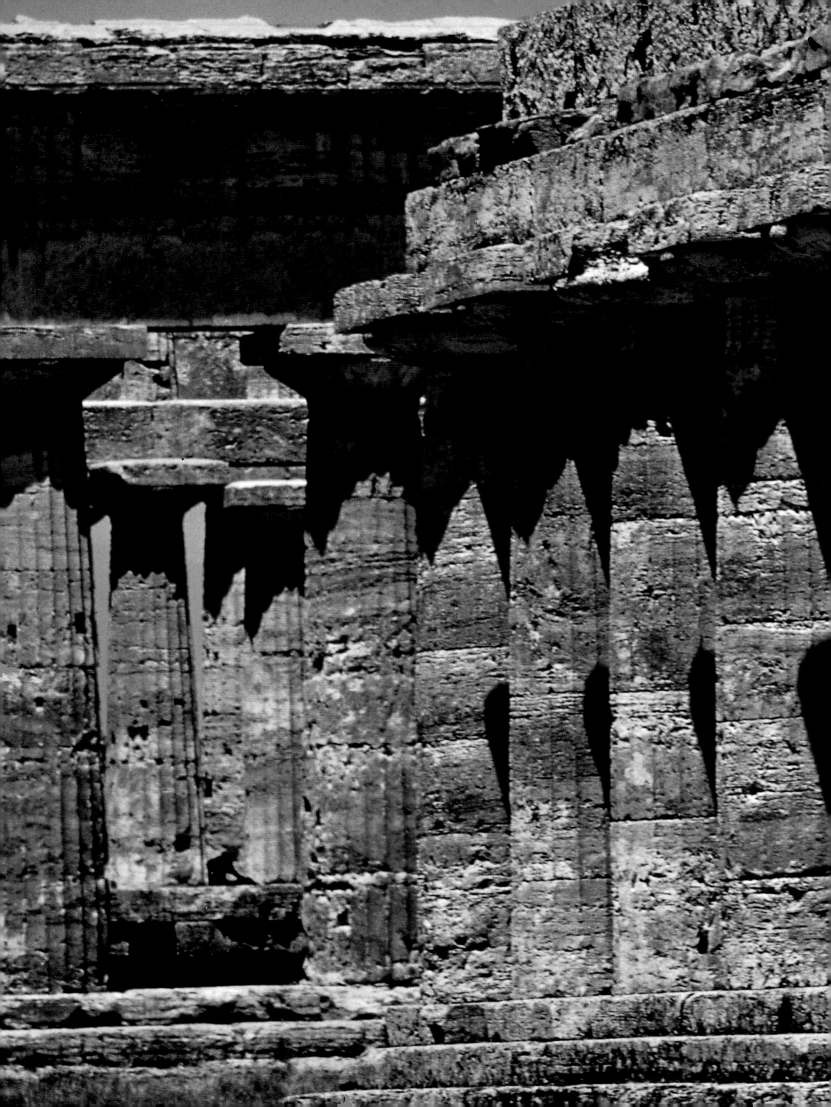

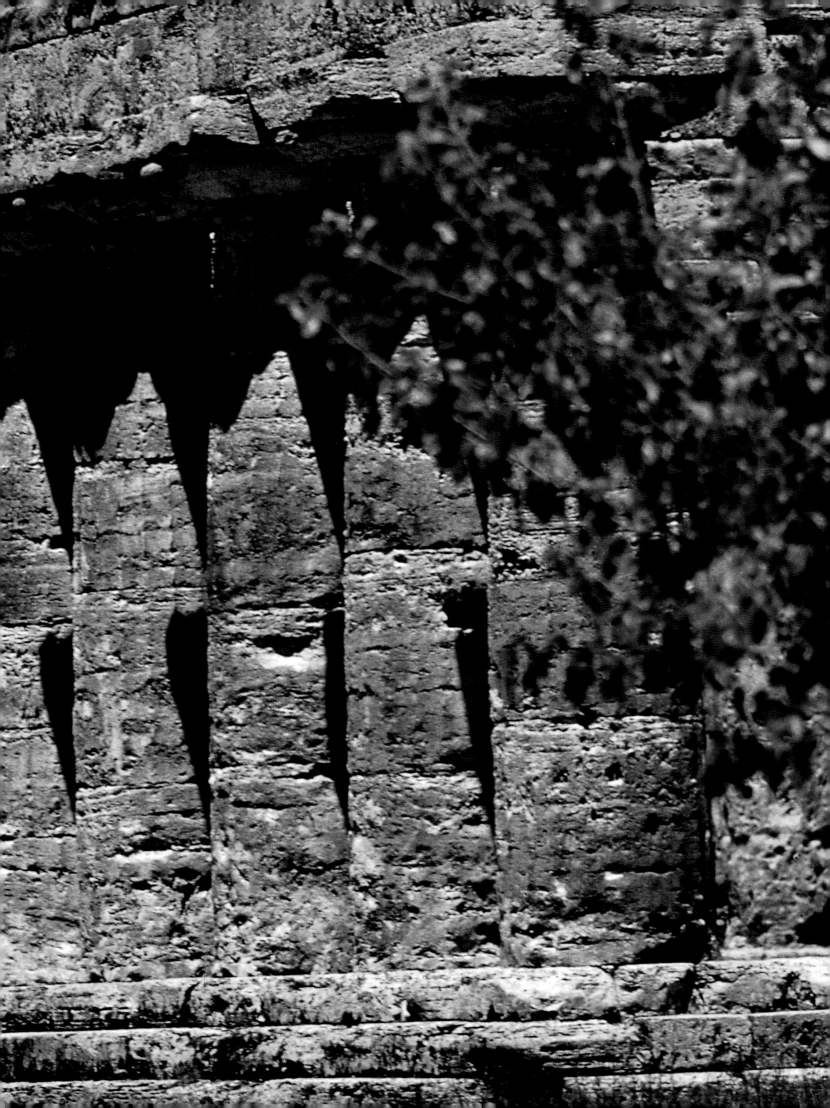

*(continued from page 12)* include the placing of a central column at the entrance to the pronaos—the initial chamber in the tripartite interior—and seven columns that run down the full length of the cella, or central hall. The unusual division of the cella suggests that, in addition to a statue of Hera, it may have housed that of a second god, possibly Zeus.

A second temple, built c. 450 B.C., was until fairly recently identified with Poseidon, god of the sea, but it is now believed to have been a sanctuary dedicated to Hera also. The plan of this temple is more elaborate than the earlier structure, with two rows of double-tiered, internal columns in the unusually large main hall. A section of these columns has survived, as well as the two pediments, making it the better preserved of the two temples.

The third temple at Paestum, the Temple of Athena, was constructed in the northern section of the city in the late sixth century B.C. It is unusual for the period in that it contains both Doric and Ionic columns. In the sixth and seventh centuries A.D. the temple served as a Christian church.

After the collapse of the Roman Empire, Paestum suffered a gradual decline. By the ninth century, the constant threat of Saracen invasion, coupled with widespread outbreaks of malaria, forced the remaining inhabitants to abandon the city. Toward the middle of the eighteenth century, the Spanish Bourbon kings of Naples played a decisive role in the systematic excavation of Pompeii, Herculaneum, and other sites in the region. The rediscovered temples of Paestum became part of an obligatory grand tour for archaeologists and a growing number of connoisseurs and collectors of ancient art. Subsequent excavations of Paestum and its environs have revealed fortified walls, regular streets, and a forum, as well as a necropolis with splendid painted tombs from the first half of the fifth century B.C. Although no sculpture has been found at the site, it has been suggested that fragments of brightly colored terra-cotta tiles discovered amid the rubble of the older Hera temple may have been part of an exterior frieze. If so, the decorative scheme would have imparted a marked sense of gaiety to these otherwise austere structures. —D.K.

The west pediment of the Temple of Athena is well preserved.
The unadorned frieze may once have been covered with colored tiles.

*Following pages:* Interior of the Temple of Athena looking west.
As ships approached the city, this temple would have stood
out from the other temples and loomed against the mountains.
Athena was a fiercely protective goddess.

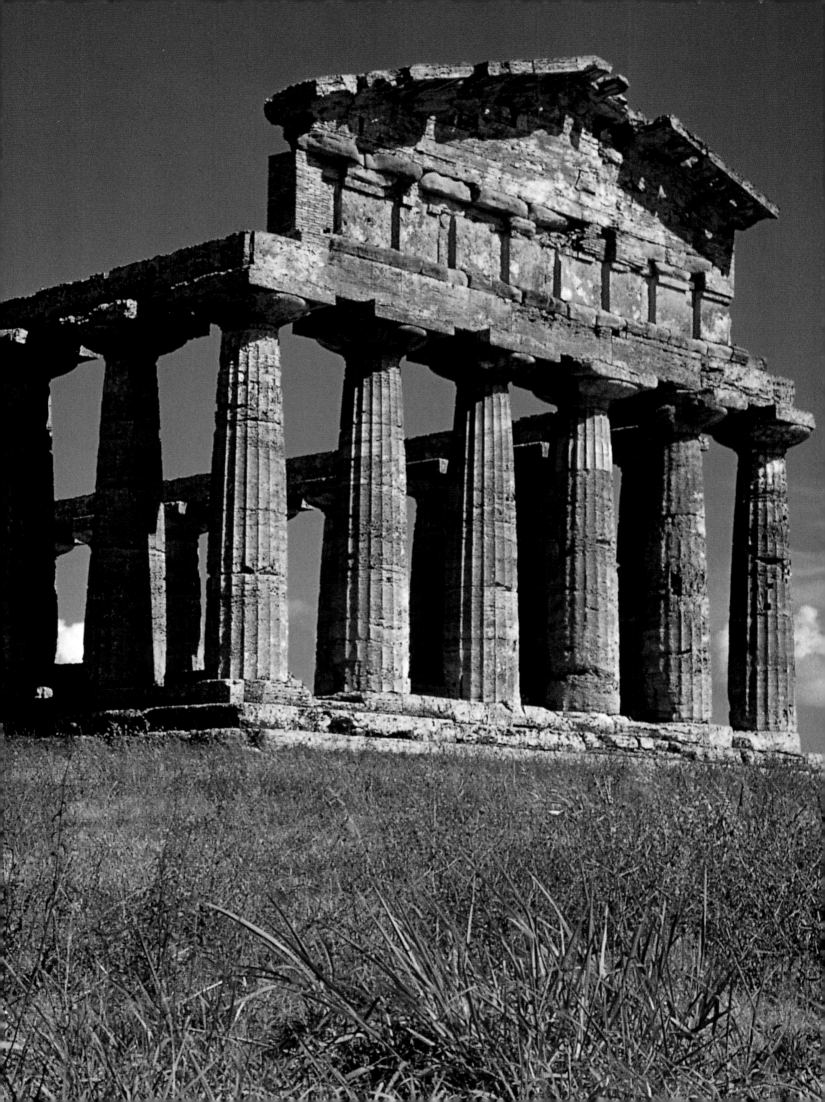

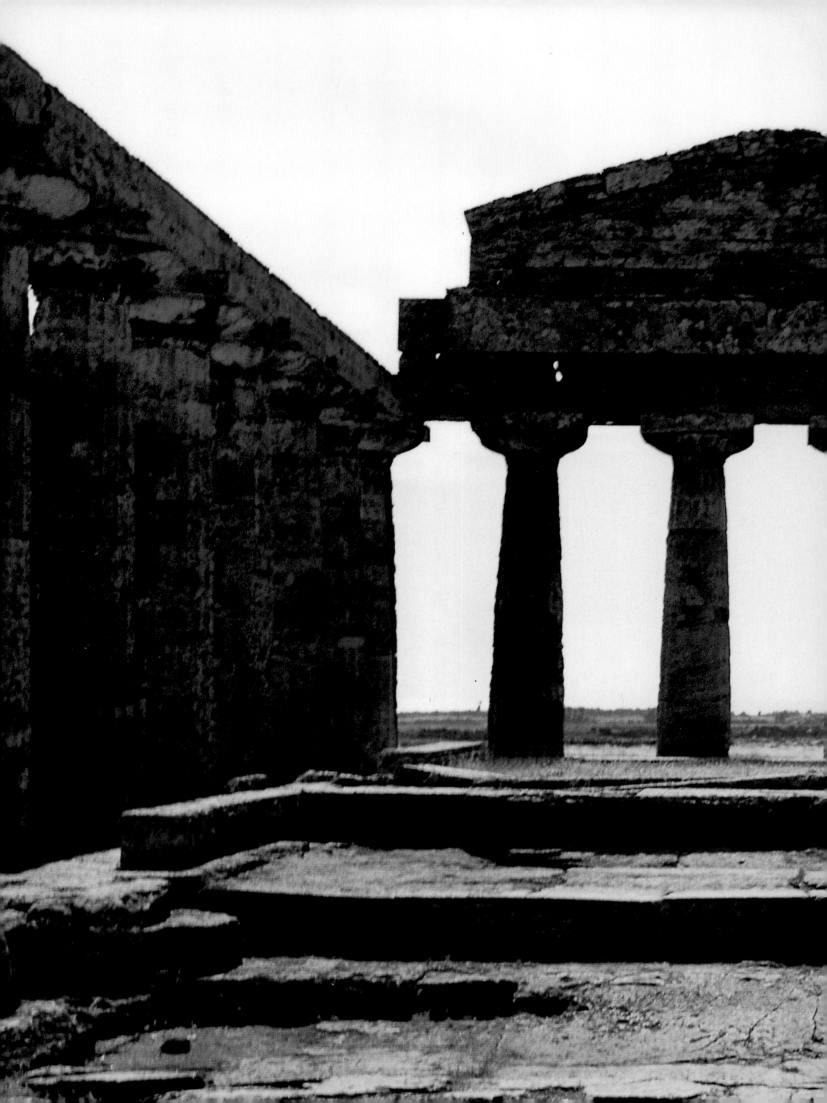

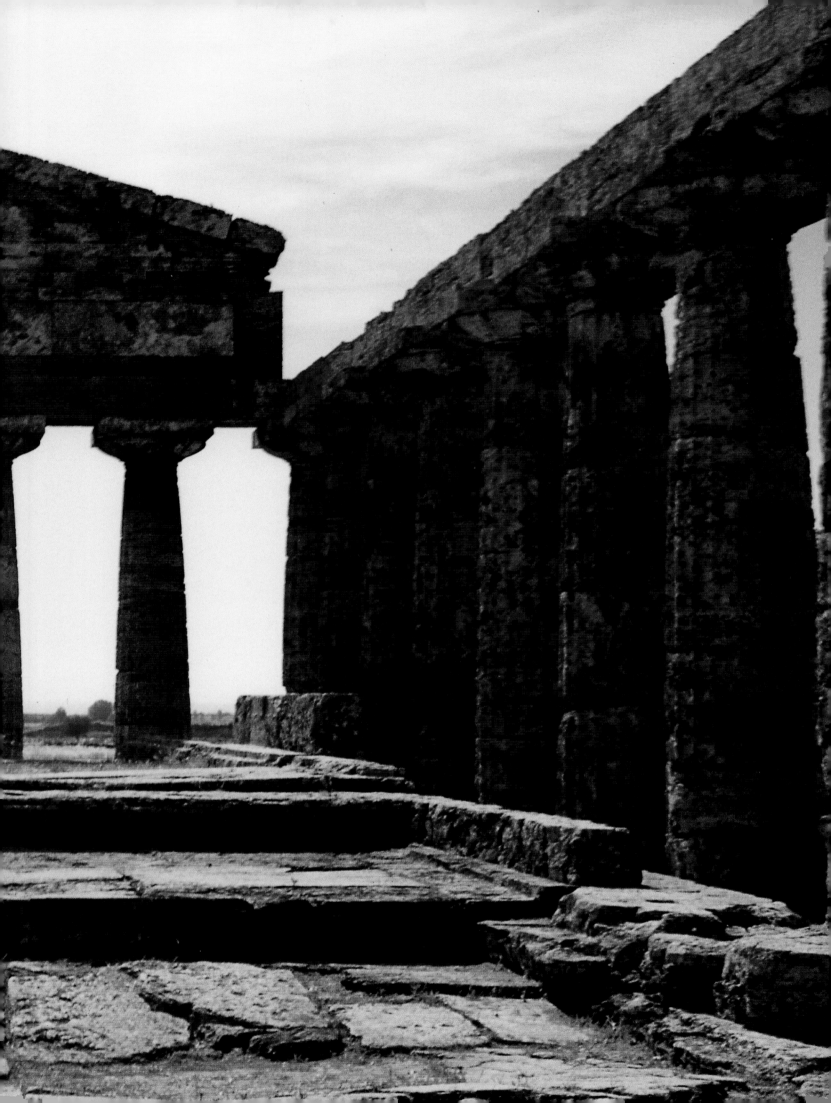

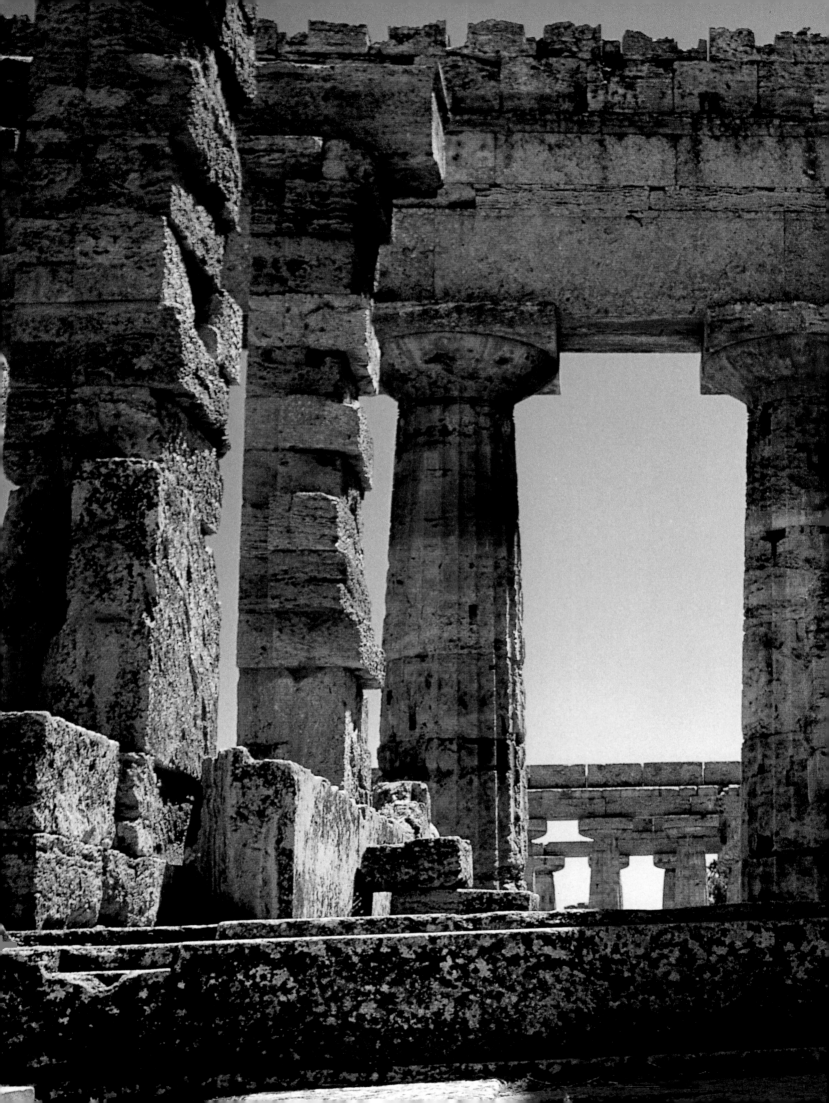

The massive stepped foundation and robust columns of the first Temple of Hera frame a view of the second temple built next to it.

*Following pages:* The second Temple of Hera with ruins of a forum.

21

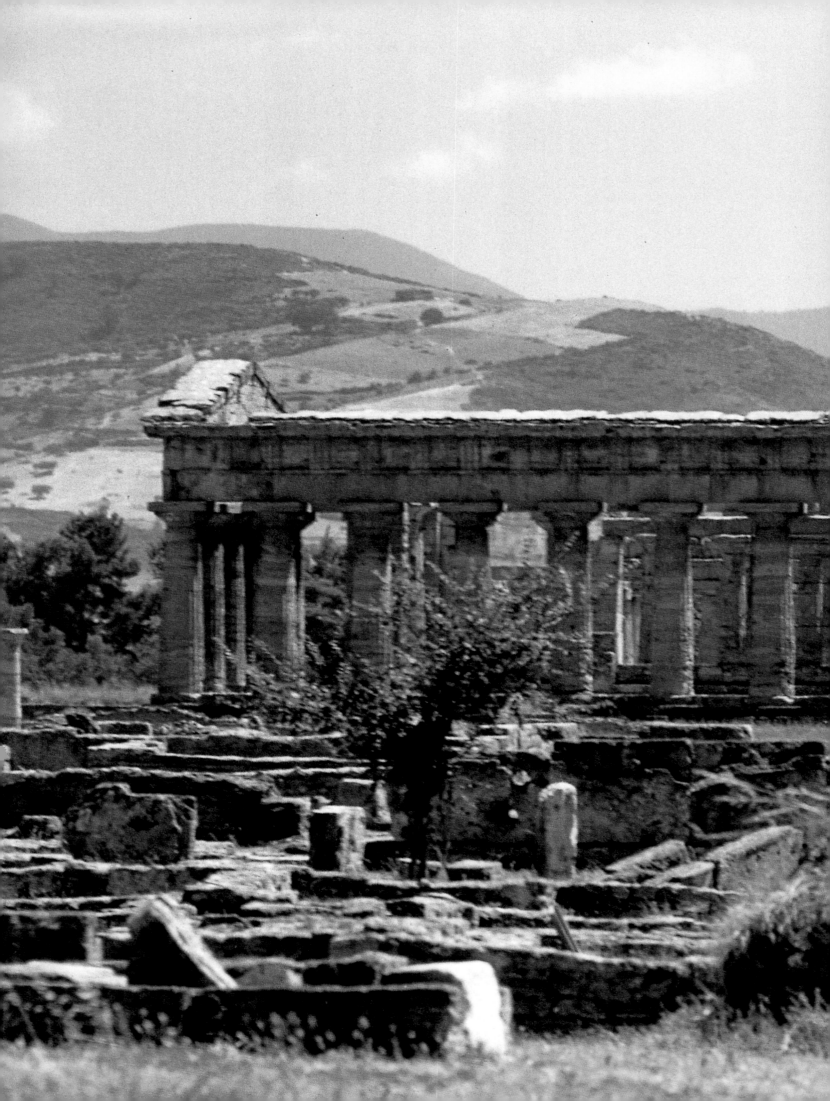

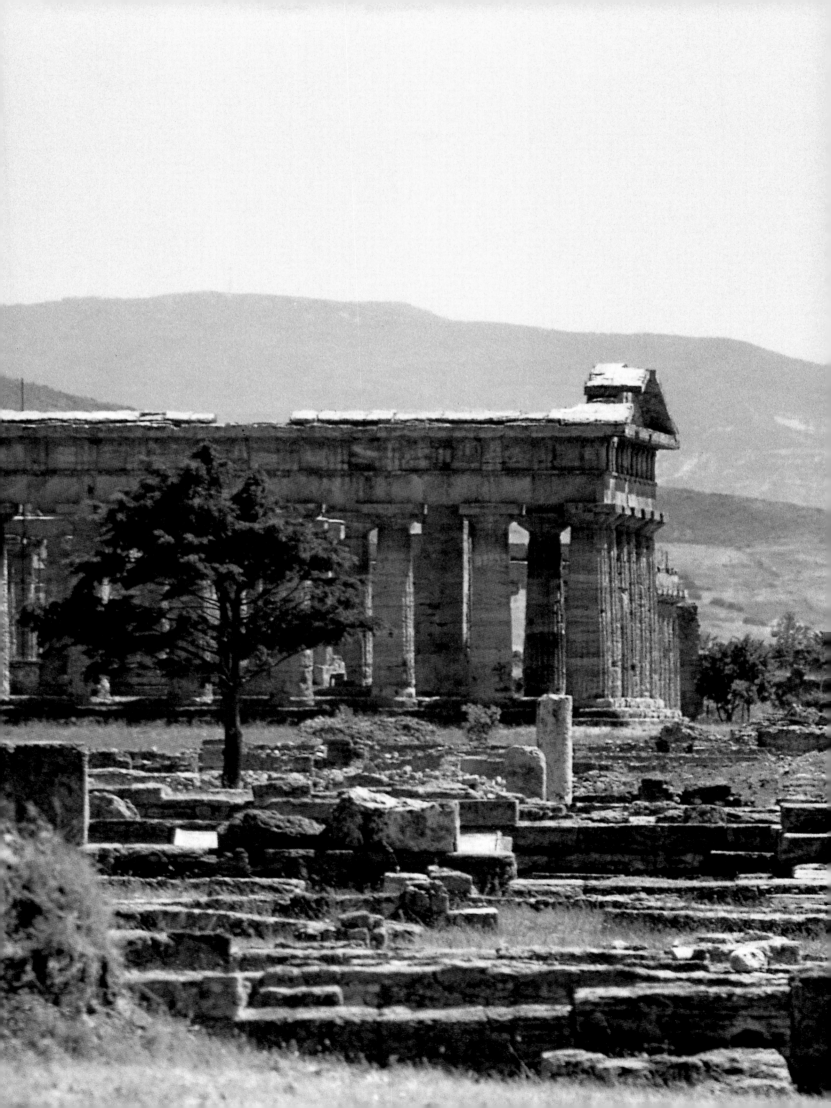

# The Parthenon

The most sublime example of Greek architecture to survive into our times is the Parthenon in Athens. Built high on the rock of the Acropolis, it reflects, with its companions, the Erechtheion and the Propylaia, the highest moment of Greek civilization. It is well worth the struggle in the heat to mount the steps, pass through the majestic Propylaia, and come upon the vista of the Parthenon. Although damaged by uncouth later civilizations, it still retains a majesty unique in Greece and perhaps in all the world. Its beautifully proportioned Doric columns, now without paint, stand luminously above the city, changing color with the changing light.

Here in the Parthenon, the Greek attempt to attain perfection reaches an extraordinary level. Even the stones damaged by the explosion of the Turkish arsenal in 1687 add to the overall effect, lending a theatrical quality. I could, and in my mind do, spend endless amounts of time admiring and meditating on the noble achievements of the human spirit. The Parthenon represents for me the ultimate message of Greek art, its proportion, dignity, and reverence. —A.L.

The Acropolis seen from the northwest. On the right is the Parthenon; to the left, the huge Propylaia, and the small Temple of Athena Nike. As Plutarch observed in the first century A.D., some five hundred years after the construction of these buildings, "They were created in a short time for all time."

*Following page:* Interior of the Parthenon, looking east.

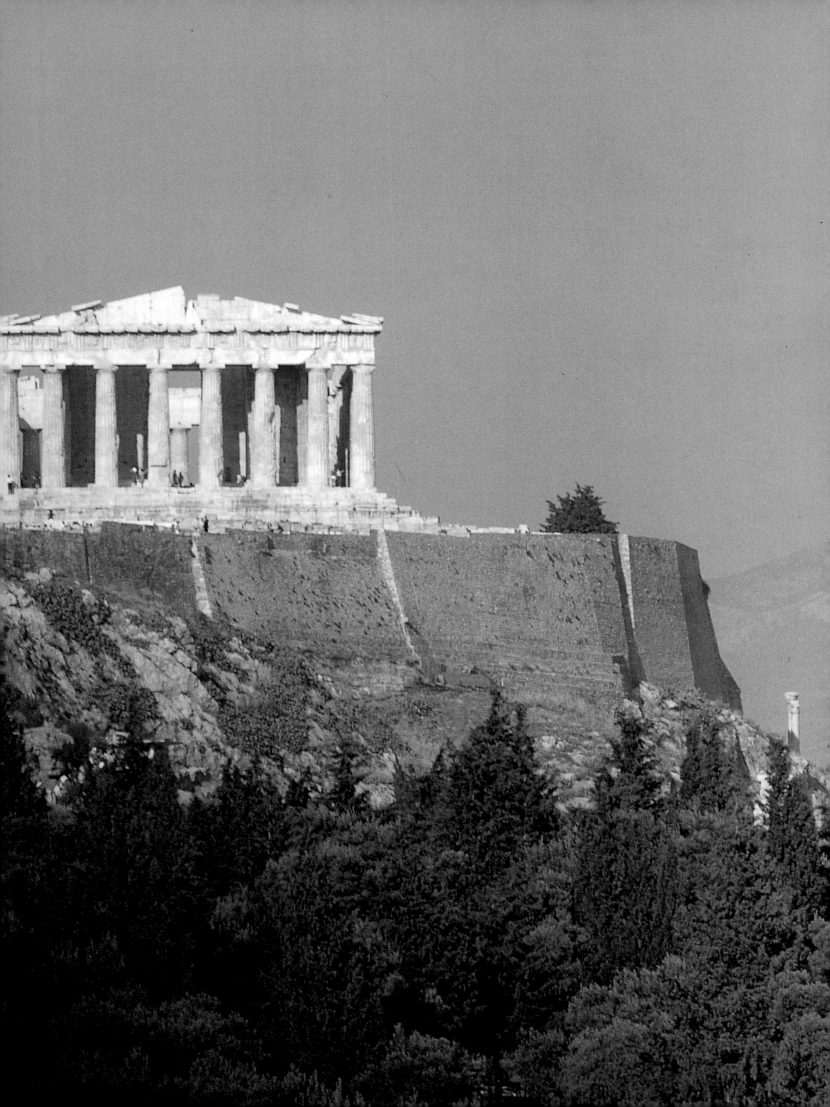

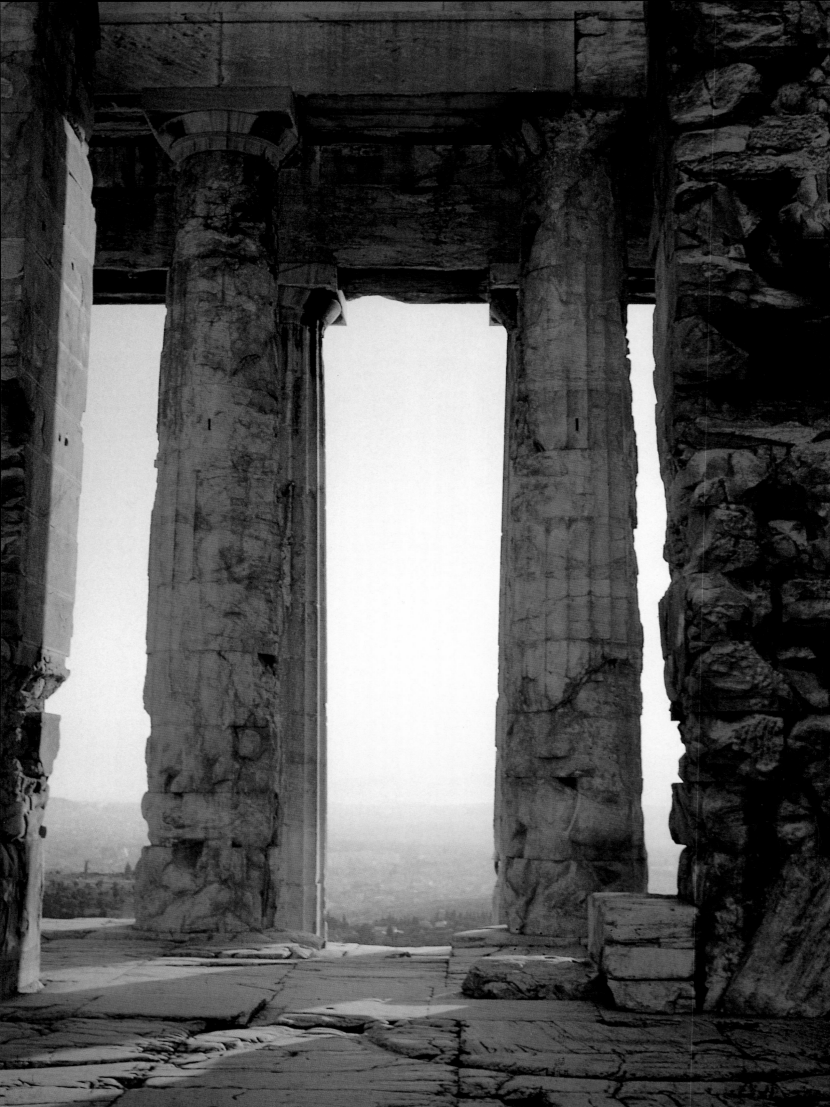

*It was a single thought in stone, . . . as intelligible as ancient thought itself. Only from near at hand were the richness of the materials and the inimitable perfection of the decoration and the details apparent. Pericles wanted to make of it as much a bringing-together of all the masterpieces of man's genius and man's hand as an act of homage to the gods. . . .*

—ALPHONSE DE LAMARTINE, 1834

The stark white outline of the Parthenon dominates the city of Athens and is visible for miles from the sea and surrounding countryside. Of all the surviving monuments of ancient Greece, none so brilliantly expresses the classical ideal. It was constructed according to a system of measurement that made it proportional to the human body. Although badly damaged during prolonged wars between the Turkish conquerors of Greece and the Venetian Republic, and long robbed of the magnificent sculpture that adorned its surfaces, the Parthenon and the other buildings of the Acropolis still retain an aura of timelessness.

From early in the fifth century B.C., the prosperity of Athens and mainland Greece was threatened by the aggressive westward expansion of the Persians. After the initial defeat of Persian invaders in 490 B.C., the Athenians decided to erect a temple to honor Athena, the city's patron and protector, and to commemorate the soldiers who died defending the city. Ten years later, with construction scarcely under way on the Acropolis—a large, flat hill accessible only from the west that had served earlier as a fortification—the Persians attacked again. This time they burned much of the city and succeeded in destroying virtually everything on the Acropolis, including the partially built temple. The Persians were finally routed the following year, and the Athenians set about rebuilding their devastated city.

Under the leadership of Pericles, who ruled Athens from about 460 B.C. until his death in 429 B.C., Athens became the most powerful and richest of the city-states in the Delian League. In 448 B.C. Pericles persuaded the Athenians to undertake the erection of a temple of unprecedented scale and magnificence to house a colossal gold and ivory statue of Athena Parthenos (Athena, the Virgin). The Acropolis was to be rebuilt as a glorification of the city's civic and cultural values and to bolster its status as the de facto capital of an empire in the making. Once the citizens approved the funds, Callicrates and Ictinus were chosen as the architects, and the sculptor Phidias, a close friend of Pericles, was charged with making the image of Athena and supervising all of the sculptural decoration. The temple was completed between 447 and 438 B.C., and the sculpture for the east and west pediments was installed in 432, three years before the death of Pericles. The cost of labor and materials, including more than twenty thousand tons of marble transported from mountain quarries, *(continued on page 33)*

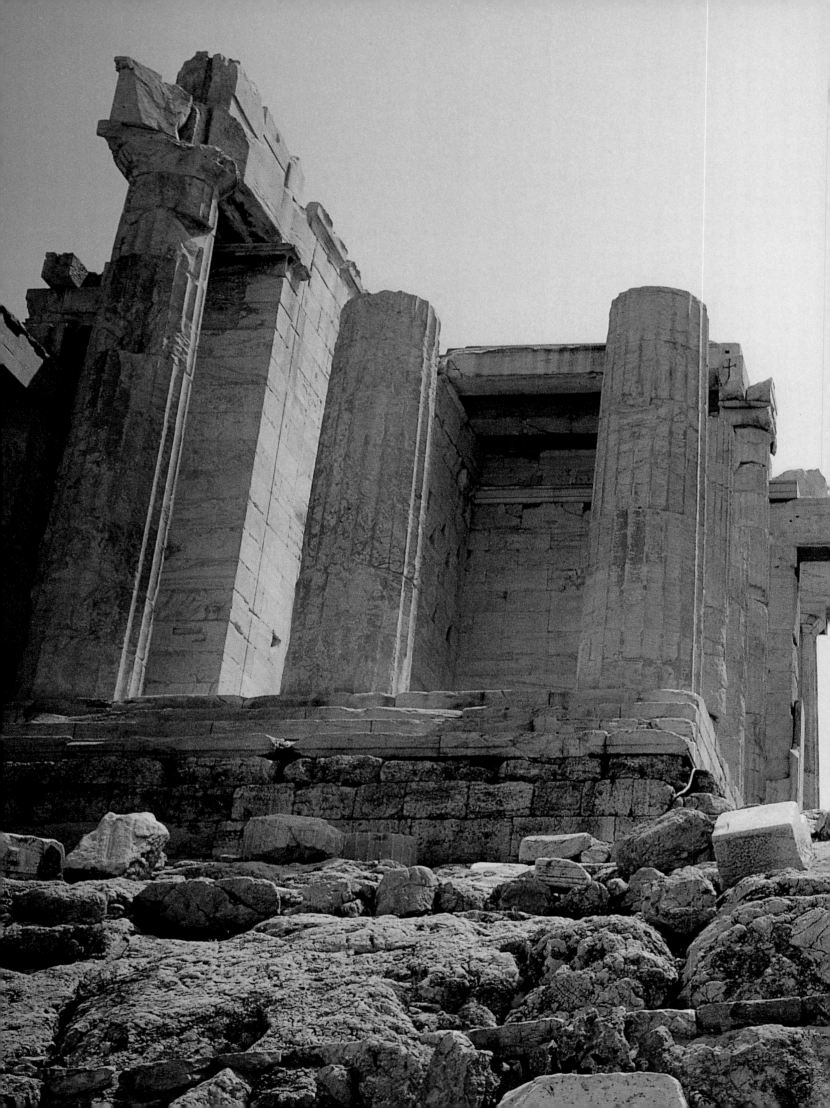

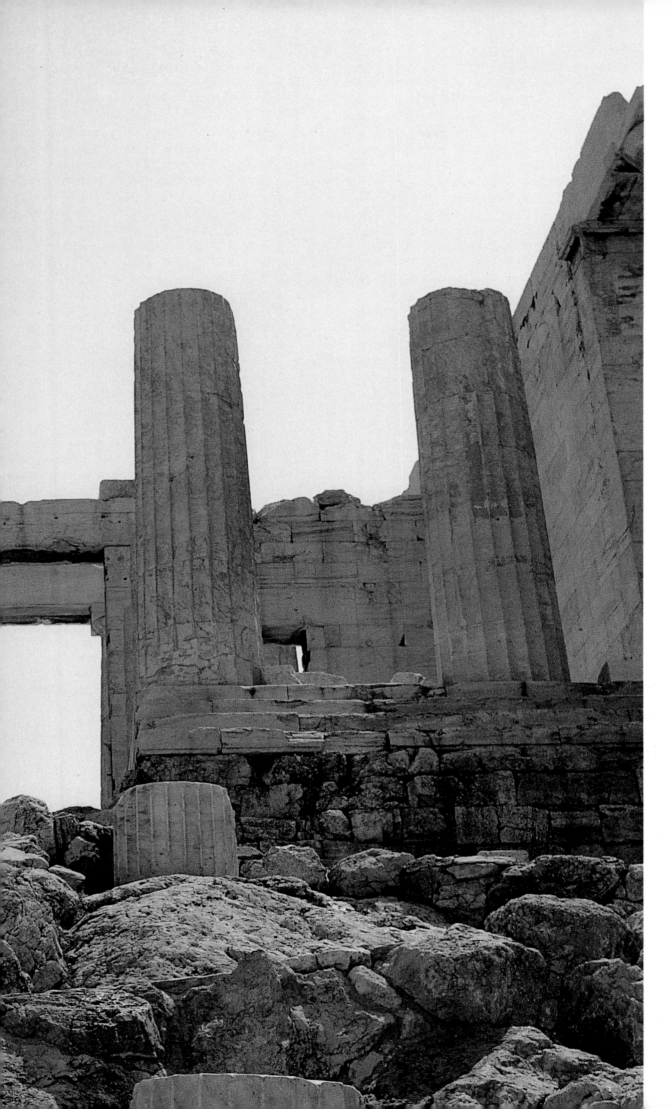

Close-up of the
Propylaia, the
construction of which
ended abruptly with
the outbreak of the
Peloponnesian War.

*Following page:*
Corner view of the
surviving peristyle
of the Parthenon.

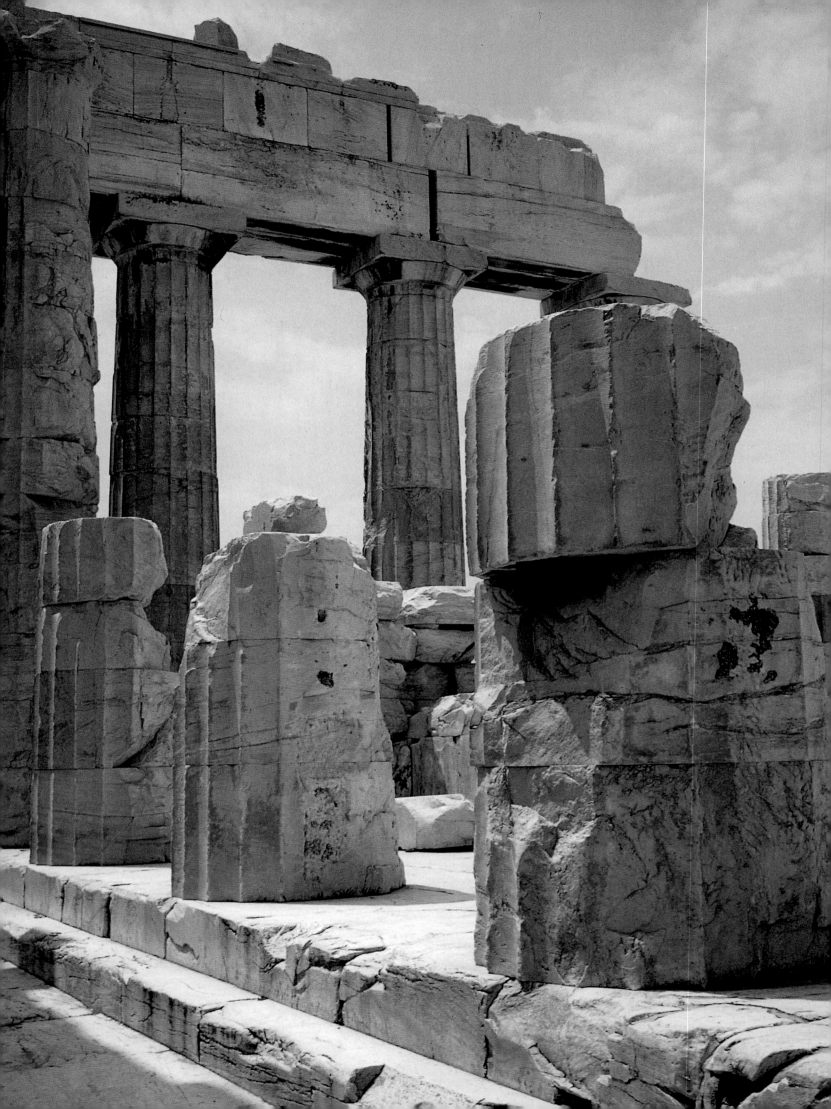

*(continued from page 29)* and great quantities of ivory, gold, and precious wood, was enormous. Pericles' political rivals criticized him for his extravagance, but he never lost the support of the majority of Athenians, many of whom benefited from being employed as workers on the various constructions.

By the end of the fifth century, visitors to the Acropolis were able to ascend a steep ramp on the west side of the hill. There they encountered the exquisite Ionic temple dedicated to Athena Nike (Athena of the Victories) before passing through the Propylaia, or ceremonial entranceway, which led to the sanctuary with its temples, altars, and armory.

The Parthenon is justly considered the most splendid example of Doric architecture. The peristyle consists of forty-six columns, eight at the east and west ends, and fifteen along the north and south sides. The architects made subtle refinements in the lines of the structure and in the shape and placement of the columns to counteract optical distortions that would be experienced when it was viewed from a distance. Everywhere gentle curves replace straight lines; even the floor slopes outward, in part for purposes of drainage, but also for aesthetic effect.

More sculpture decorated the Parthenon than any other Greek temple. Its two large pediments contained larger-than-life-sized figures that were carved in the round and affixed to the wall with iron pins. The dynamic group in the west pediment depicted Athena's struggle with her uncle Poseidon for possession of Athens, and those of the east pediment represented the birth of the goddess. Ninety-two metopes on the exterior frieze portrayed battles between Lapiths and centaurs, gods and giants, or Greeks and Amazons. The themes emphasized the triumph of Greek civilization over barbarism and despotism. A continuous frieze in low relief extended some 525 feet along the outside cella walls, beneath the ceiling of the portico.

The Roman conquerors of Greece admired its artistic achievements and adopted its religion, with the result that most temples remained untouched until the advent of Christianity. Sometime in the sixth or seventh century A.D., the Parthenon was transformed into a church dedicated to the Virgin, and it served intermittently as an Eastern Orthodox or a Roman Catholic church until it became a mosque when the Turks conquered Athens in the late 1450s. In September, 1687, during an assault on Athens by armies of the Venetian Republic, the Turks converted the Parthenon into a powder magazine. In the course of the Venetian bombardment, the center of the temple received a direct hit that destroyed most of the interior and significantly weakened the surviving structure. Throughout the eighteenth century the sad evidence of the Parthenon's devastation was recorded in artists' drawings. Broken fragments of sculpture and architecture lay everywhere. Some would be used as building materials or burned for lime; others were carried away as souvenirs.

In 1799, the Earl of Elgin was appointed as the British ambassador to the Ottoman Empire. Aware of the decline of the Acropolis, Elgin gathered a group of artists and sent them to Athens to make drawings and casts of the surviving monuments. He was convinced that if the remaining sculpture was not removed it would be destroyed by time, vandals, or casual theft. In 1801, the government granted him permission to remove whatever he wished. Ultimately, some 247 feet of the Panathenaic frieze, fifteen metopes, and a number of figures from the pediments were shipped to London. In 1816, they were sold at a modest price to the British government and installed a few years later in the British Museum. —D.K.

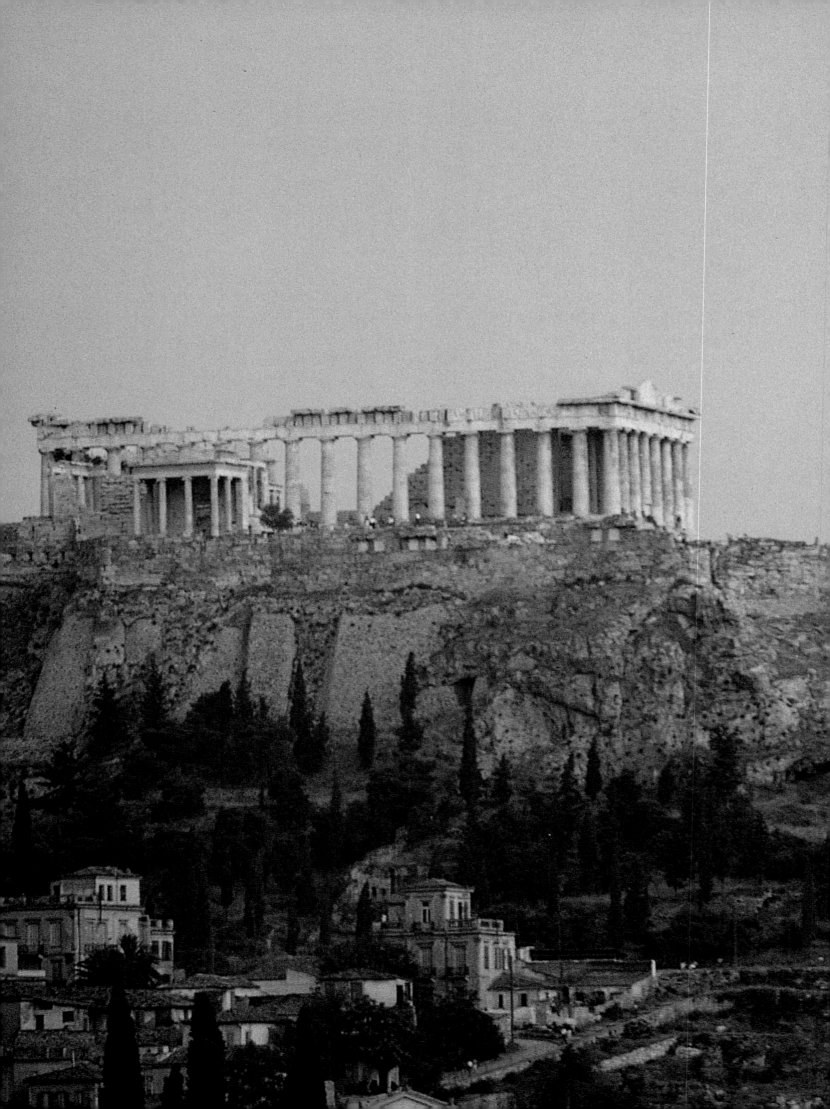

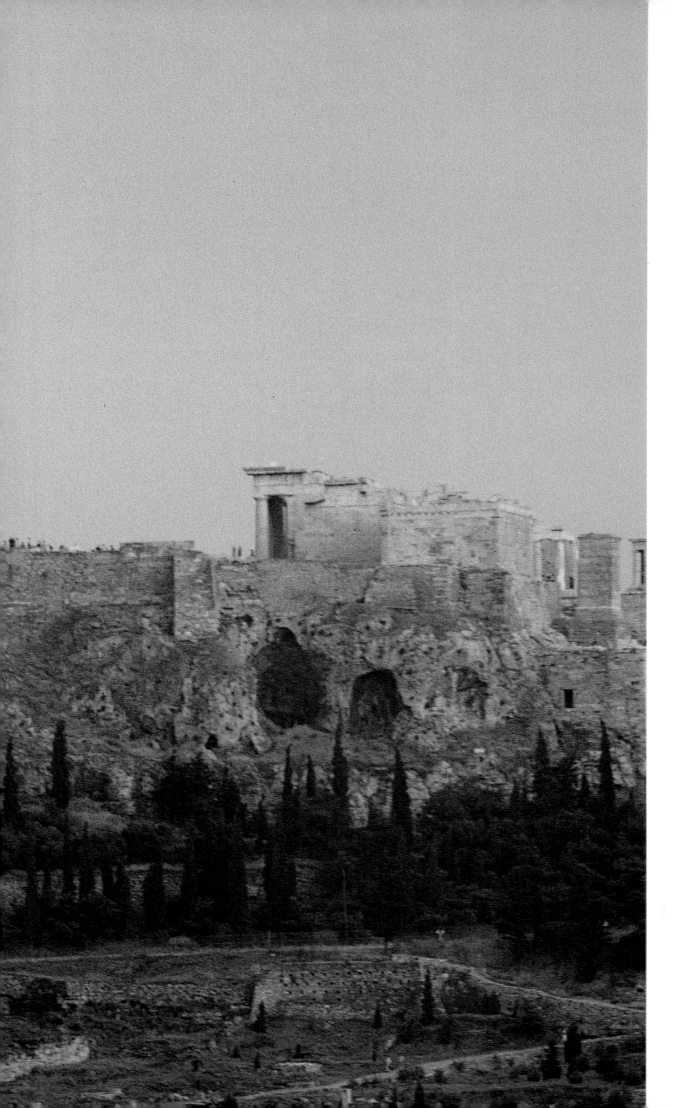

The Acropolis
seen from the
north. The small
temple next to
the Parthenon is
the Erectheion.

# The Pantheon

The one remaining Roman temple in Rome, the Pantheon has survived intact and in continuous use. In it you sense the power and the engineering brilliance of the Roman Empire. Built to honor all of the gods, today it honors the great of Italy, from Raphael to kings and queens. The immense circular interior is as high as it is wide, with square coffers that indent and lighten the structure. It is awesome and breathtaking, illuminated only by a central open oculus that offers glimpses of the Roman sky. This great open eye is in my imagination a permanent halo, constantly encircling the saints and heroes, ancient and modern, entombed within this remarkable structure. —A.L.

*O Jupiter of the Capitol, O Mars Gravidus, author and establisher of the Roman name, O Vesta, guardian of the sacred flame that burns forever, and all the gods who have lifted this massive Roman Empire to the grandest pinnacle of the whole world—upon you in the name of the people I call aloud in supplication: guard, preserve, protect this order, this peace, this Emperor. . . .*

—VELLEIUS PATERCULUS, second century, A.D.

The Roman emperor Hadrian, who reigned between A.D. 117 and 138, was an enlightened statesman, and a great patron of the arts. Hadrian wrote poetry and painted, and his devotion to Greek art and culture engendered a revival of classical values that resonated throughout his vast empire. His interest in and knowledge of architecture was profound, and it is generally agreed that he played an active role in the design of his magnificent villa at Tivoli. In Rome, his name is associated with many public buildings, of which the most celebrated is the Pantheon, or "temple of all the gods," constructed between A.D. 125 and 128.

The site of the Pantheon was once the focal point of a complex of baths and public gardens built by Agrippa in 27 B.C. Such was Hadrian's modesty that instead of putting his name on the Pantheon's exterior, he chose to honor his predecessor by placing the words "Marcus Agrippa, son of Lucius, three times Consul, built this" on the architrave above the porticoed entrance.

The design of the Pantheon combines Greek and Roman elements. The huge pedimented porch is supported by sixteen towering Corinthian columns, but behind this traditional Greek structure is a distinctively Roman rotunda. This particular synthesis became a model for generations of architects, including Brunelleschi, Bramante, Palladio, and even Thomas Jefferson. The vast scale of the building was made possible by the engineering skills of the Romans and, in particular, by their bold use of concrete, which they mixed with travertine, tufa, brick, and pumice. The walls of the circular drum that supports the dome are seventy-five feet high and some twenty feet thick, and the entire structure rests on a foundation that extends about fifteen feet below the ground.

On entering the spherical space, one is immediately struck by the calculated symmetry and harmony of its design. The distance between the apex of the dome and the marble floor is identical to that of its diameter: 143 feet. The eye is drawn upward to the circular opening in the dome which, on clear days, provides a brilliant shaft of light, the position and character of which gradually change. Around this opening, the massive surface of the dome is broken up by concentric rings of decorative recesses known as coffers—small near the top and larger at the base—that serve to distribute the weight of the concrete.

The Pantheon was converted into a Christian church in the sixth century, and the spaces that once housed statues of the seven planetary gods later served as the final resting place for some of Italy's greatest men. —D.K.

The oculus of the dome seen through the great bronze doors of the Pantheon.

*Following pages:* View of the dome, showing the coffered surface, which once may have contained gilded rosettes, to suggest stars.

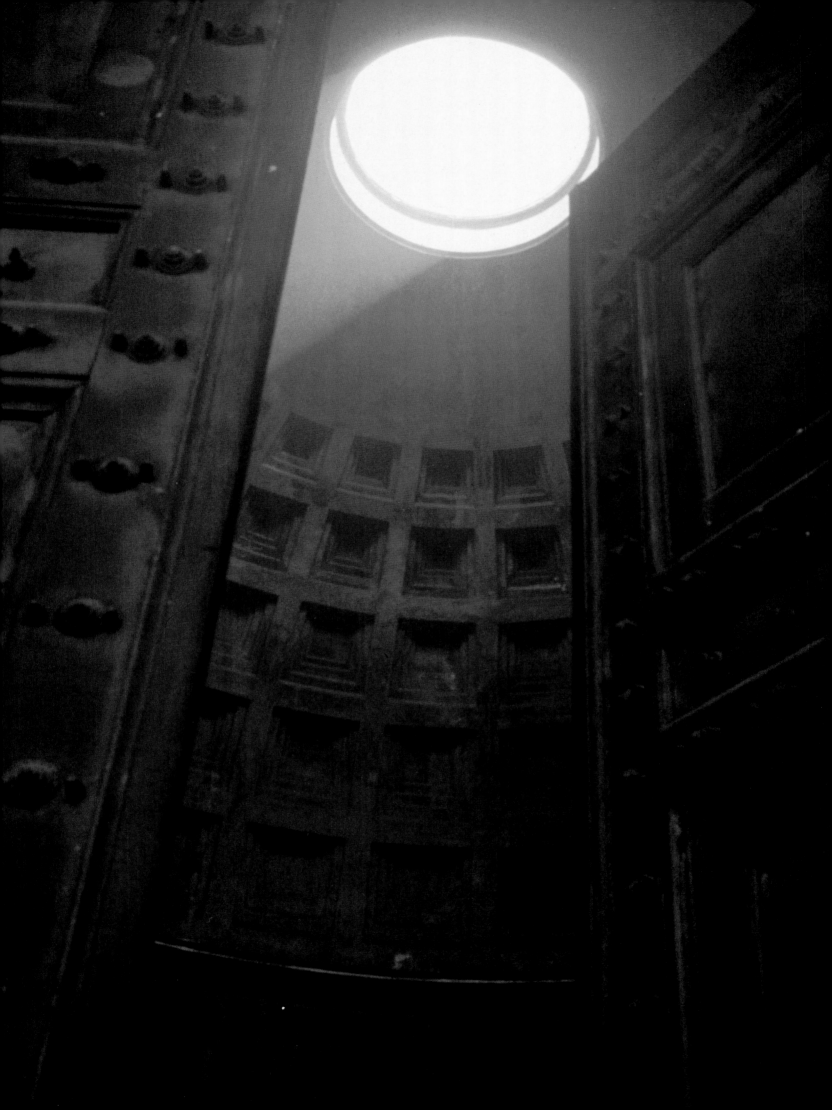

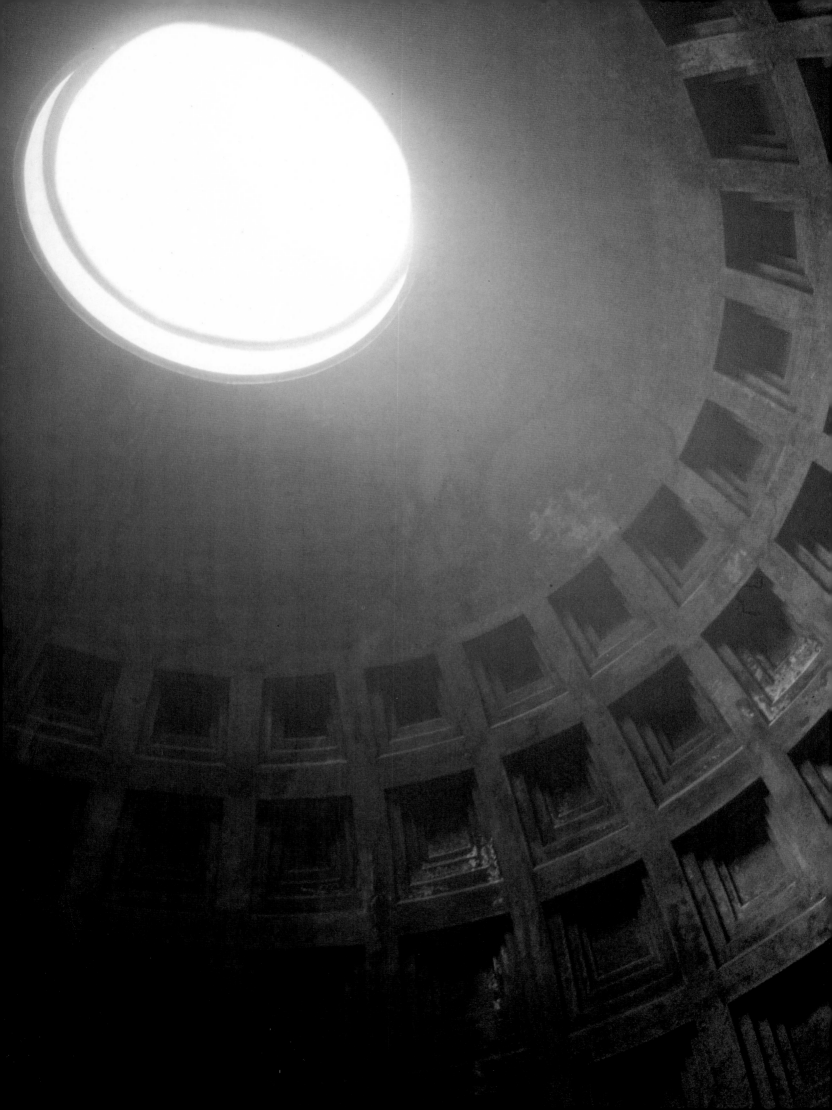

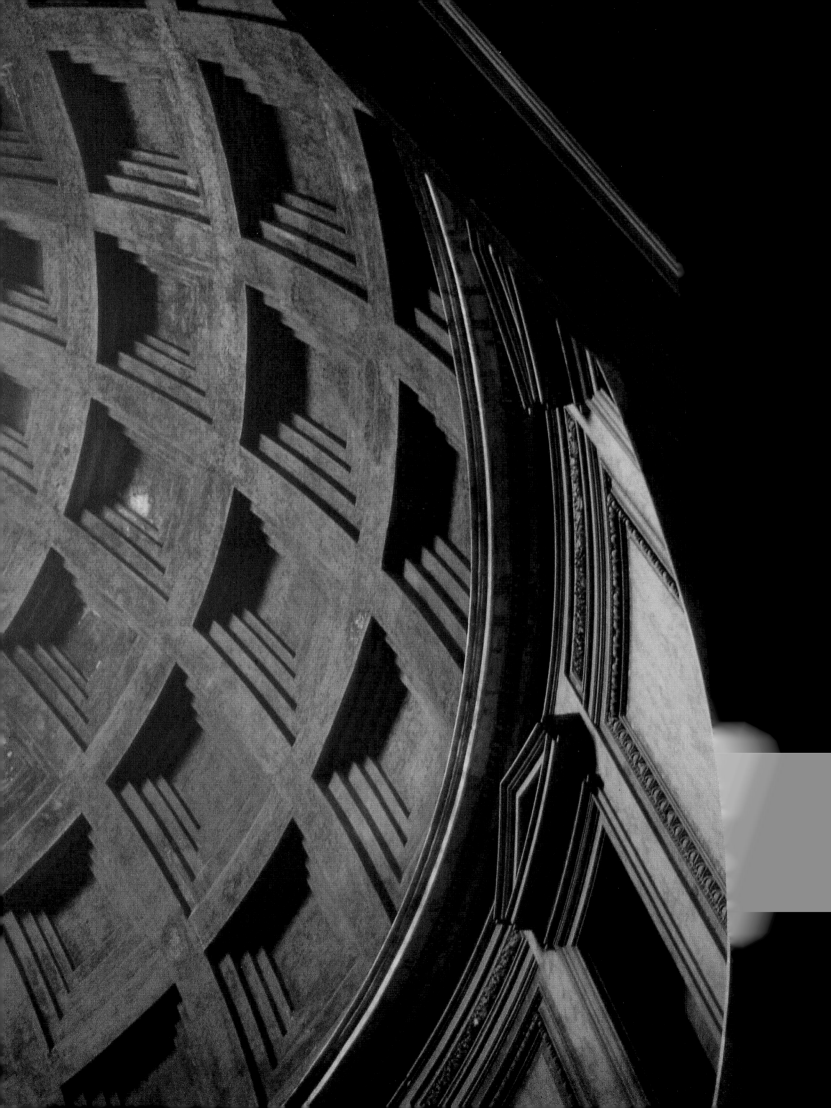

# Hosios Loukas

The land of Greece itself, its mountains, rivers, and streams, has for me an intrinsic nobility. No country has such a variety of changing perspectives. As you penetrate deep into the countryside and drive from one whitewashed church or village to another, you are taken away from your everyday life and plunged into a rich culture. The people are kind and smiling when you stop at a village and rest in the shade. It is striking to travel from our cluttered metropolises and discover the bond between the Greeks and their land, which is as moving as the simplicity and intensity of the earliest menhirs.

Sprinkled over this incredibly boisterous landscape, at the bottom of a hill or the top of a mountain, you will find stone structures, ancient and recent, built by people hoping for God's favor. As we drove from Athens to Delphi, we stopped at the church of Hosios Loukas. It is a Byzantine church, its plan based on the Greek cross. Outwardly rather humble, the simple structure glows inside with glorious mosaics. Some were destroyed by earthquakes, but what remains shows the roots of what later became the decorative lushness of churches like St. Mark's in Venice. I was particularly moved by the windows, small circular openings filled with alabaster that lend a glow to the architecture and the glorious mosaics. —A.L.

*We believe that the first and greatest blessing for all mankind is the confession of the Christian faith, true and beyond reproach, to the end that it may be universally established. . . .*

—EMPEROR JUSTINIAN, A.D. 554

In A.D. 313, Constantine the Great issued the Edict of Milan, which guaranteed religious freedom to all the people of the Roman Empire. The influence of Christianity and the number of its adherents subsequently increased dramatically, and in 426, Theodosius II signaled its triumph by ordering the closing of all pagan temples. By this time, the port city of Byzantium, which Constantine had renamed Constantinople in A.D. 330, had assumed Rome's place as the cultural and political center of the Mediterranean world. Its sphere of influence extended over Anatolia, the Levant, northern Africa, Greece, much of Italy, and even parts of Spain. The division of the empire was reflected in the formation of Eastern and Western branches of Christianity, although an official separation did not occur until the eleventh century.

The monastery of Hosios Loukas, located on the outskirts of the village of Stiris, near Delphi, in central Greece, was founded by a hermit whose prophecies and miracles made it an important pilgrimage place for members of the Eastern Church. The two adjoining churches that are part of the monastery follow the plan of a Greek cross. The four arms of the cross are of equal length and are intersected by a dome. The exteriors of the churches are extremely lively. Decorative patterns are created by the use of light-colored stone and red brick and the placement of numerous double windows. The interiors of the churches are enriched by polychrome marble and mosaic. The dome of the small tenth-century Church of the Virgin Theotokos rises over concave triangular sections of wall known as pendentives, while that of the larger and slightly later Katholikon is supported by small arches, squinches, built over the upper corners of square walls.

In the colorful interior of the Katholikon, the worshiper's eye is drawn to the circular dome, which seems to float above a band of arched windows. Its center is dominated by the traditional image of Christ Pantocrator, "ruler of all." The walls and ceilings of the Katholikon are covered by mosaics composed of colored glass and transparent glass containing thin sheets of pure gold. These produce a shimmering and dematerializing effect when sunlight permeates the church. The severe, almost primitive style of the mosaics in the vaulted narthex, or vestibule, reflects the asceticism of the monastic communities in this isolated and mountainous region. —D.K.

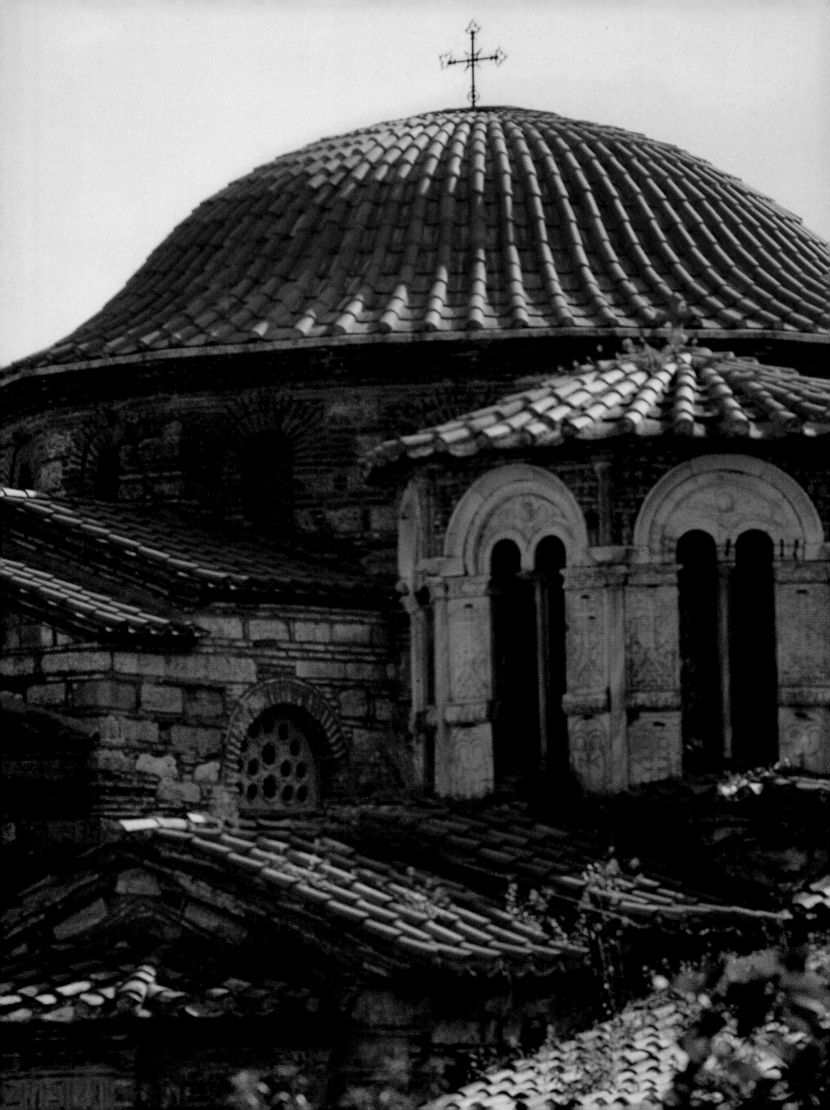

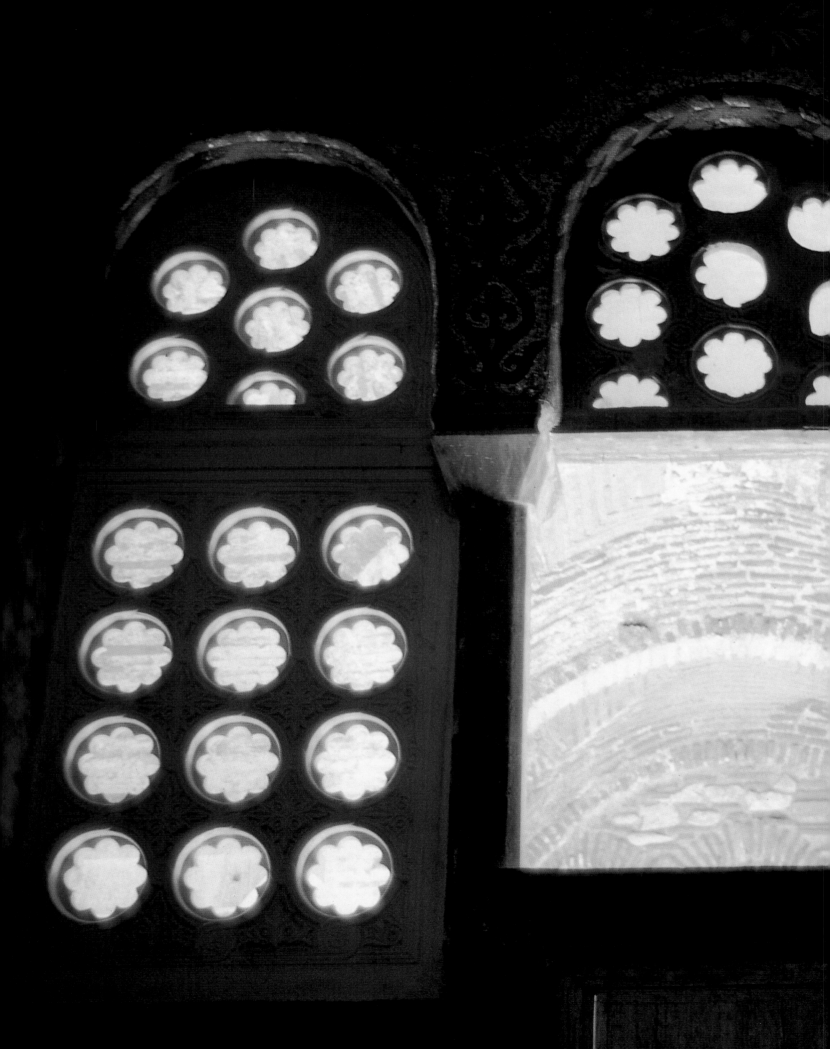

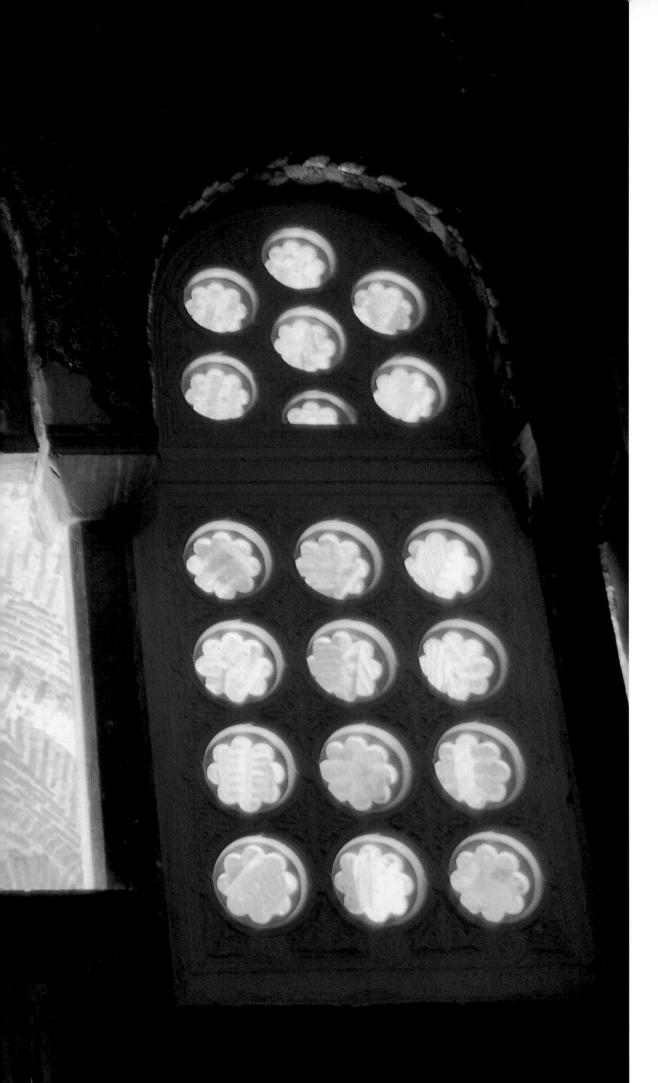

Patterned windows seen from the interior of the tenth-century Church of the Virgin Theotokos.

*Preceding page:* The exterior walls and main dome of the Katholikon date from the eleventh century.

*Following pages:* Interior of the Katholikon.

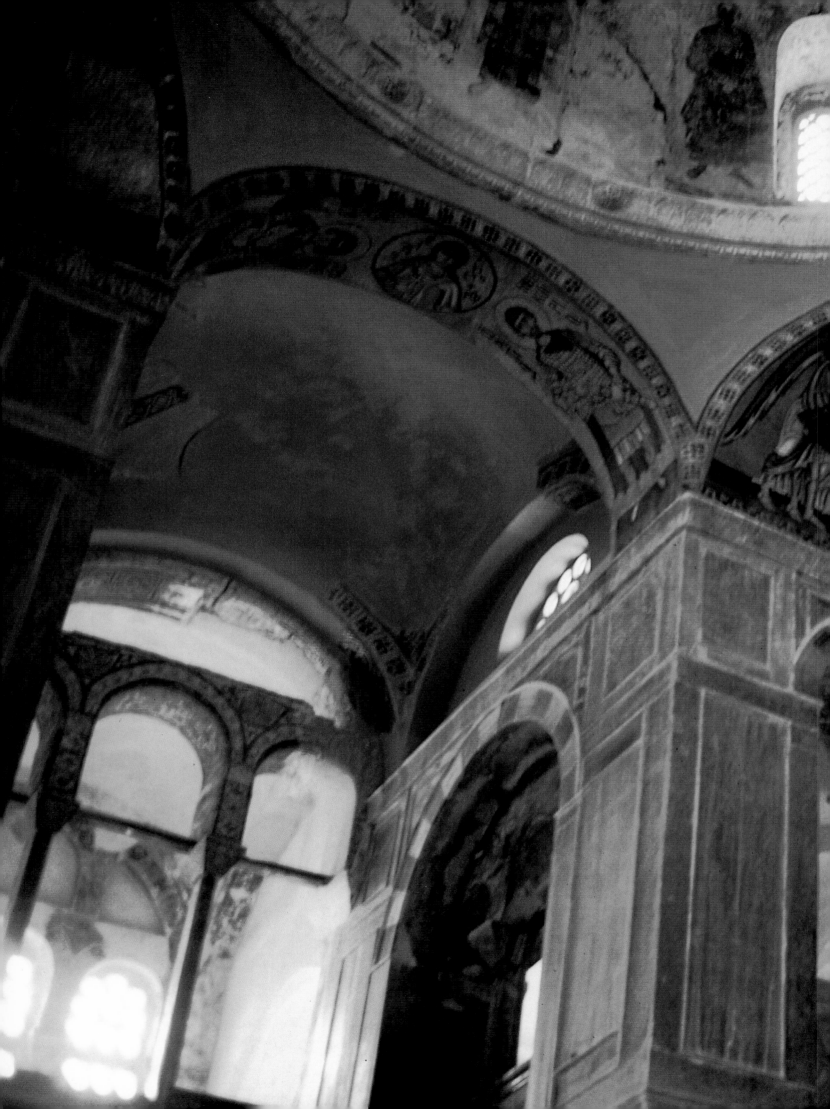

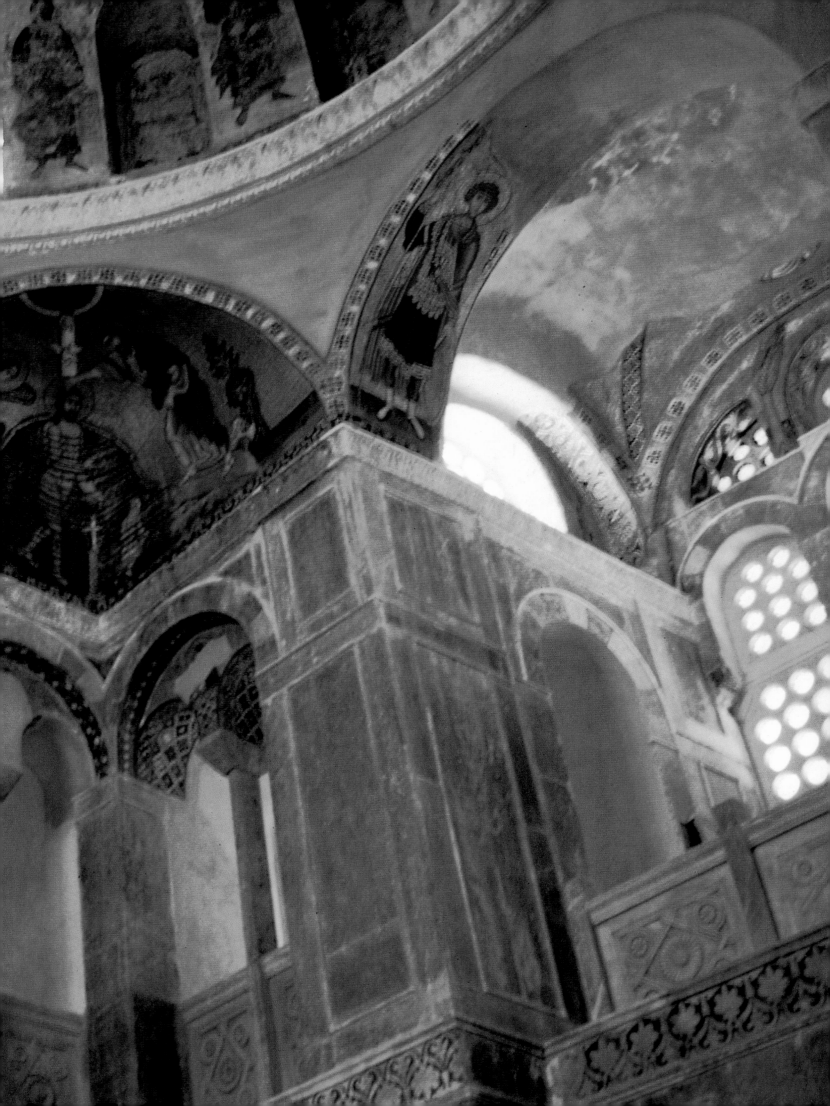

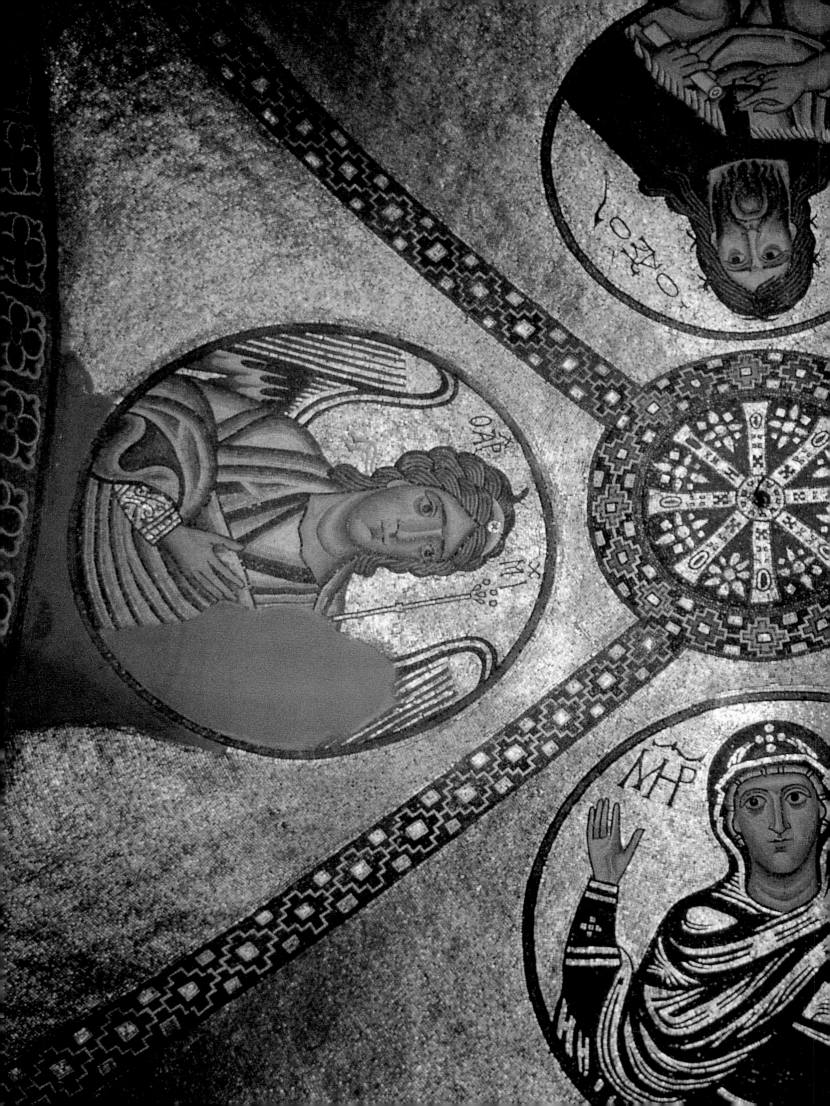

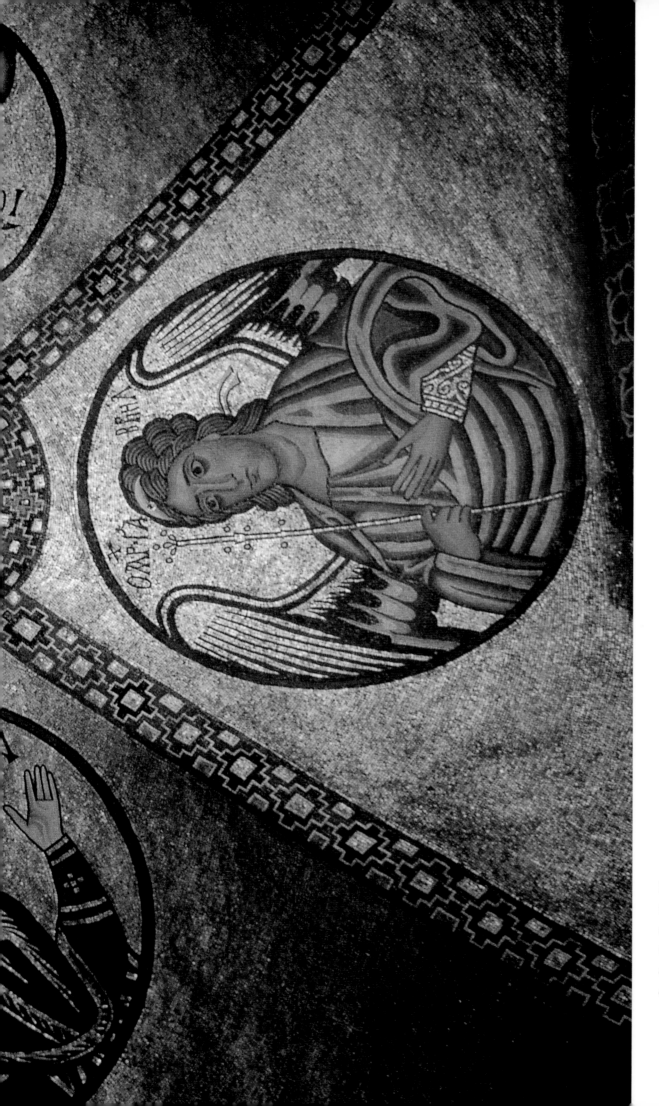

Mosaics representing the Virgin, St. John, and the Archangels Gabriel and Michael cover the vestibule of the Katholikon.

# Santa Maria dell'Assunta on Torcello

Early churches like Santa Maria dell'Assunta on Torcello have a nobility that was seldom achieved in cathedrals built later, when ecclesiastical architecture was a vehicle for expressing the power of the Church or of kings and princes. The higher the structure, the stronger the prince; the grander the architecture, the more powerful the Church establishment; the richer the decoration, the more prosperous the town. One is struck at first by the majesty of those buildings, and it is only later, as one absorbs the atmosphere, that the impulse to worship makes itself felt through the creations of the painters and sculptors who worked on the project.

Isolated on an island in Venice's lagoon, Santa Maria dell'Assunta stands as a dignified and dramatic place of worship. The mosaics of the Last Judgment on its walls truly bring a shudder of terror. A black Madonna, one of the wonders of religious art, seems to levitate in the half-dome above the altar. An extraordinary detail: the shutters of the cathedral are made of slabs of marble to better protect the building from attack.

Torcello has become a very worldly place. When we were last there, the wedding of a friend of the Prince of Monaco was being celebrated. And people come to dine in the famous inn owned by Cipriani, where the food is glorious. I have taken summer vacations for at least forty years at the Lido in Venice, five miles south of Torcello. It offers such splendid comforts: the beach, the swimming, the cabanas to rest in, the luxurious hotels. Why so many great artists of the past gravitated to Venice I'm not sure. I suppose that the rich and powerful republic, in order to enhance its splendor, was willing to pay them to come. And of course Venice's changing light and the fascination of its lagoons hold an unbelievable attraction for visual artists. Curiously, it was not the sculptors or architects, but the painters who dominated the city's creative life. Somehow, the stones of Venice seem overpowered by water, and in fact they are. Water, with its reflections, its movement, its unexpected storms, has a magnetic effect on landlocked artists. —A.L.

The Cathedral of Santa Maria dell'Assunta was begun in 1008.

*Following page:* The apse mosaic seen from the altar. The figures of the apostles are said to date from the eleventh century.

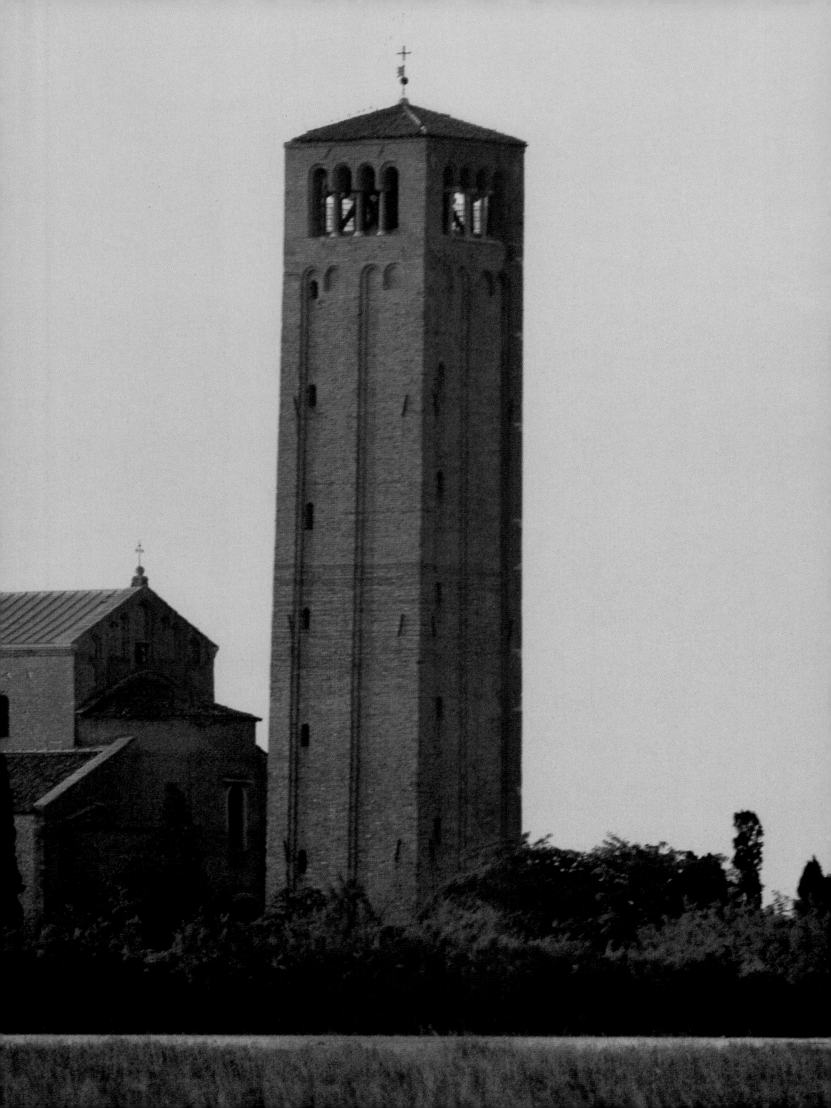

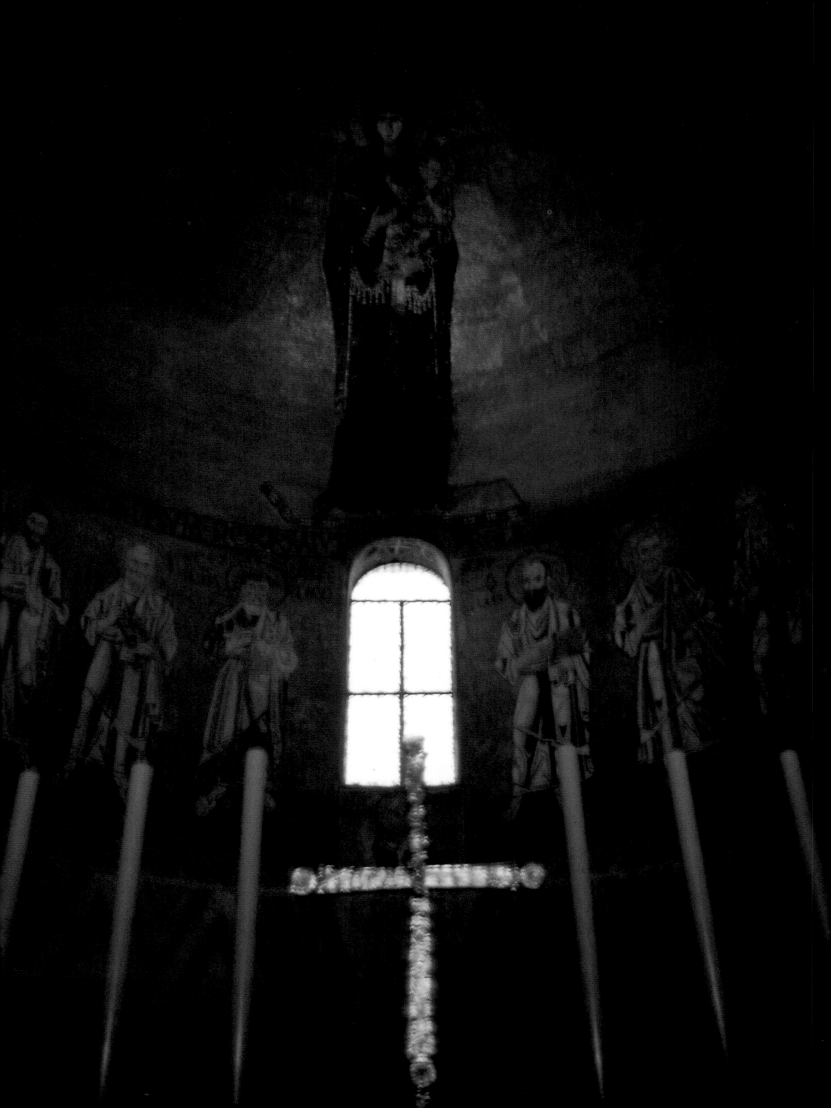

Torcello is situated in a remote corner of Venice's lagoon, about eight miles northeast of the city. It is a small island, over which looms the tall campanile of Santa Maria dell'Assunta (Saint Mary of the Assumption). The unadorned brick exterior of this sturdy cathedral belies the splendor of its marbled interior and colorful mosaics. Nor do the small vineyards, orchards, and rustic dwellings of the island give evidence of its early history, when the population reached twenty thousand and its importance rivaled that of Venice.

An ancient chronicle records that Torcello was founded by the bishop of a city, Altinum, on the Italian mainland that was under constant siege by the Lombards during the sixth century. A heavenly voice was said to have commanded the bishop to climb to the top of a nearby tower and study the stars, whose reflected path on the water presumably led him and his flock to the safety of the island. After settling there they named it Torcello (little tower) to commemorate the structure that played such a crucial part in its discovery.

Although the present church dates from 1008, a stone bearing the date 639 recalls the foundation of its predecessor, which was erected under the patronage of the emperor Heraclius and the exarch Isaac of Ravenna, making it the oldest building in the lagoon. Over the next four hundred years the island community and its cathedral flourished, but it was gradually overshadowed by Venice, and by the fifteenth century was in decline, partially because of the persistent threat of malaria.

The plan of the cathedral resembles that of the sixth-century basilicas of Sant'Apollinare Nuovo and Sant'Apollinare in Classe in Ravenna, testifying to the island's close spiritual contacts with that important north Italian city. The timber-roofed nave is divided into three

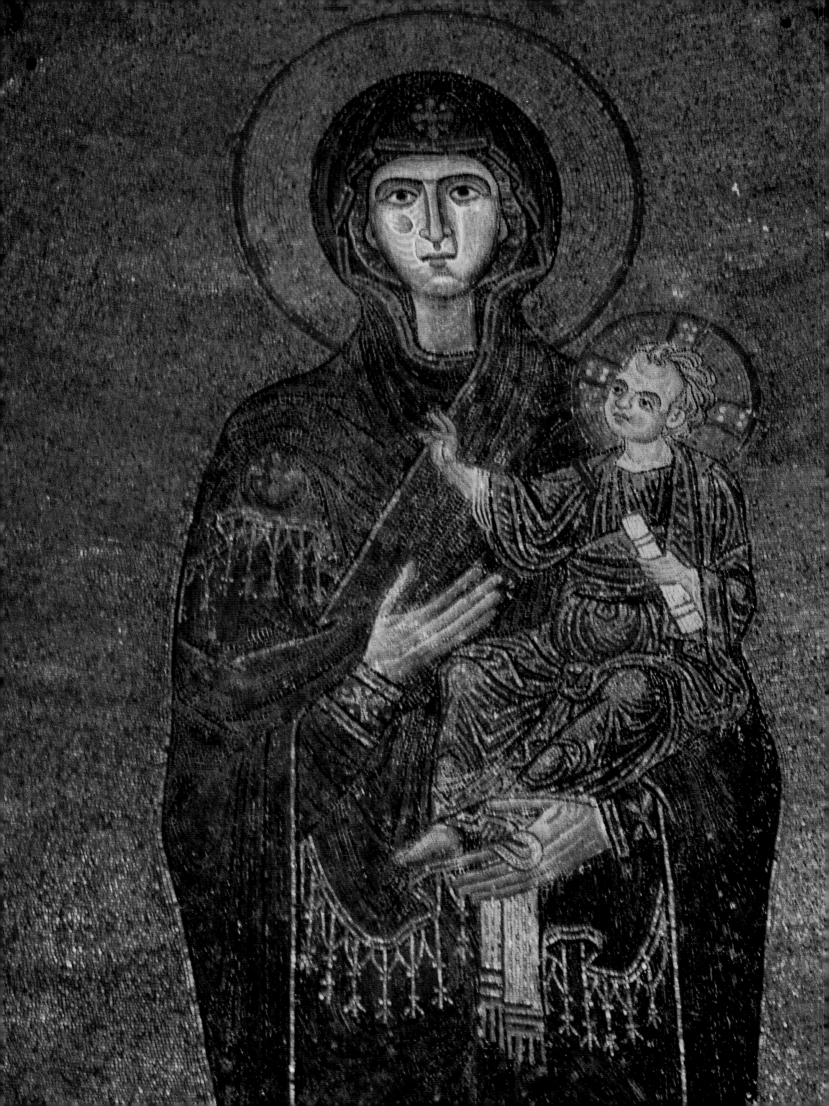

*(continued from page 57)* aisles by eighteen beautifully proportioned Greek marble columns with delicately carved capitals. These stately columns direct the visitor's attention to the marble altar screen, and beyond it the simple altar and semicircular elevated choir with seats for the bishop and high clergy. The golden vaulted apse is adorned with a striking twelfth-century mosaic of the Virgin and Child. The slender, simply dressed mother holds her infant son with one arm, while the other is rigidly folded against her bosom. Her tearstained face is grave, and if one considers the position of the mosaic, her gravity is understandable, for she is looking at the huge mosaic on the west wall, representing the sobering spectacle of the Last Judgment.

The west wall mosaic reflects the hieratic style of Byzantine art. It is a five-tiered composition depicting the Crucifixion, the Descent into Limbo, Christ in Glory with the Virgin and Saints, the Resurrection of the Body, the Separation of the Blessed and the Damned, and Heaven and Eternal Fire. The initial impact of this complex ensemble is overwhelming, reminding us that the joys of Heaven and the tortures of Hell were vividly real to the people who worshiped in this church. Certain of the individual episodes are notable for the freedom of their artistic invention. Particularly compelling is the spectacle of the Damned enveloped in an ever-widening stream of flame that emanates from the throne of Christ, diverting our attention from the realm of the Blessed and forcing us to contemplate the gruesome forms of disembodied worm-ridden skulls that float in a dark void. —D.K.

Detail of the Virgin and Child from the apse mosaic.

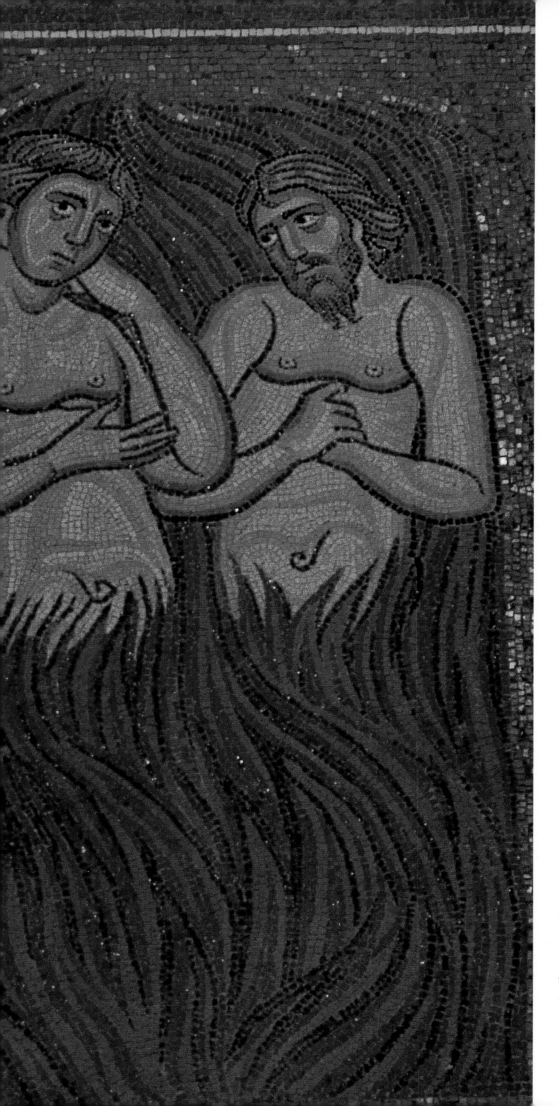

Details of the wicked consumed by
the Eternal Fire, from the mosaic of
the Last Judgment on the west wall.

*Following pages:* Images of skulls
were calculated to inspire terror in
the hearts of the faithful.

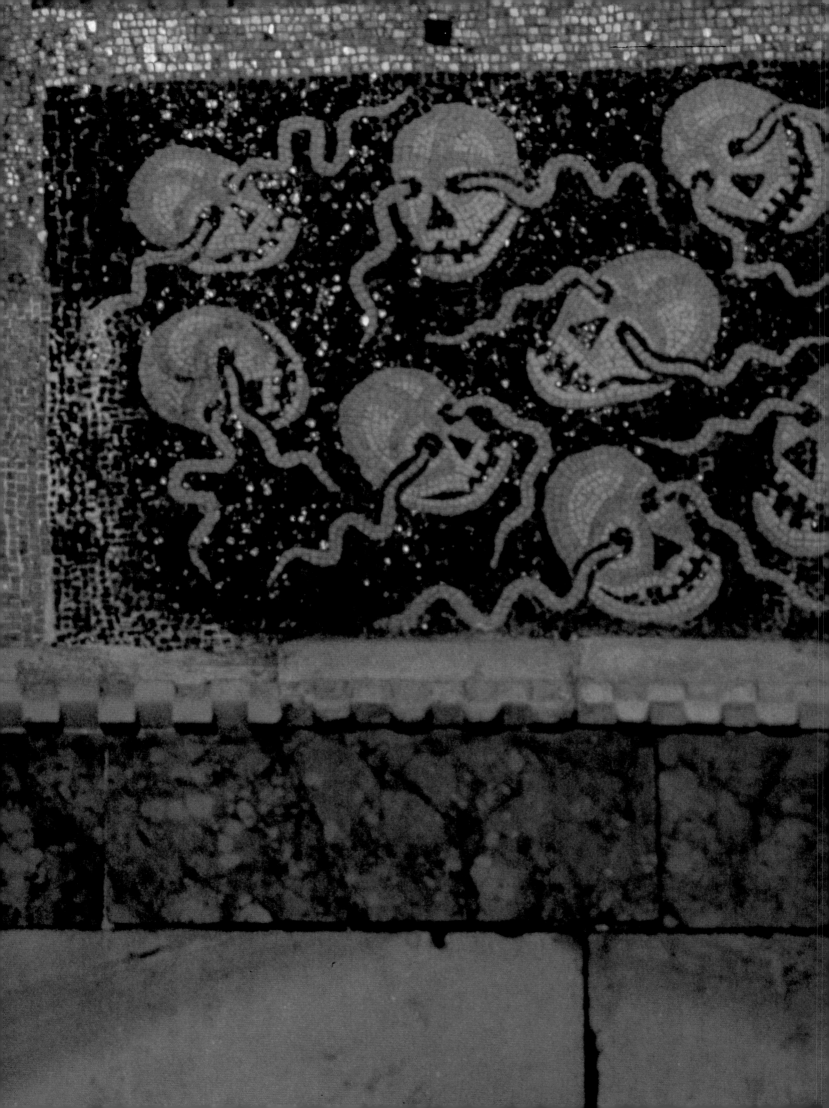

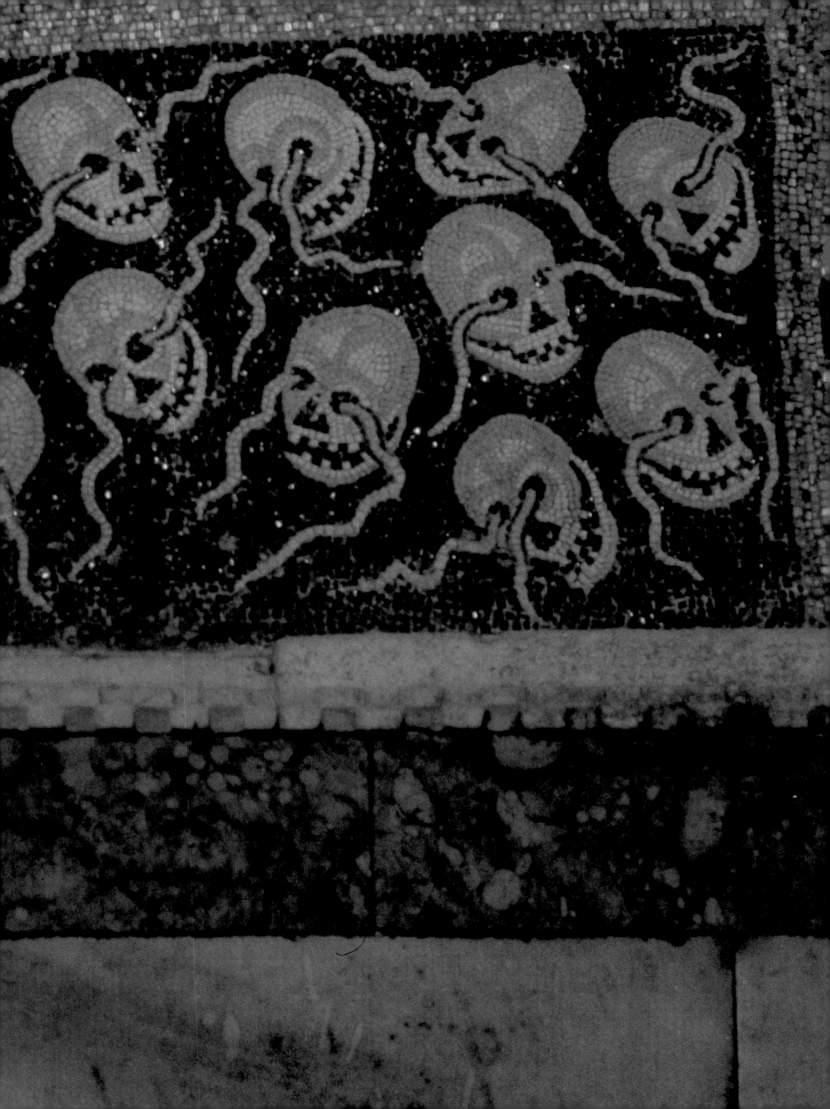

# St. Mark's Basilica

For centuries the Cathedral of St. Mark has been at the center of power in Venice. Each generation of rulers imposed evidence of its importance on St. Mark's, making lavish donations that were not disinterested. Jewels and gold from Constantinople and the Orient made their way into the basilica, lending a pagan feeling to much of the interior ornamentation. To some extent this distracts from attempts to commune with the Deity. You have to penetrate deep into St. Mark's, behind the altar, to find some semblance of respect for the Supreme Being. The Renaissance encouraged a competition of egos, and much of the religious art from that period had more to do with artists seeking to outdo each other than with worship. Of course, I admire the mosaics and many aspects of the architecture, with its cupolas and wonderful ornaments, but St. Mark's seems to me primarily a glorious jewel that should be treasured more as a fine work of human craftsmanship than as a place of worship. —A.L.

By the tenth century, Venice, which had long enjoyed cultural and commercial ties with the Byzantine Empire, was becoming the dominant power in the Adriatic. Legend has it that in 828 the city's growing devotion to the Apostle Mark prompted two local merchants (one from Malamocco on the Lido, the other from Torcello) to steal the saint's body from its tomb in Alexandria. They presented it to the doge, who ordered the construction of a chapel to house the precious relic. To excuse the pious theft, a legend was invented that claimed that Saint Mark had stopped on the future site of the city and that while sleeping there he was visited by an angel. The angel said to him: *"Pax tibi, Marce, evangelista meus. Hic requiescet corpus tuum."* (Peace to you, Mark, my Evangelist. Here your body will rest.) For nearly a thousand years thereafter, these words were emblazoned on flags or carved in stone throughout Venice and its extensive territories.

The initial chapel, consecrated in 832, was destroyed in a fire in 976 and replaced by another that was then demolished to make way for the grandiose basilica begun in 1063. The enormous scale of St. Mark's reflected not liturgical needs but rather the increasing power, prestige, and wealth of the city and her leaders. Many of its features, including the modified Greek-cross plan and five great domes, link it to earlier Byzantine prototypes and, in fact, its model was the Church of the Holy Apostles in Constantinople. Even before the basilica's consecration in 1094, Venetian ships returning to the city were obliged by law to bring back offerings for its embellishment. Among the most spectacular of such "gifts" are the gilded bronze horses of the first century—the only surviving quadriga from antiquity—that were plundered from the hippodrome in Constantinople in 1204 and subsequently installed in the loggia above the main entrance. When Napoleon dissolved the Venetian Republic in 1797, these horses were sent to Paris, where they adorned the Arc du Carrousel. Although they were restored to the loggia in 1815, visitors now see replicas. The originals *(continued on page 70)*

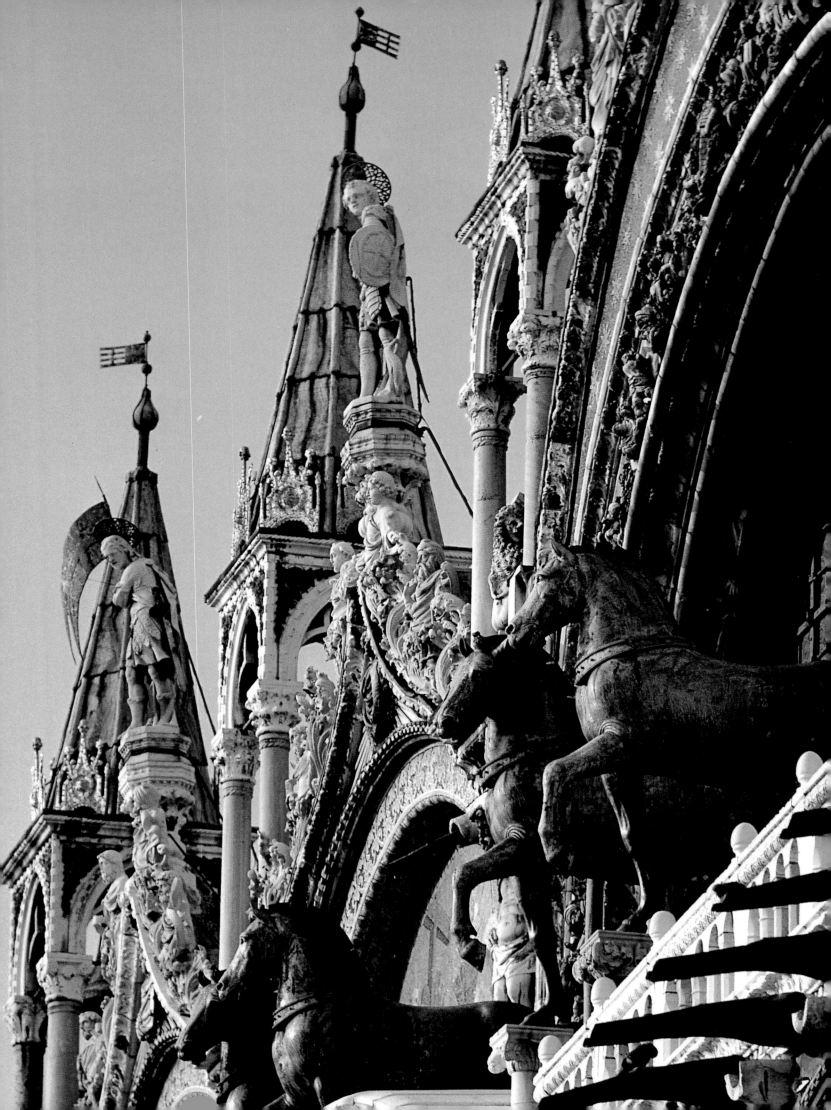

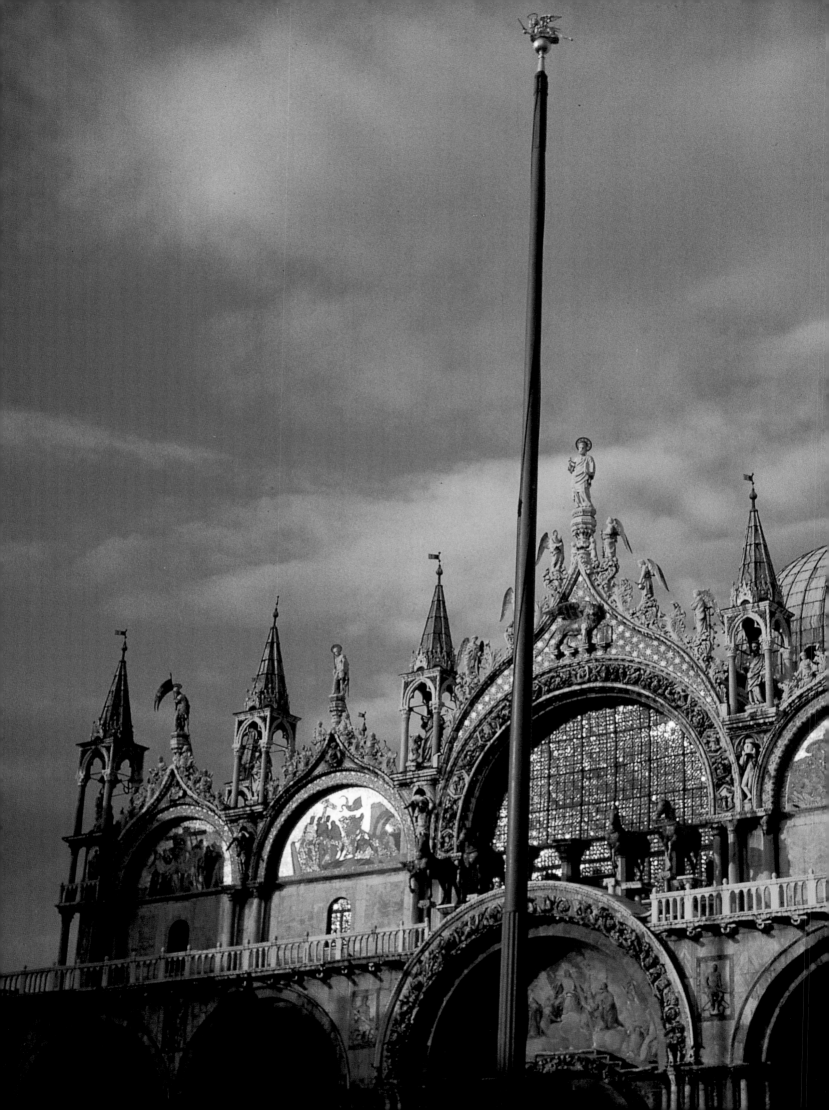

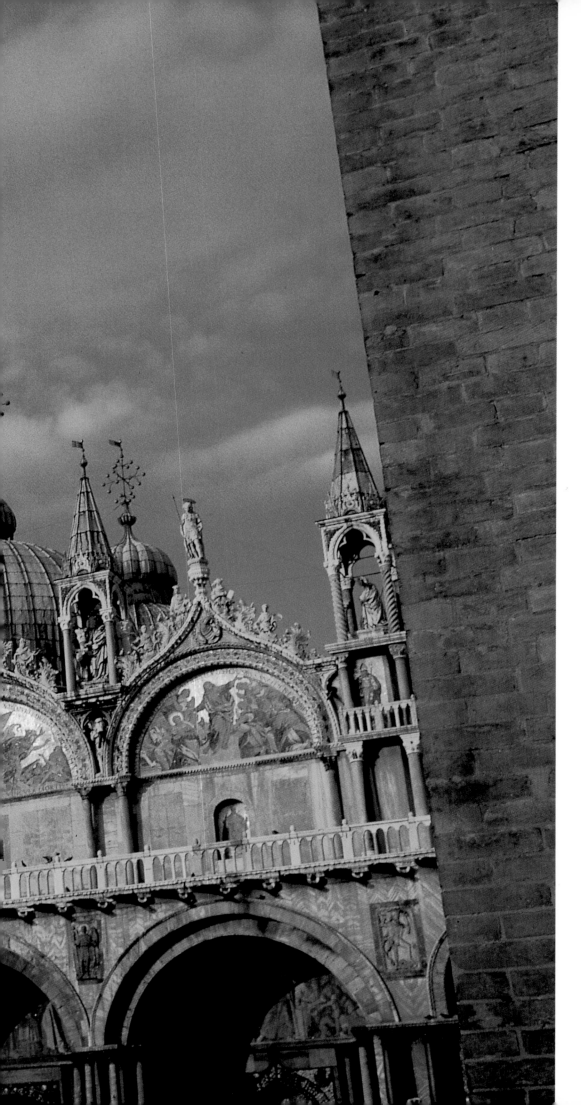

Partial view of the façade of St. Mark's, showing its five portals, loggia, and mosaics dating from the thirteenth to the seventeenth centuries.

*Preceding page:* The upper section of the façade.

*Opposite following page:* The basilica and the restored campanile, seen from the far end of St. Mark's Square.

*(continued from page 66)* have been placed in the Museo Marciano to protect them from pollution. Another celebrated spoil, set into a corner of the façade near the entrance to the Doge's Palace, is the early fifth-century sculpture depicting the Emperor Diocletian and his co-rulers Maximian, Valerian, and Constantine. Known as the Tetrachs, this beautiful porphyry group, carved in Egypt, is said to have been part of the treasure sent back to Venice by Doge Enrico Dandolo after the Fourth Crusade.

As one approaches the basilica from the vast piazza, the shimmering façade with its profusion of precious marbles, colorful mosaics, ogival arches, and gilded towers indeed resembles the "treasure heap" Ruskin described. Its splendor seems all the more astonishing when we realize that because Venice did not have access to large quantities of marble or travertine, the builders applied these rich surfaces to a skeleton of humble brick.

The complex space of the interior, created by the interplay of the great central dome, the smaller cupolas, and the giant vaults, is strangely compartmentalized. Two stories of large piers pierced by arcades, the columns of the bays, and the galleries, enhance the dialogue of space and light. More than 45,000 square feet of mosaics cover the walls and much of the elaborate pavement. Ruskin called the mosaics a great Book of Common Prayer. Their subjects are drawn from the Old and New Testaments as well as the lives of the saints. The earliest mosaics date from the twelfth century and are the work of Greek masters who were called to Venice. Many of the later mosaics were executed after drawings prepared by such famous local painters as Titian, Tintoretto, and Veronese.

Although linked for almost a thousand years with Venice's government as the doge's official chapel, St. Mark's finally became its cathedral in 1807, replacing the church of San Pietro di Castello. —D.K.

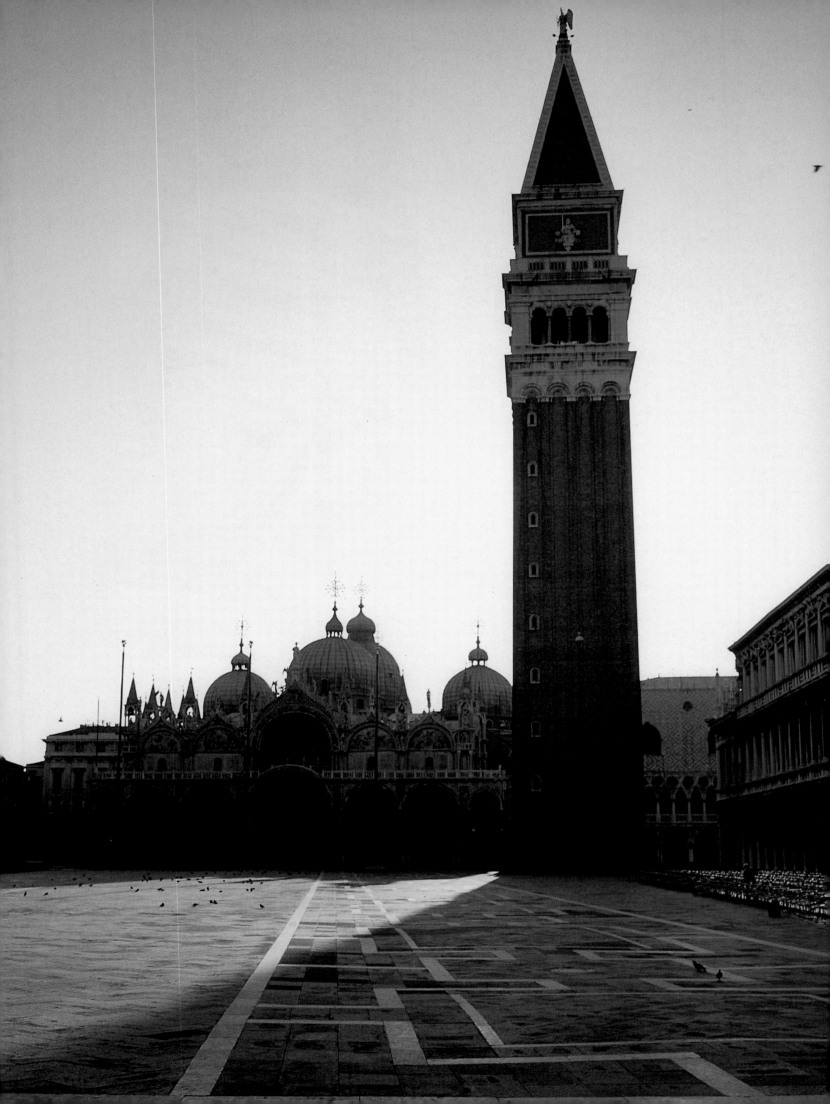

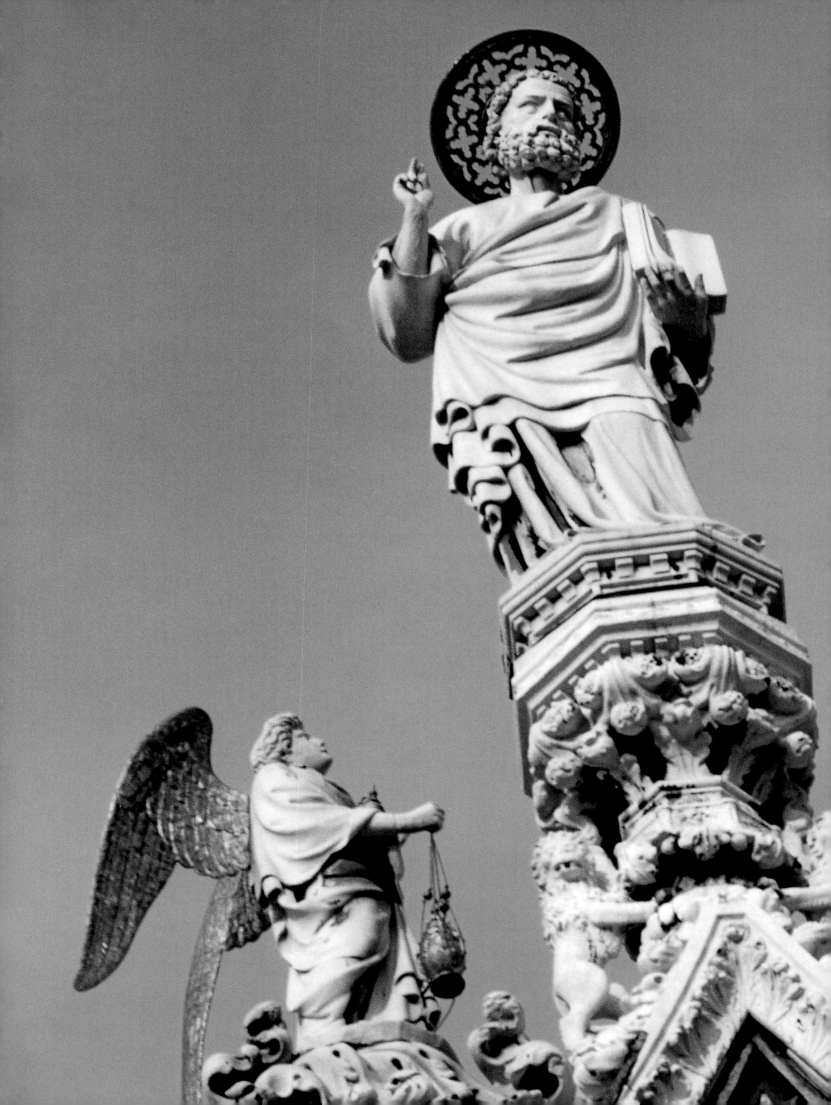

A statue of St. Mark, flanked by angels with censers, adorns the central arch of the façade.

*Following pages:* Four antique bronze horses stood on the loggia for more than seven hundred years. They were replaced by replicas in 1981. The originals, which are now in a museum to protect them from pollution, were taken from Constantinople as plunder in the thirteenth century.

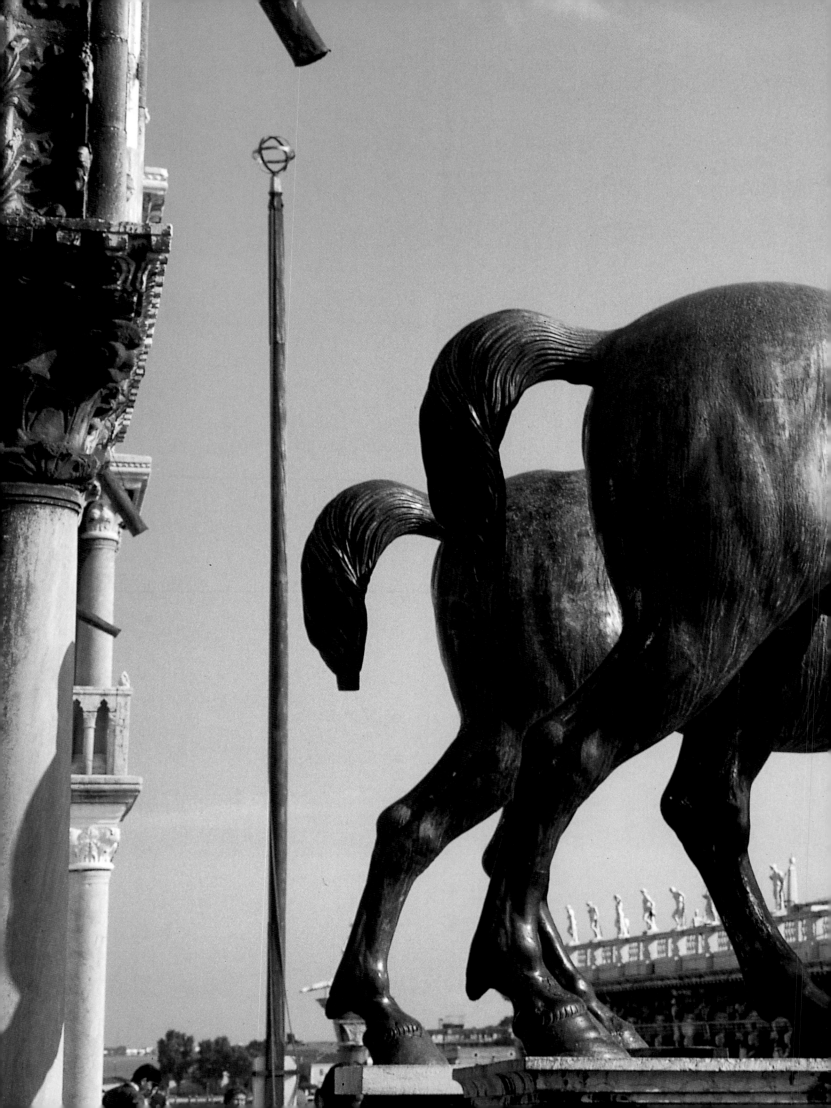

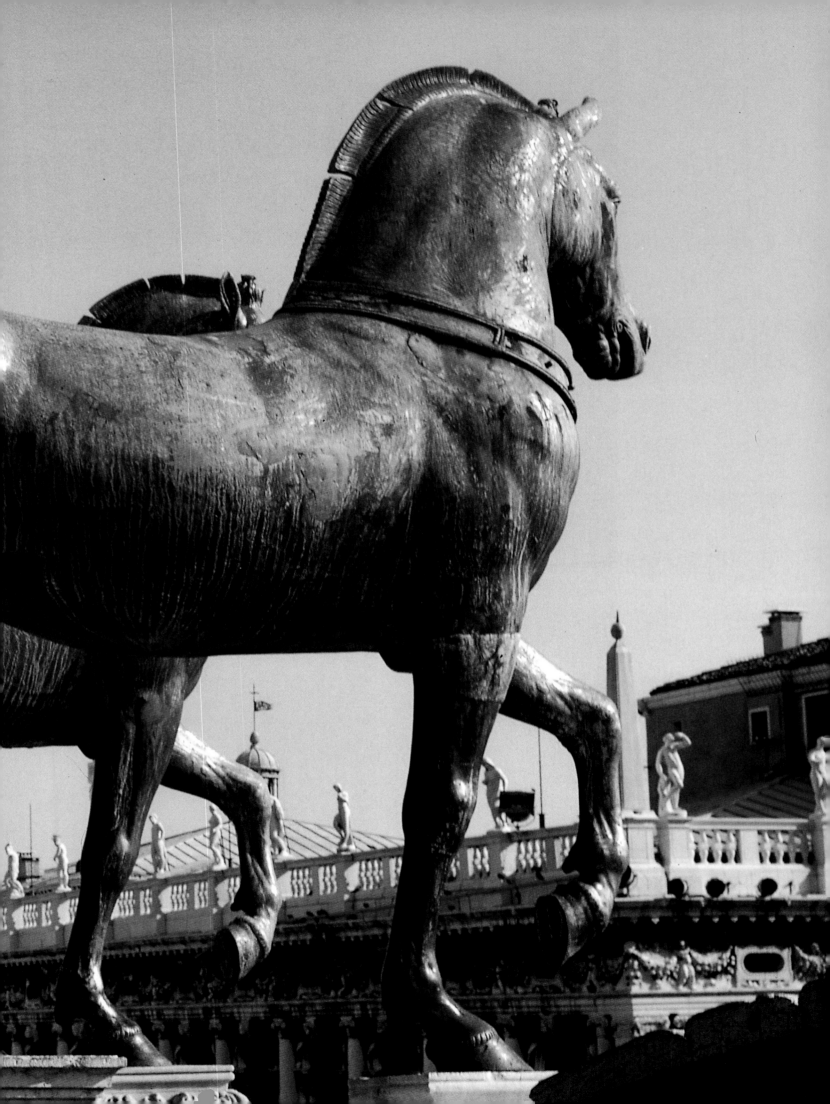

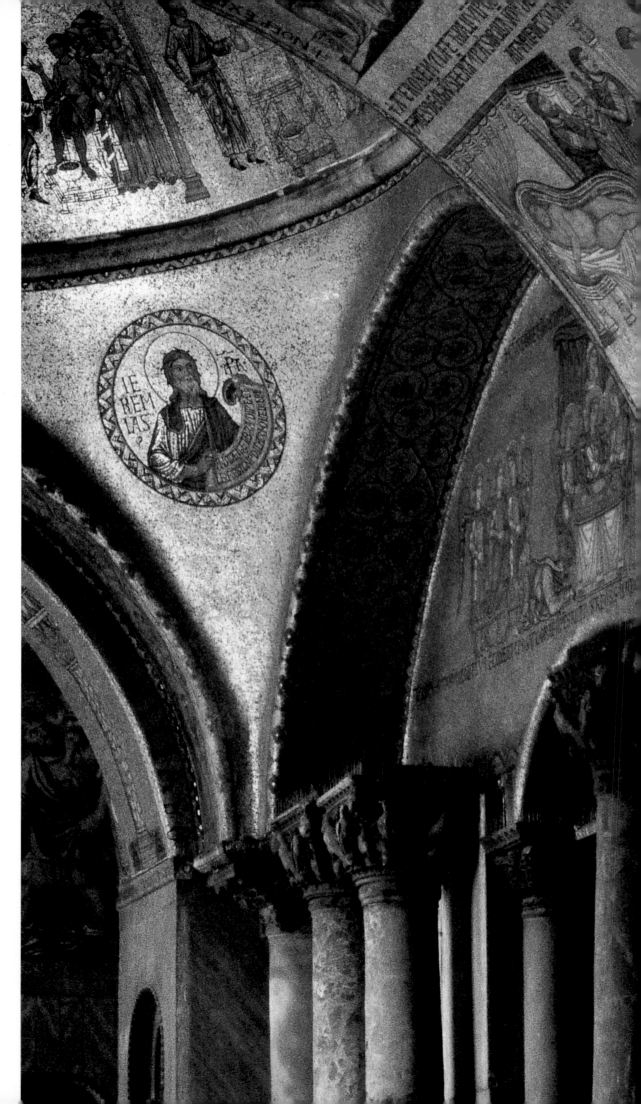

A cross section of
vaults in the interior
of the basilica of
St. Mark's, with
mosaics that date from
the thirteenth to the
sixteenth centuries.

*Following page:*
One of four
large seraphim
from a mosaic in
the cupola.

*Opposite following page:*
Noah and the Ark
is one of a group of
thirteenth-century
mosaics in the
vestibule that depict
stories from the
Old Testament.

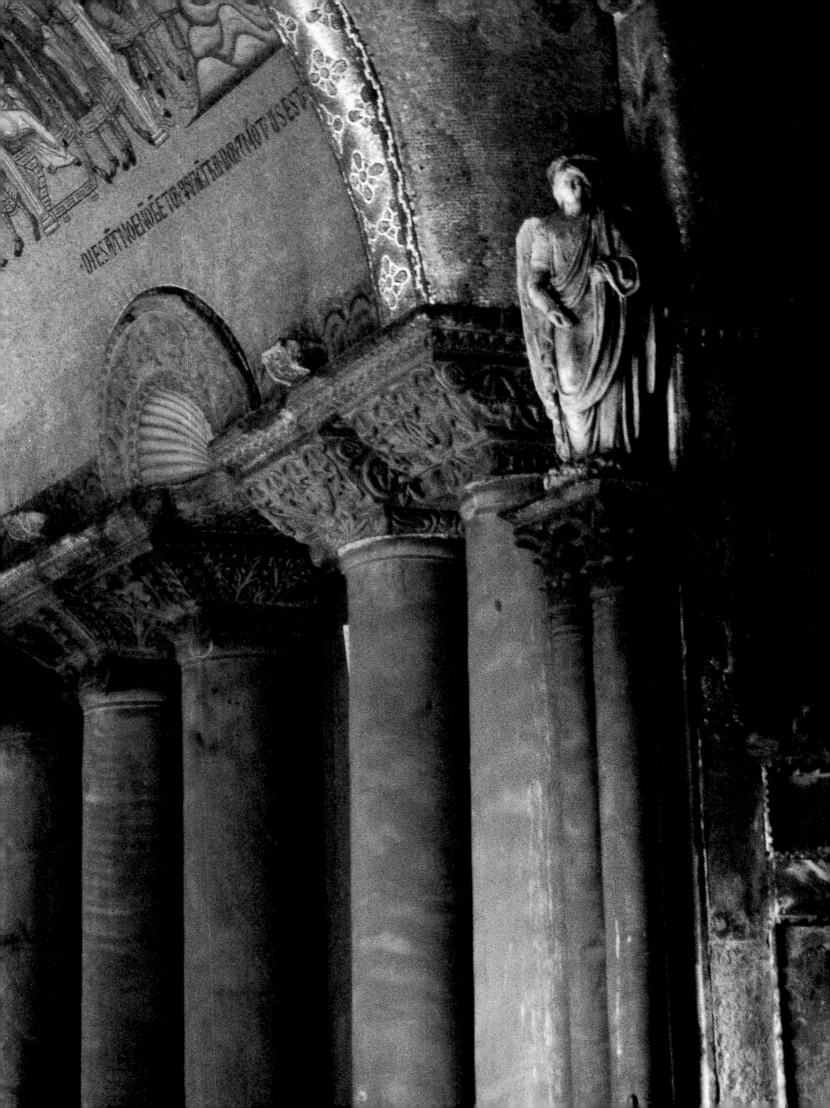

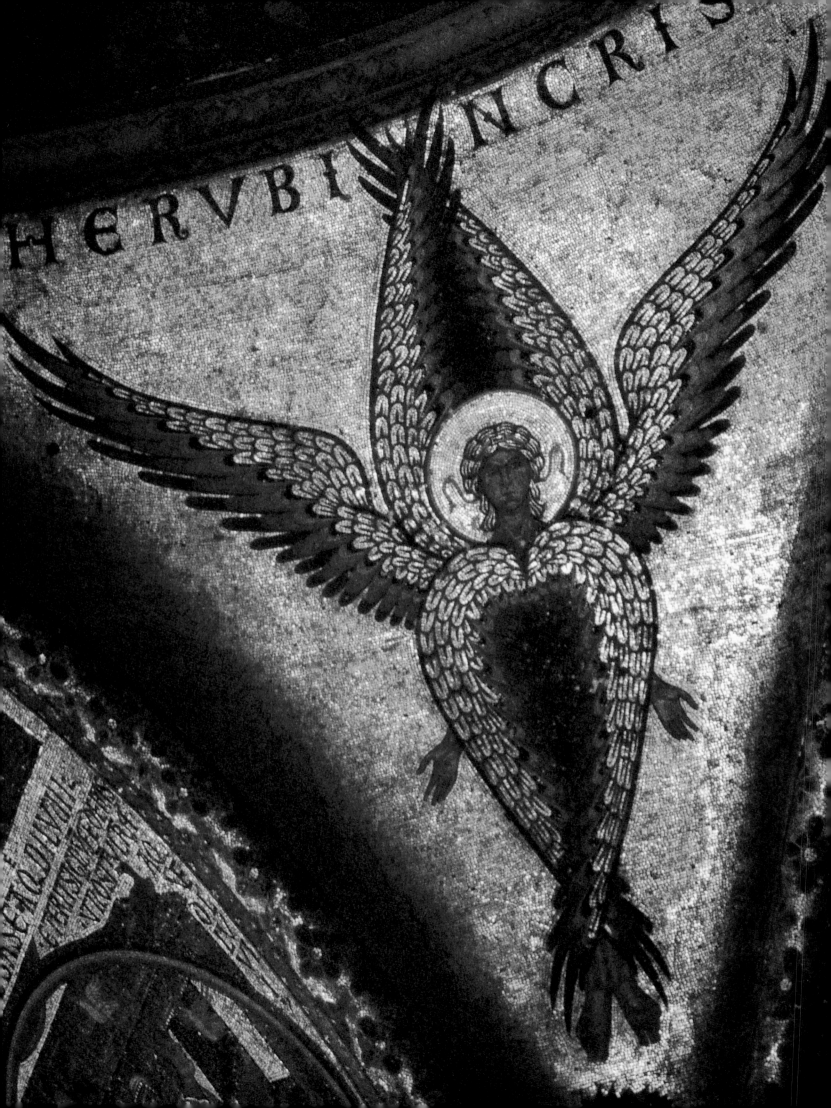

PTAETQVINDECICVBITISALCIORF
NPTAECTOISCAROSVPTAEMISNOECO
BT

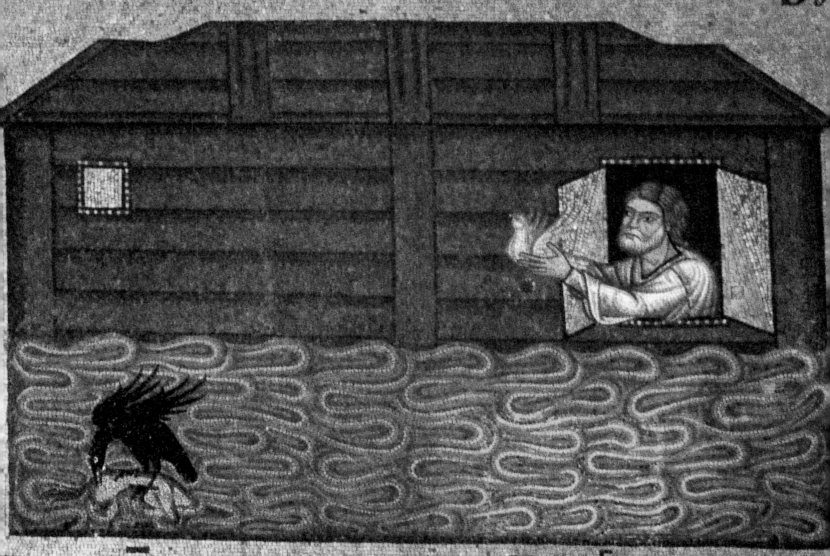

TELLEXNOEXCESSASETQ DILVVII
VINNVBIB:                    ETERITSIGNVFEDE
                               TNOSITVR

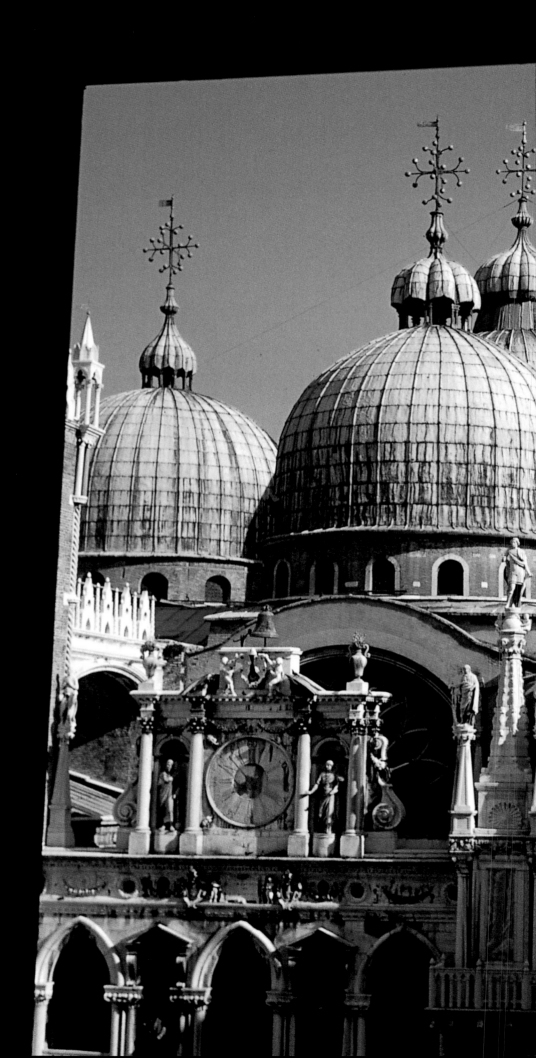

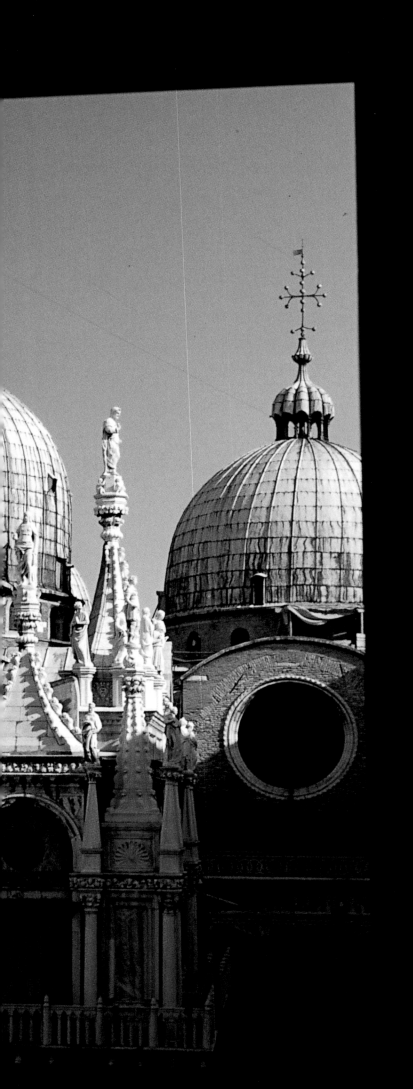

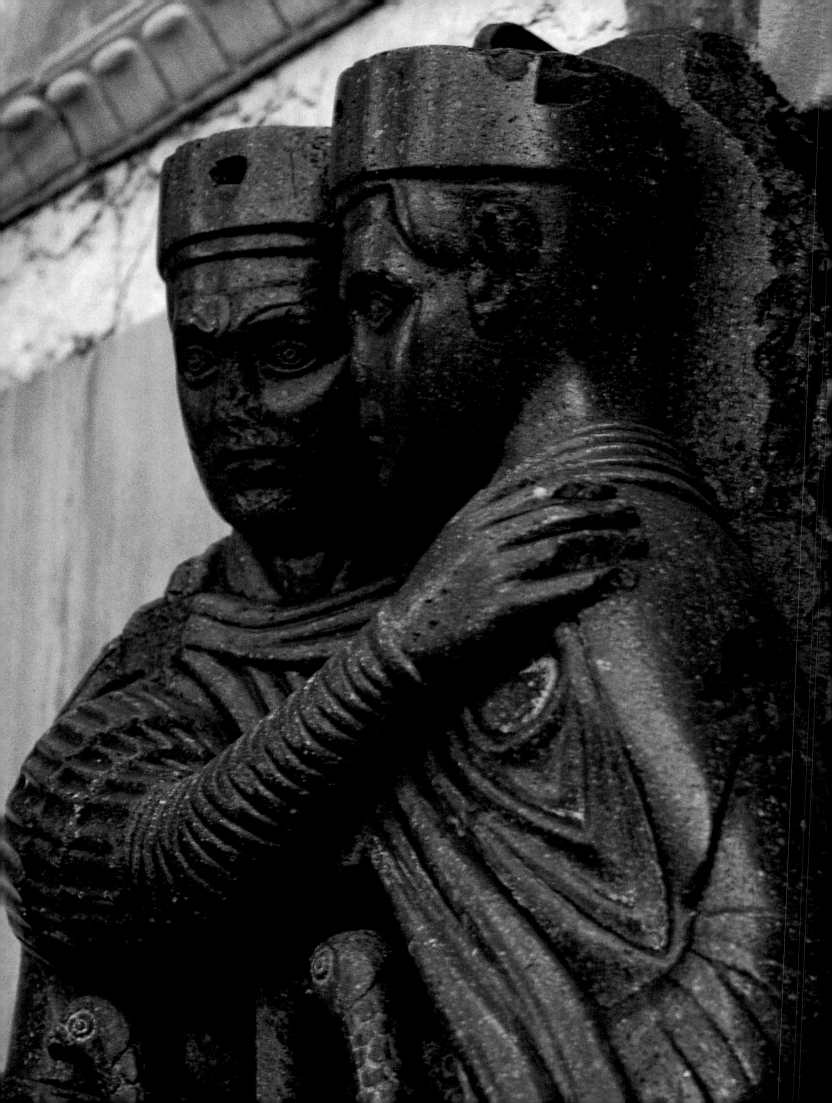

Detail of the Tetrarchs, a fourth-century porphyry relief of the Emperor Diocletian and three of his co-rulers of the Roman Empire. In the early thirteenth century it was placed on a wall of the church near the entrance to the Doge's Palace.

*Preceding pages:* Four of the basilica's five domes are seen rising above the late-fifteenth-century Torre dell'Orologio.

*Following pages:* Elaborate stone tracery and ogival arches are typical of the Oriental details on the exterior of the basilica of St. Mark's.

83

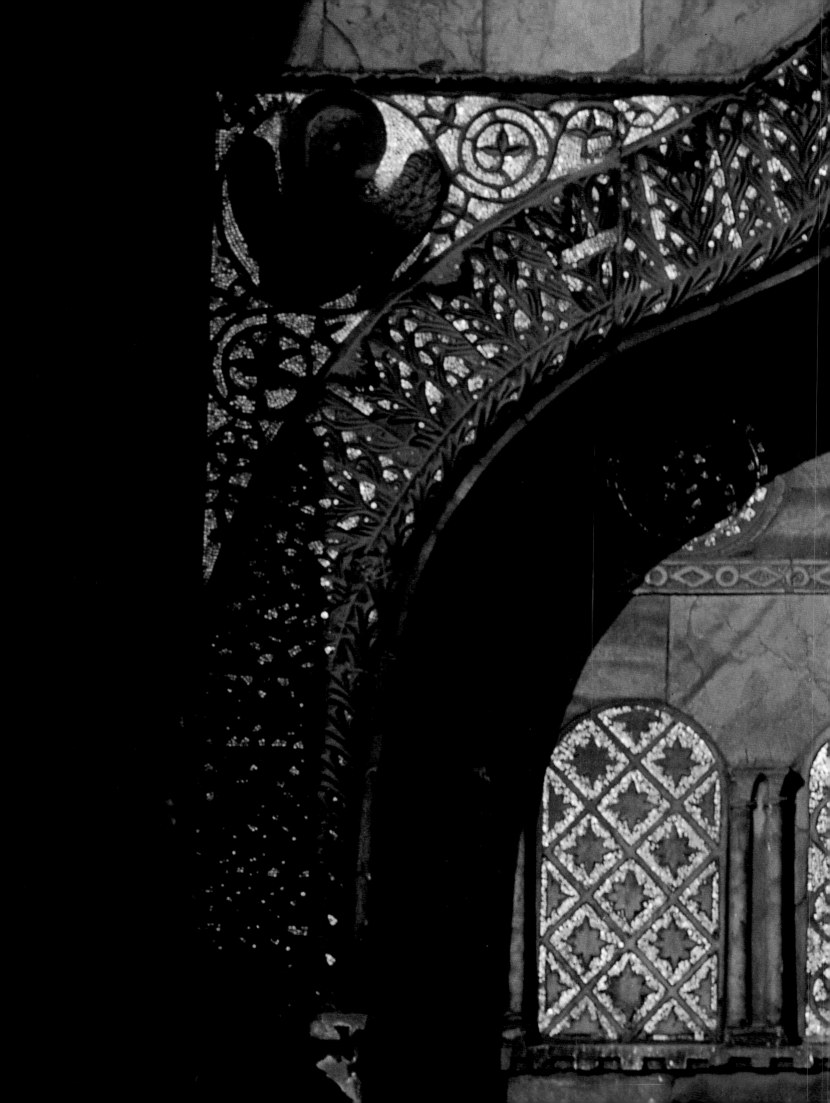

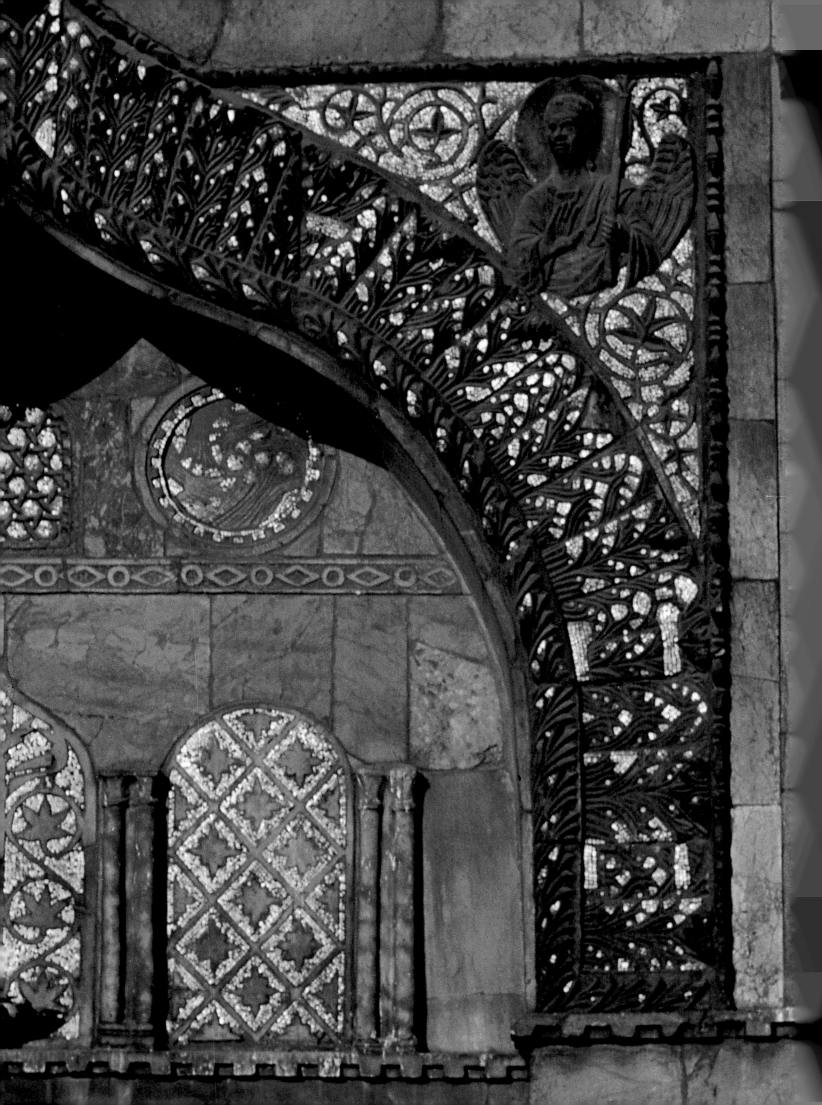

# Chartres Cathedral

When you drive out of Paris in the summer, toward the southwest, you soon encounter field after field of ripe wheat, a golden sea. And in this yellow splendor stands, like a lighthouse, the soaring shape of Chartres Cathedral. But when you draw closer and enter the still great and partly unspoiled medieval town of Chartres, and near the cathedral, there is no sense of great majesty, of over-powering glory. The gray stones have a silent, beseeching quality. The figures surrounding the entrances to the building are elongated human forms that seem to anticipate the elevation of our prayers. We immediately know that we are in a sacred place, a place dedicated to rising above the human condition.

For me, Chartres is the noblest of all cathedrals. It is not overly ornate. It has a severity in its conception that does not distract. As a child, I went to Chartres very often. I am truly enamored of its economy: it seems gloriously pure and unspoiled, the finest example of French religious architecture. It is no wonder that many French

*(continued from preceding page)* kings chose Chartres for their coronations. There is a tradition that when the kings came to be crowned, the stained-glass windows were removed and plain glass inserted to let in more light so the court costumes and jewels could dazzle.

As you enter the cathedral, you are struck by the darkness. The stained-glass windows glow in this gloom and direct the mind to contemplation. An extraordinary blue dominates. This blue, Chartres blue, is unique. Stained-glass windows, I think, add a sense of wonder to one's solitude as one prays in the church. The magnificent rose window seems to signify God's omnipresence. You should stay as long as you can in the interior, so that the magic of the light from the stained glass can blend with the solidity of the lofty columns and somehow create a space, not too big and not too small, where prayer can be said. As in many French medieval churches, the altar does not hold all the treasures of the cathedral. It is very touching that the focus seems to be on each individual, and each individual's prayer.

During the years I lived in Paris, in the Thirties, one had the joy, the freedom to drive out, with very little traffic, in any direction one's heart desired, and my heart very often made me drive to Chartres. One tempting reason to go to Chartres, a frivolous mission, is very French. It is to buy some rare candies called Menchikoffs. When Chartres was occupied by the Russians in the Napoleonic Wars, a special confection was created, a chocolate mousse surrounded with praline. People travel especially to get this delicacy from an old shop that still exists today behind the church. —A.L.

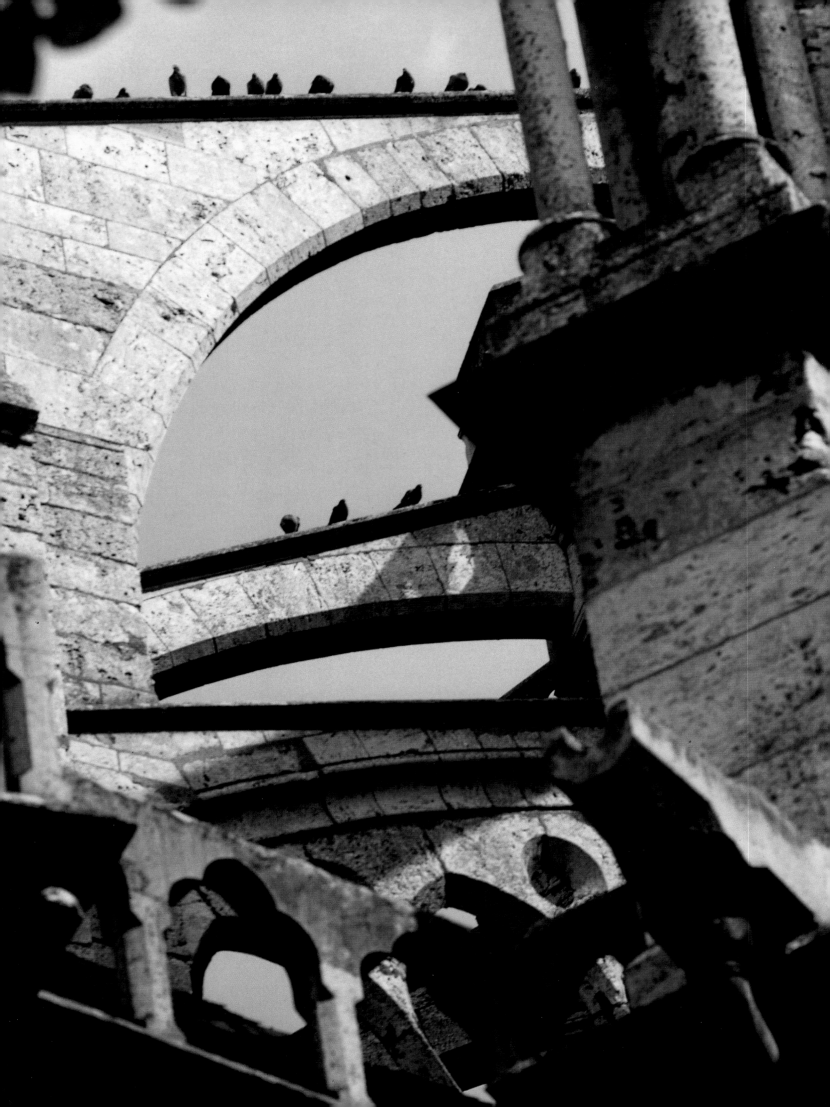

*The endless upward reach of the great west front, the clear, silvery tone of its surface, the way three or four magnificent features are made to occupy its serene expanse, its simplicity, its majesty, and dignity—these things crowd upon one's sense with a force that makes the act of vision seem for the moment almost all of life. The impressions produced by the architecture lend themselves as little to interpretation by another medium as those produced by music. Certainly, there is an inexpressible harmony in the façade of Chartres.*

—HENRY JAMES, *Portraits of Places*, 1883

Begun in 1134 and completed in the early sixteenth century, Chartres Cathedral mirrors the Book of Revelation's description of the New Jerusalem, or City of God: "a wall great and high with three gates at each of its four sides." For centuries before it came to be France's model cathedral, it housed a treasure, a silk tunic said to have been worn by the Virgin when she gave birth to Christ. It was a gift from Charles the Bald in 876. The miraculous powers associated with the holy cloth made the town a center for the growing devotion to Mary.

After a disastrous fire, that consumed most of the church but left the west façade standing, a new structure was undertaken between 1194 and 1220. The notable speed with which Chartres was rebuilt surely accounts for its remarkable architectural coherence. While the surviving façade, with its three splendid portals, determined the length of the structure, the later architects expanded the width of the transept and greatly increased the overall height of the building. This was made possible by the use of powerful exterior masonry supports—flying buttresses—that extended along the side walls and the apse. This technical innovation also enabled the walls to be opened and filled with an unprecedented number of stained-glass windows, rendering its interior more luminous than those of previous French churches. The builders of Chartres created one of the widest naves in Europe and erected vaults that rise to a height of 118 feet. The arches of the nave arcade are narrower than any that preceded them and are separated from the tall windows of the clerestory by a low passageway. Nothing is permitted to distract the worshiper's eye from its upward course.

When seen from a distance, the most striking feature of the west façade is its uneven towers: the relatively plain spire on the south end dates from about 1160; the loftier and more elaborate northern spire was not completed until 1513. Yet as one approaches the cathedral, it is the harmonious conception of the celebrated Royal Portal that is most powerfully felt. In the

A sundial bearing the date 1528 has been superimposed on a twelfth-century sculpture on the south wall of the cathedral at Chartres.

*Preceding page:* Flying buttresses on the south wall.

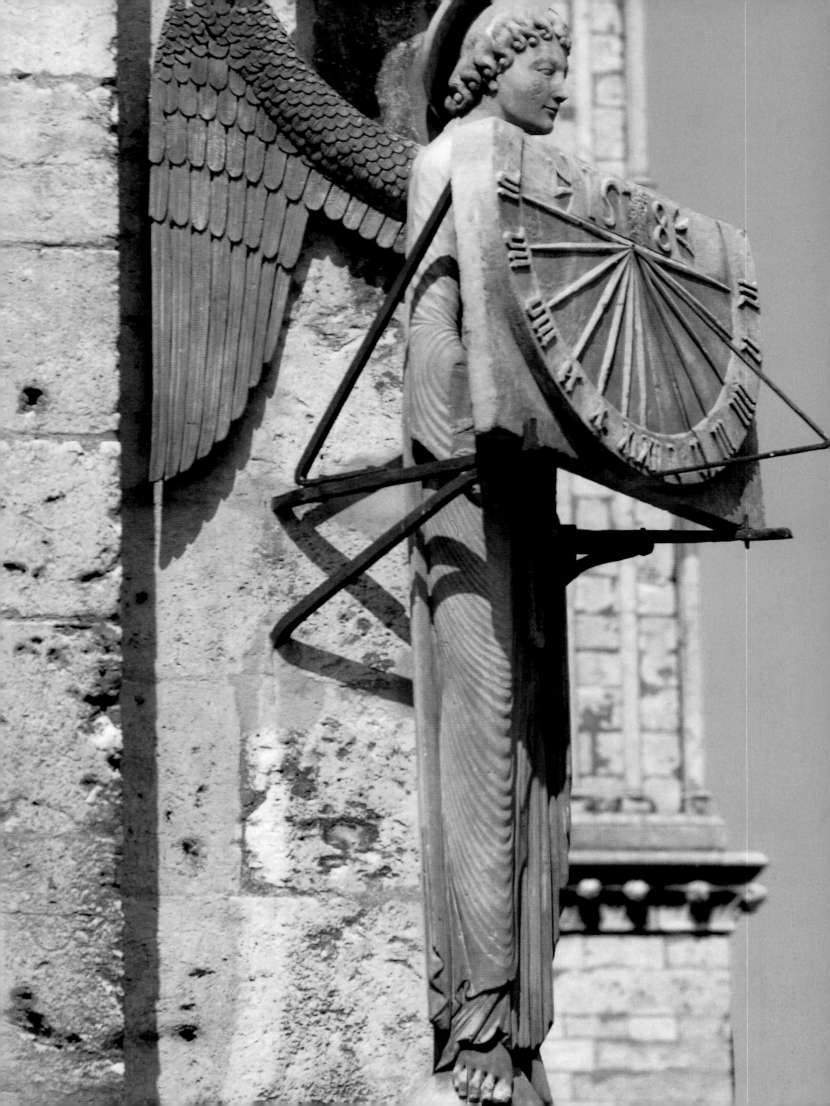

*(continued from preceding page)* tympanum above the central entrance the compelling high relief of Christ as judge is flanked by symbolic representations of the four Evangelists, as described in the Book of Revelation. This solemn scene is framed by portals depicting the Ascension and the enthroned Virgin and Child. Among the most impressive elements in the sculptures of the portal are the rigid and elongated figures, attached to slender columns, who purportedly represent Christ's royal ancestors, the kings and queens of Judah. The delicately carved patterns of their garments parallel the verticality of the shafts, and the serenity of their idealized features seem to announce the calm and sense of order that emanates from the entire structure.

Most of Chartres's stained-glass windows have survived, giving it a unique status among the Gothic cathedrals of France. The town was celebrated for its glass-making workshops, and by 1260 local craftsmen had installed some 22,000 square feet of stained glass in 186 windows. The majestic ensemble on the west façade dates from around 1150. It consists of three lancets, or arched windows, surmounted by a large circular rose window. Images of the ancestry of Christ and his Second Coming echo the iconography of the sculpture in the portal below.

The light that filters through the many windows suffuses the interior with brilliant colors. Light had profound religious connotations in the twelfth and thirteenth centuries, and the stained-glass windows, often described as a Bible for the illiterate, were conceived as sources of both material and spiritual illumination. While simple lay people may not have understood the complex theological interpretations of light, they certainly recognized that the miraculously luminous atmosphere of the cathedral interior, so different from the mean, dark realities of the world outside, was meant to inspire them with a vision of a more perfect world, the timeless celestial kingdom that awaited the righteous. —D.K.

Figures representing the Ancestors of Christ from
the central bay of the Royal Portal.

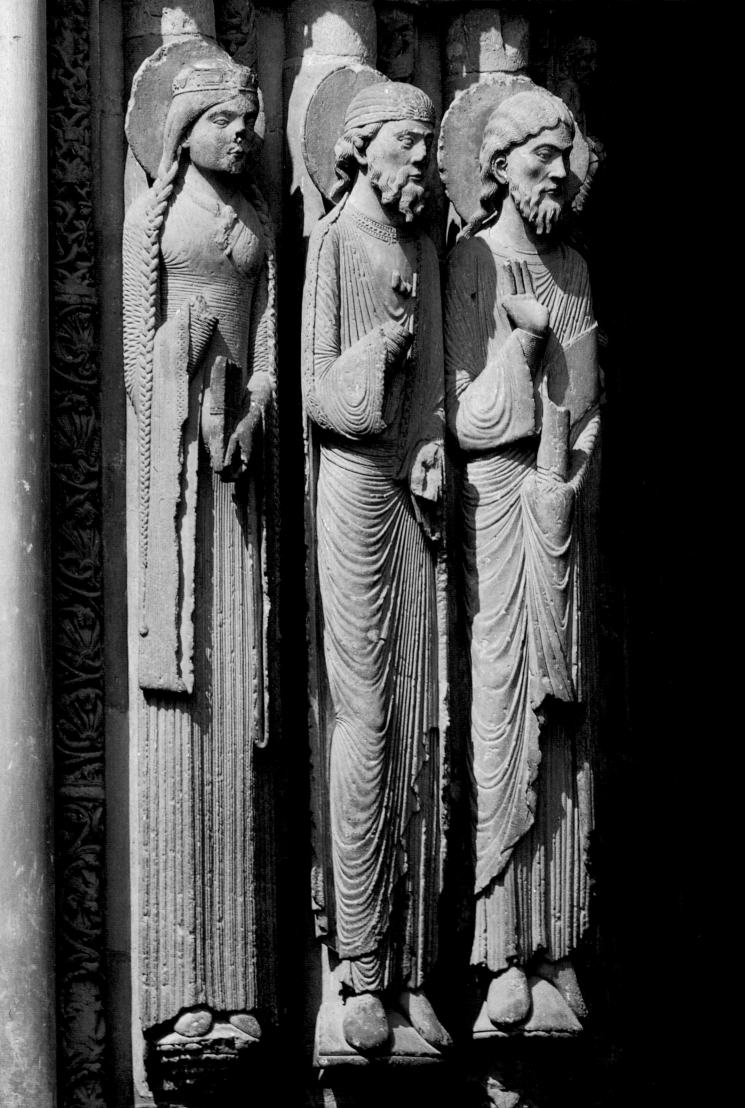

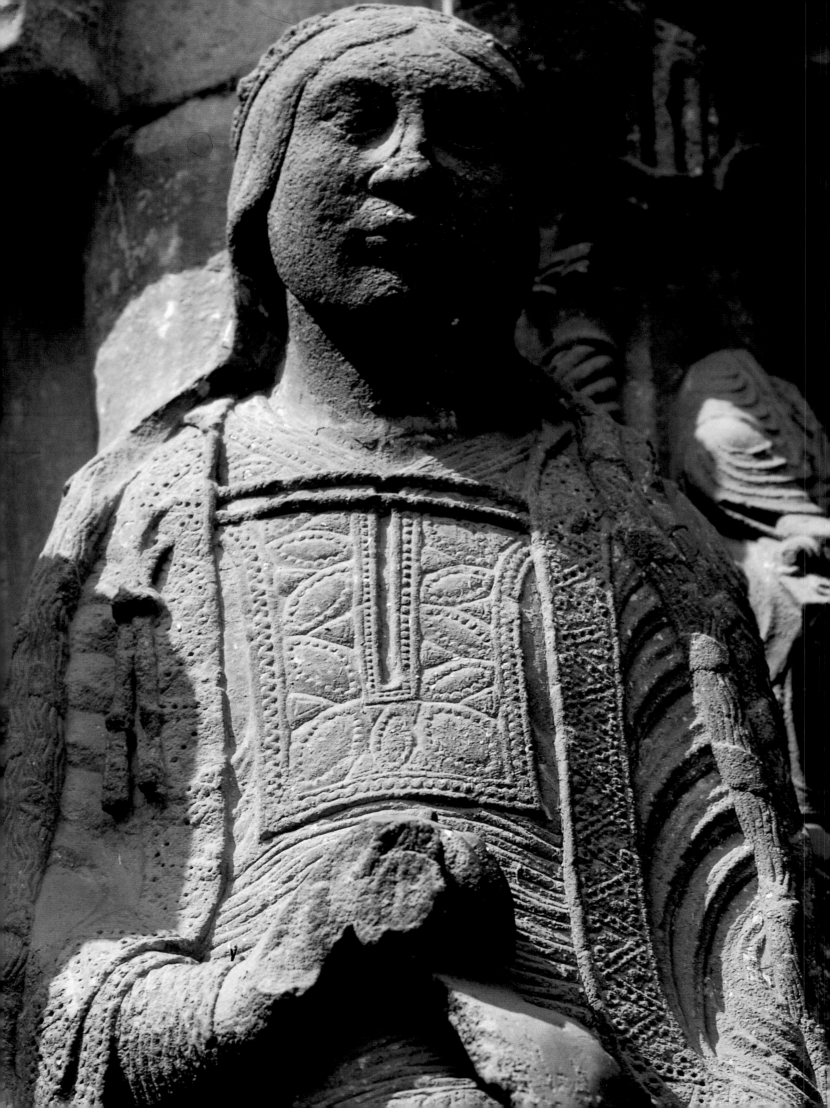

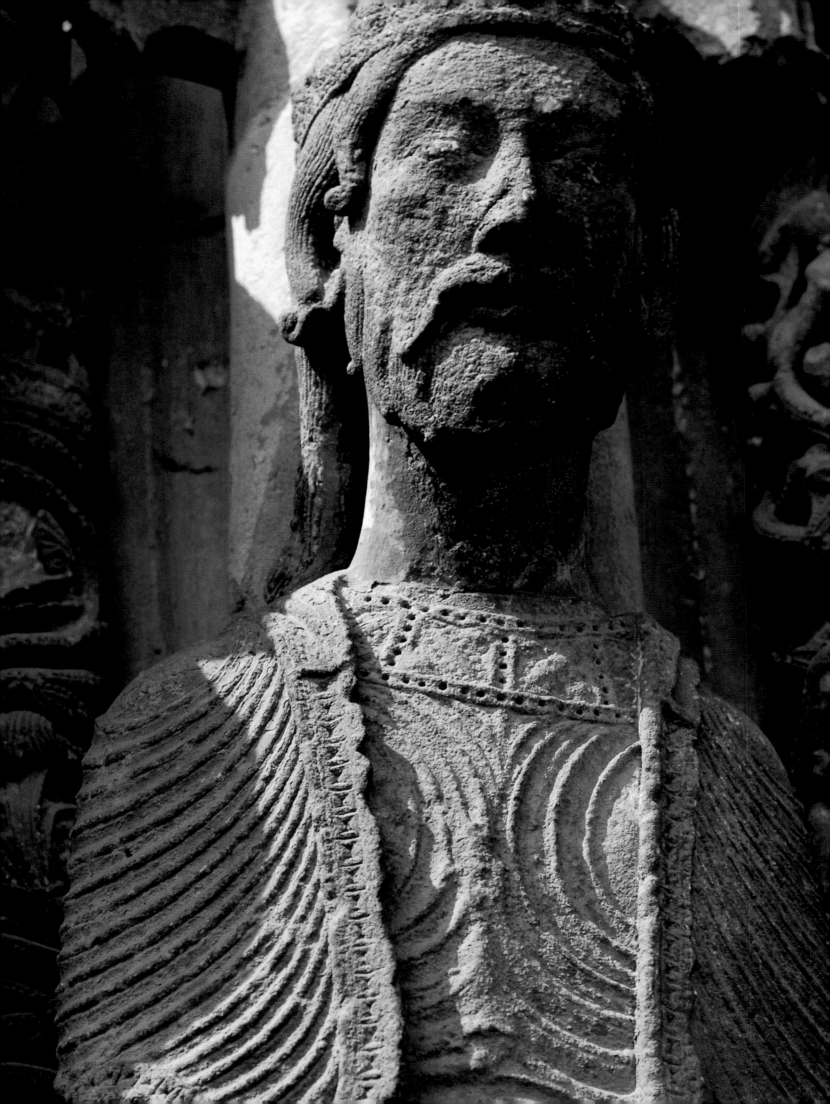

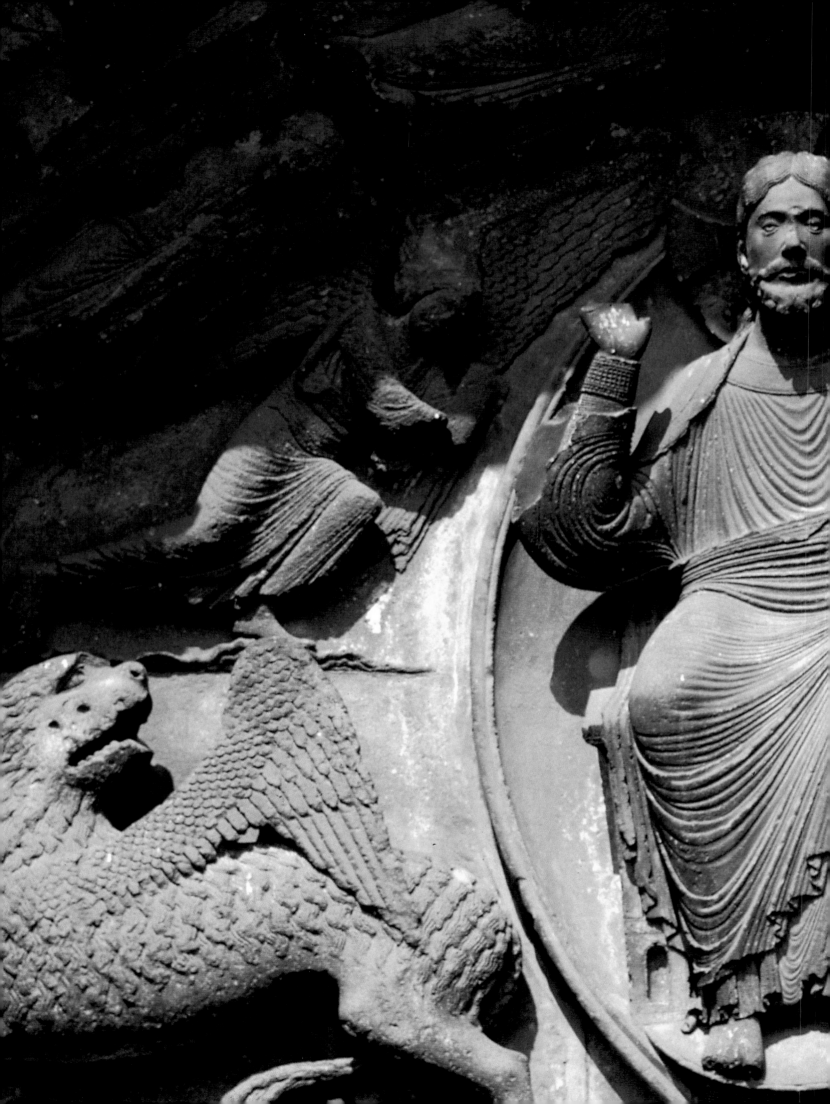

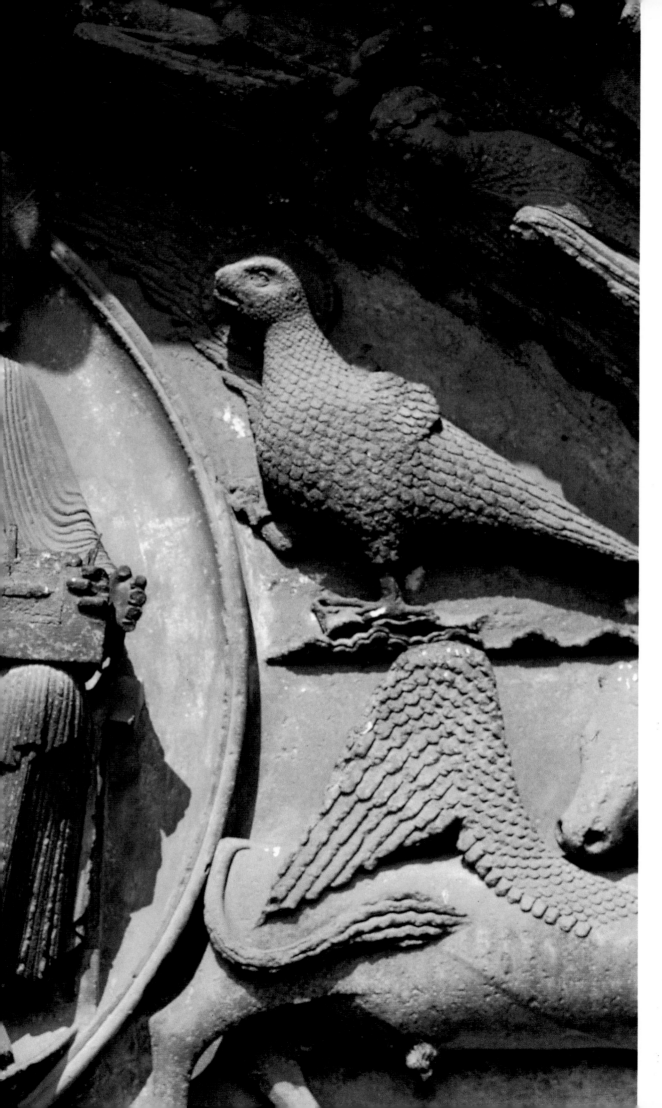

Tympanum relief of Christ in Majesty forms the central bay of the cathedral at Chartres.

*Preceding pages:* Detail of the Ancestors of Christ from the left bay of the Royal Portal.

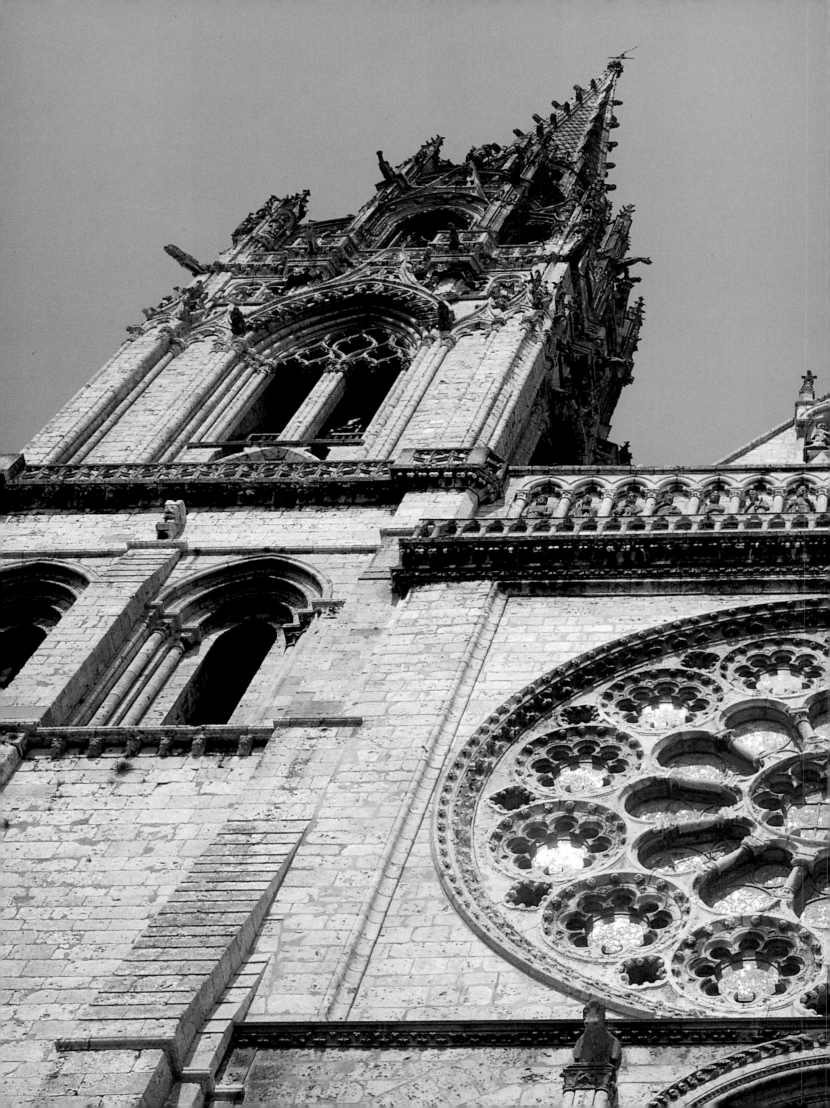

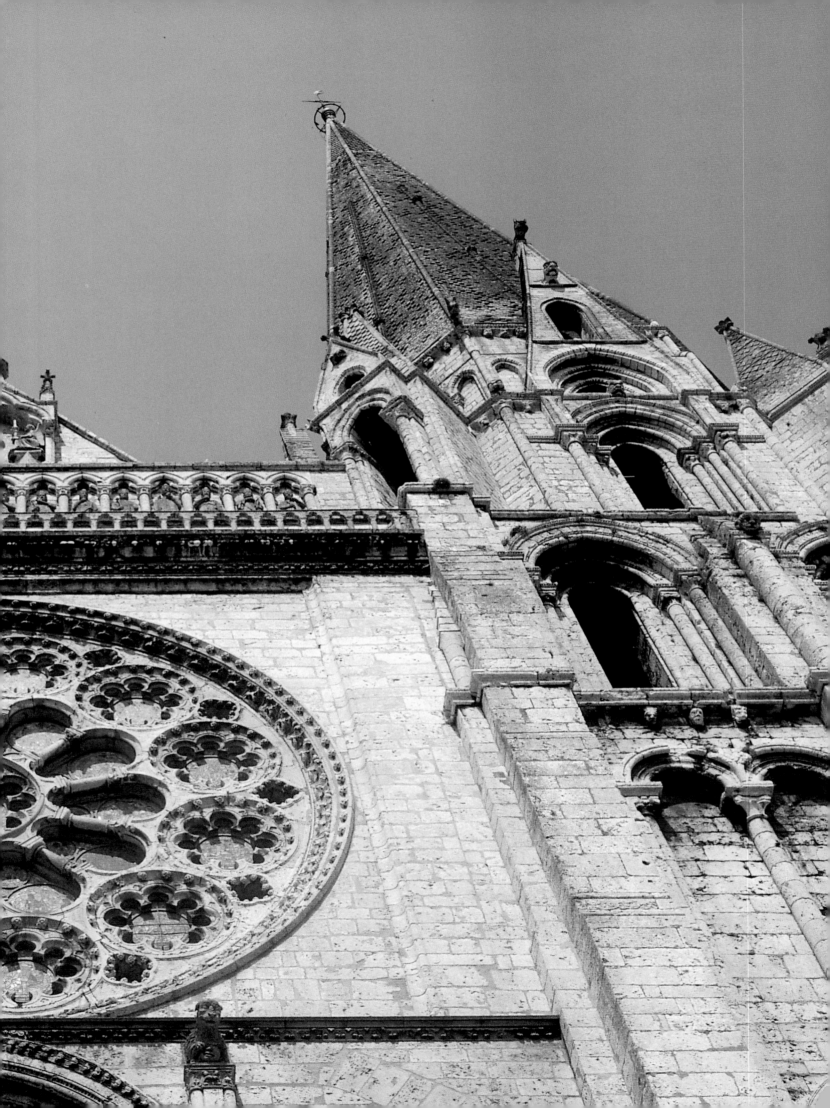

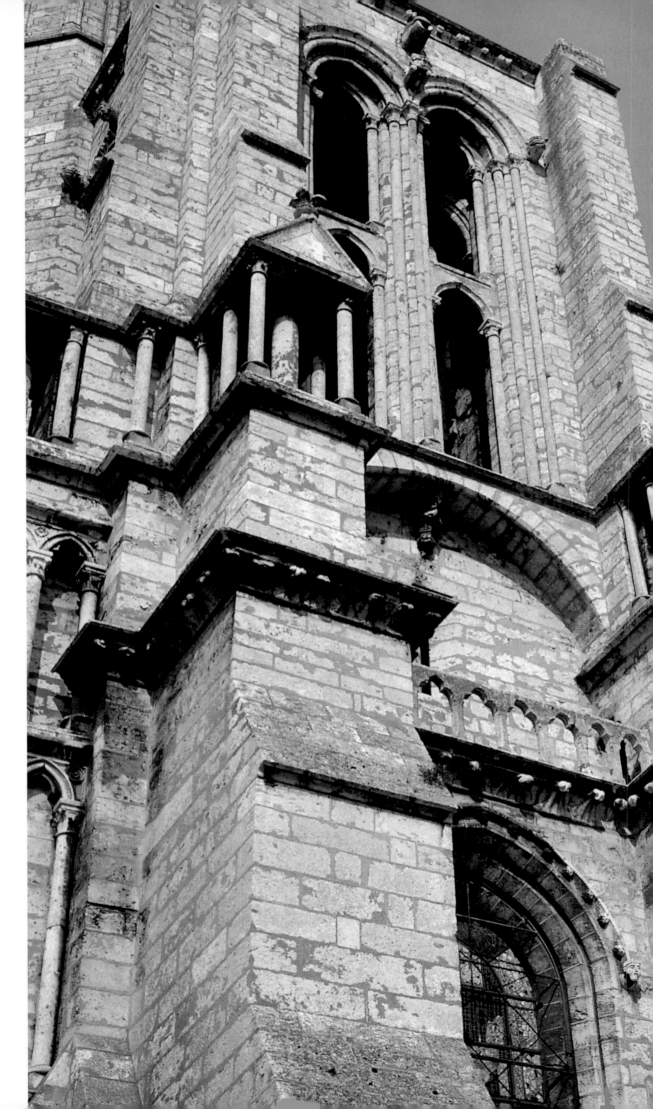

South wall of
the nave, with flying
buttresses visible
at the top.

*Preceding pages:* View
of the upper part
of the west façade.

*Following page:*
The magnificent
rose window of the
west façade, seen
from the nave.

*Opposite following page:*
Detail of a thirteenth-
century window in the
ambulatory depicting
scenes from the life
of the Virgin.

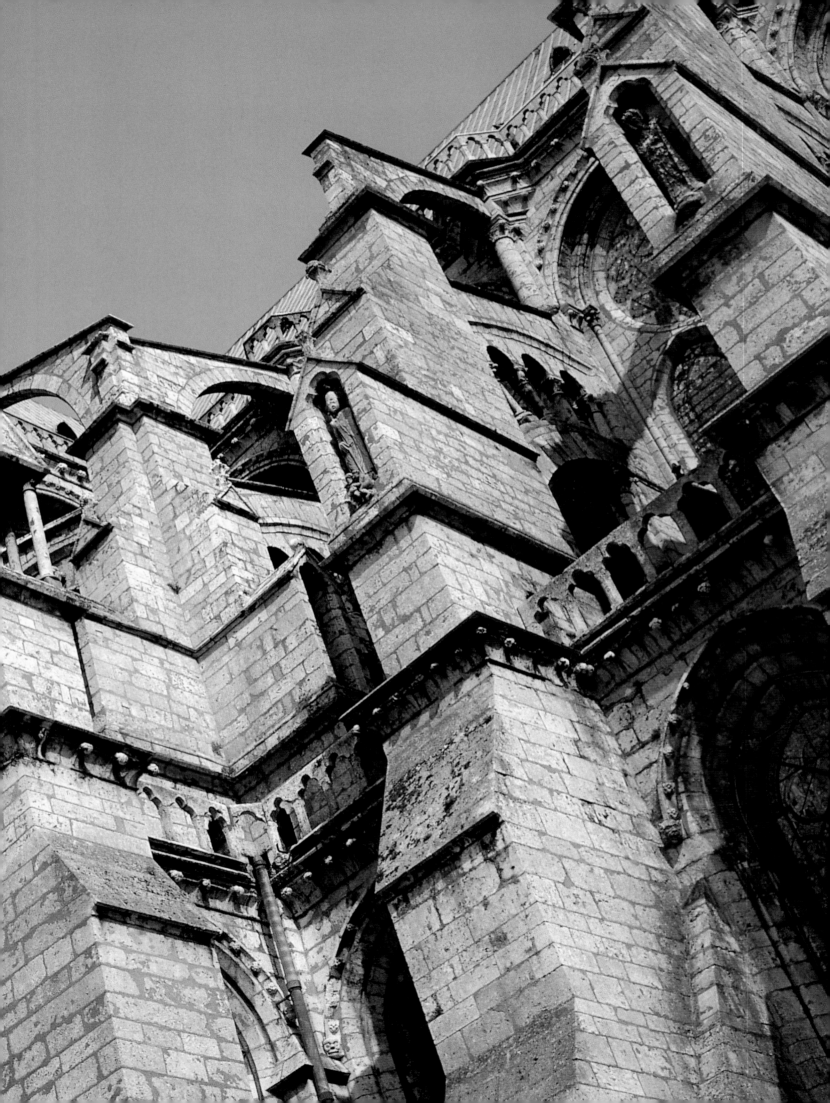

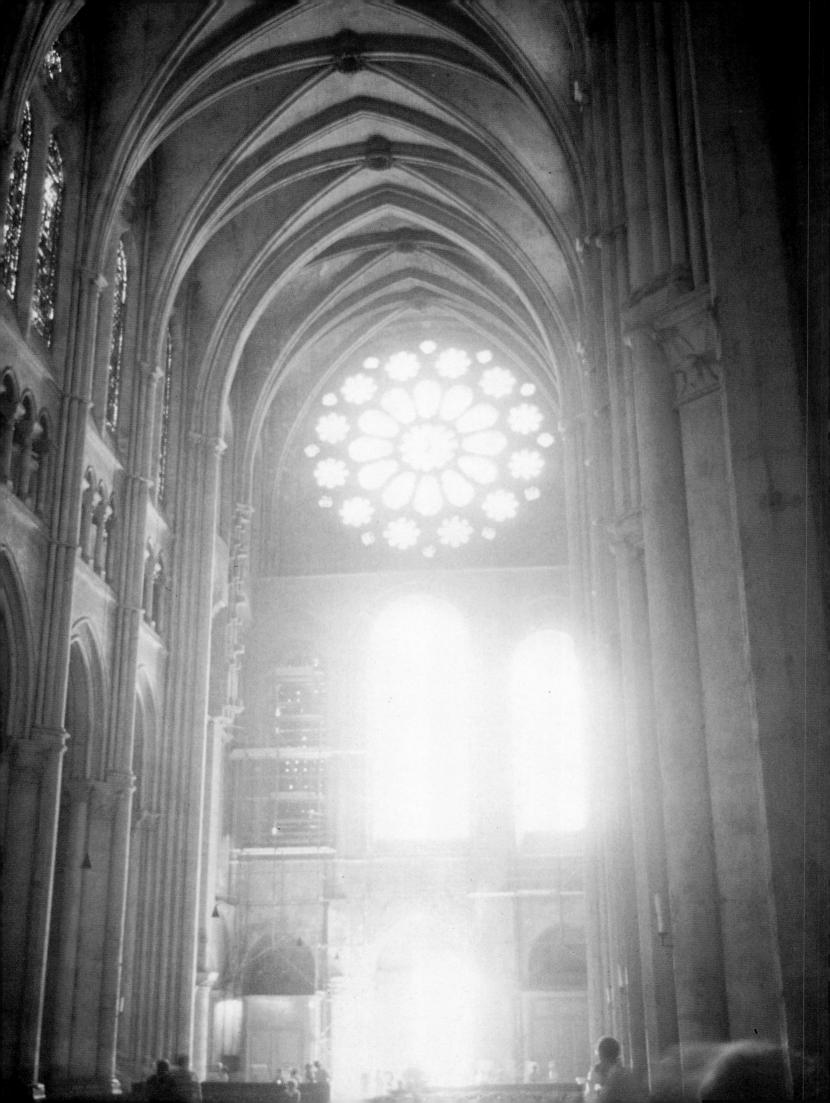

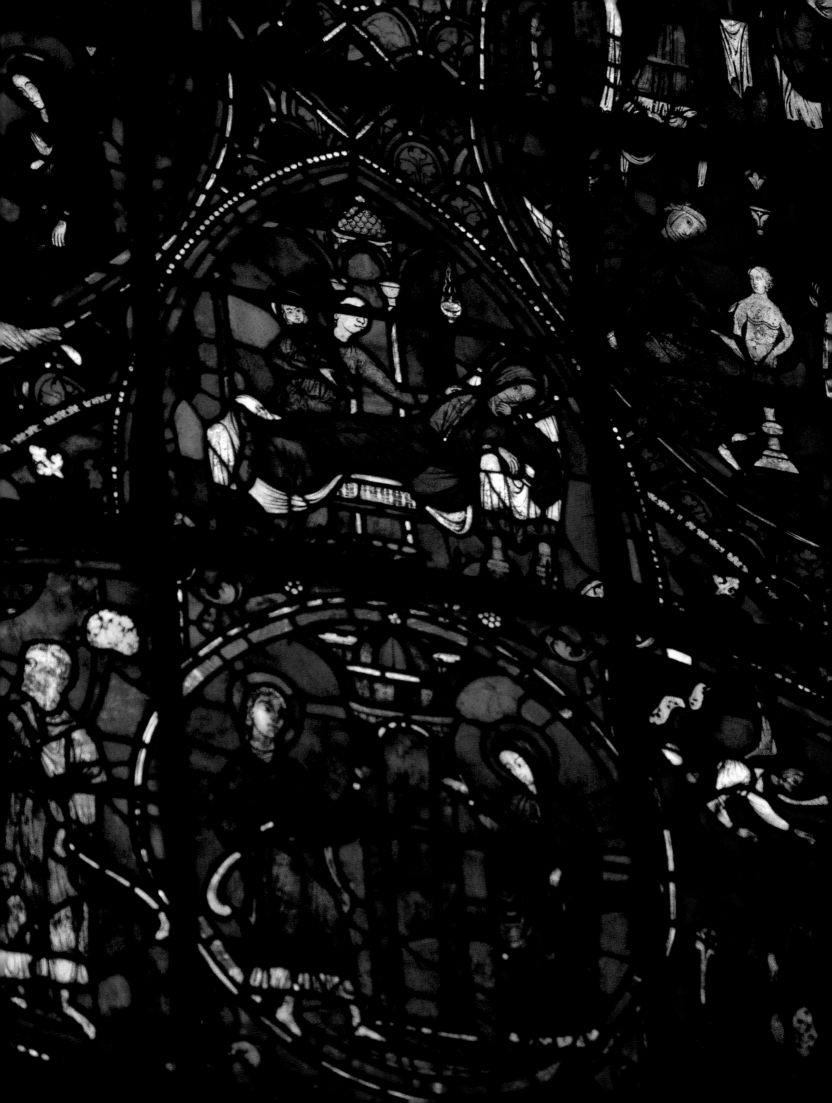

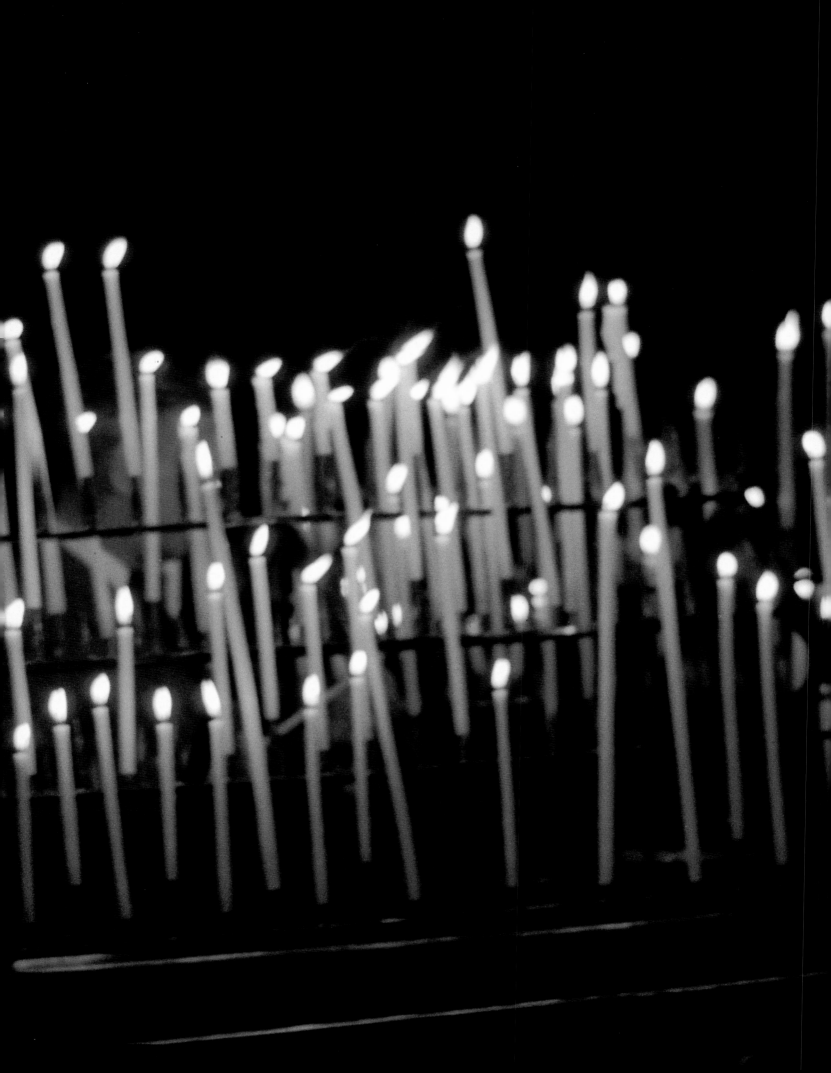

Details from the
Incarnation Window,
which dates from 1150.

*Opposite preceding page:*
Votive candles before
the altar to the Virgin.

*Preceding page:*
A sixteenth-century
carved wooden
statue of the Virgin
and Child is one
of the most venerated
objects in Chartres.

# Notre-Dame de Paris

Notre-Dame, lodged on the Ile de la Cité, with the river Seine on both sides, has withstood centuries of religious wars and revolutions. Instantly recognizable by its distinctive gargoyles, demons in stone that clasp parapet corners, the cathedral of Paris is an evergreen legend, popularized in works like Victor Hugo's *Hunchback of Notre-Dame*. The exterior of the cathedral reflects a plain style of architecture. Sculptures on its massive façade are concentrated in a horizontal band, with biblical kings lined up above three portals. Angels in the arches of the portals provide an audience for the holy scenes below. The buttresses that support the nave and apse of the cathedral are for me an especially moving element in the structure of Notre-Dame. Like flying wings of stone, they allow the weight of the center of the church to be spread out through them, so that windows can be larger, and vaults higher and wider, without endangering the building's stability.

When you live in Paris you are sometimes taken to La Tour d'Argent, a famous restaurant that specializes in duck cooked in its blood. As you sit on the terrace you can see Notre-Dame from the back. In the evening, when the buttresses are illuminated, it is a scene of fantastic beauty. Of course you don't go to La Tour d'Argent every day, but you can always walk all around Notre-Dame and study this architectural marvel. Such a walk—crossing the bridges, strolling on the quais, and browsing for treasures in the bookstalls that line them—can be a real meditative experience. Surrounded by water under the changing light of the Parisian sky, Notre-Dame seems to dominate its environment from all angles like a stately vessel. Echoing the motto of Paris, "Fluctuat Nec Mergitur," it floats but does not sink. —A.L.

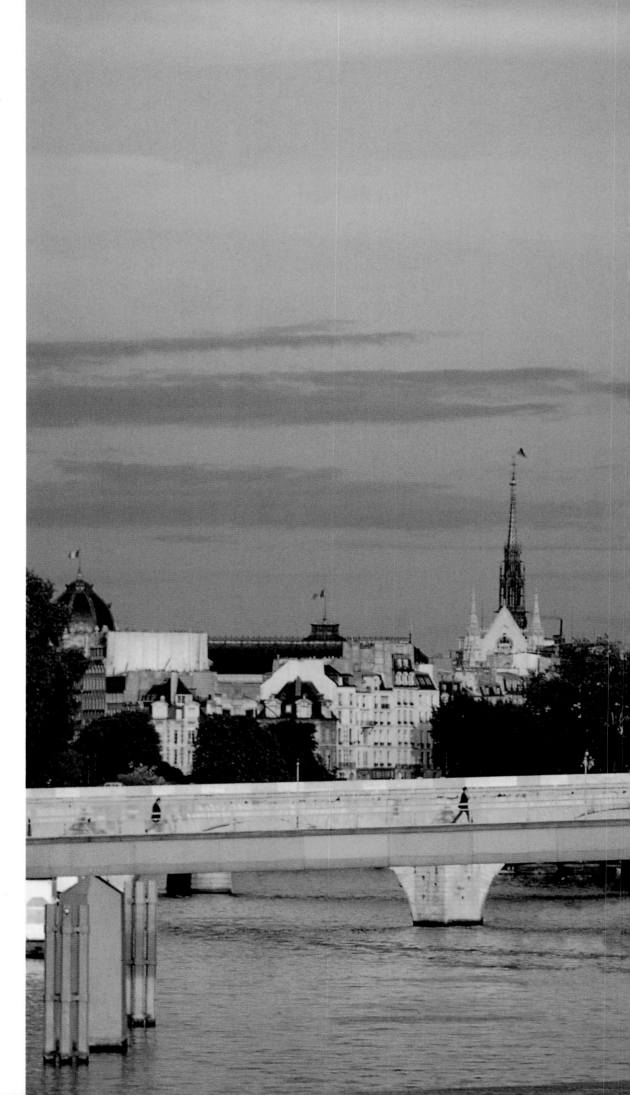

A view of the Ile de la Cité from the west. The twin towers of Notre-Dame are in the center, framing the tall spire that was added in the mid-nineteenth century.

*Following page:* The chancel of the cathedral dates from 1163–82, but the flying buttresses were remodeled in the next century.

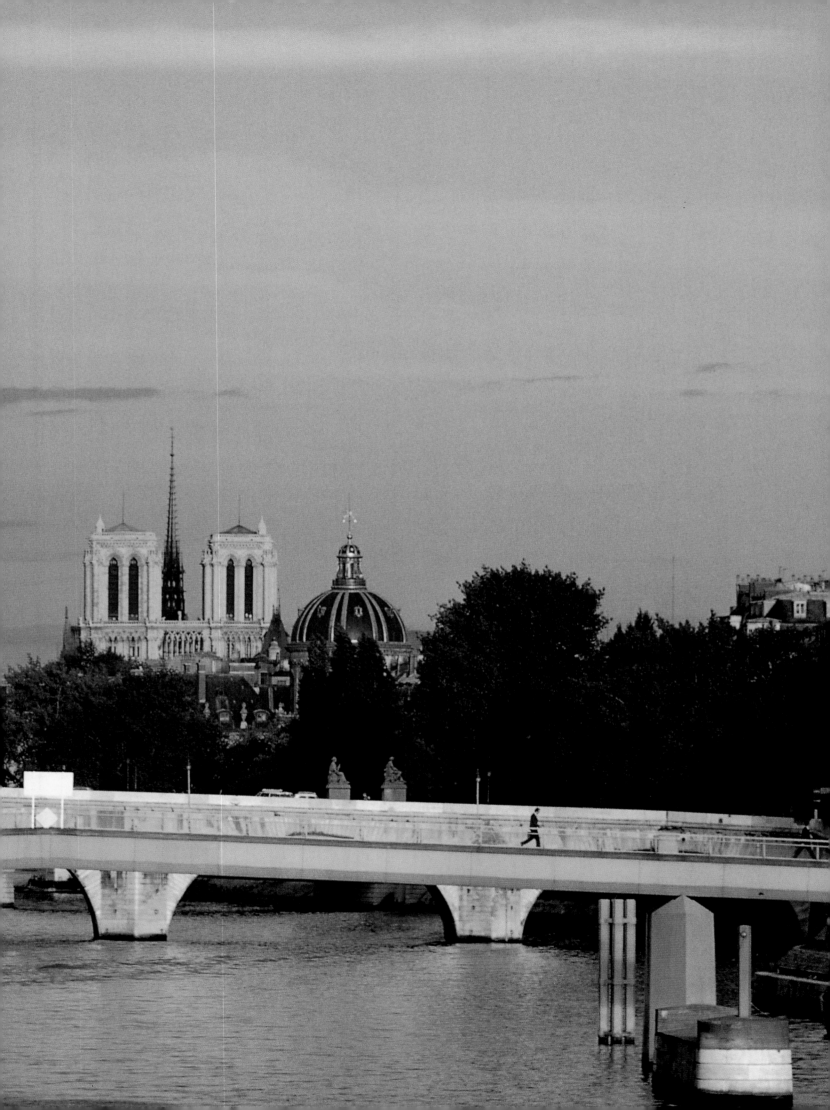

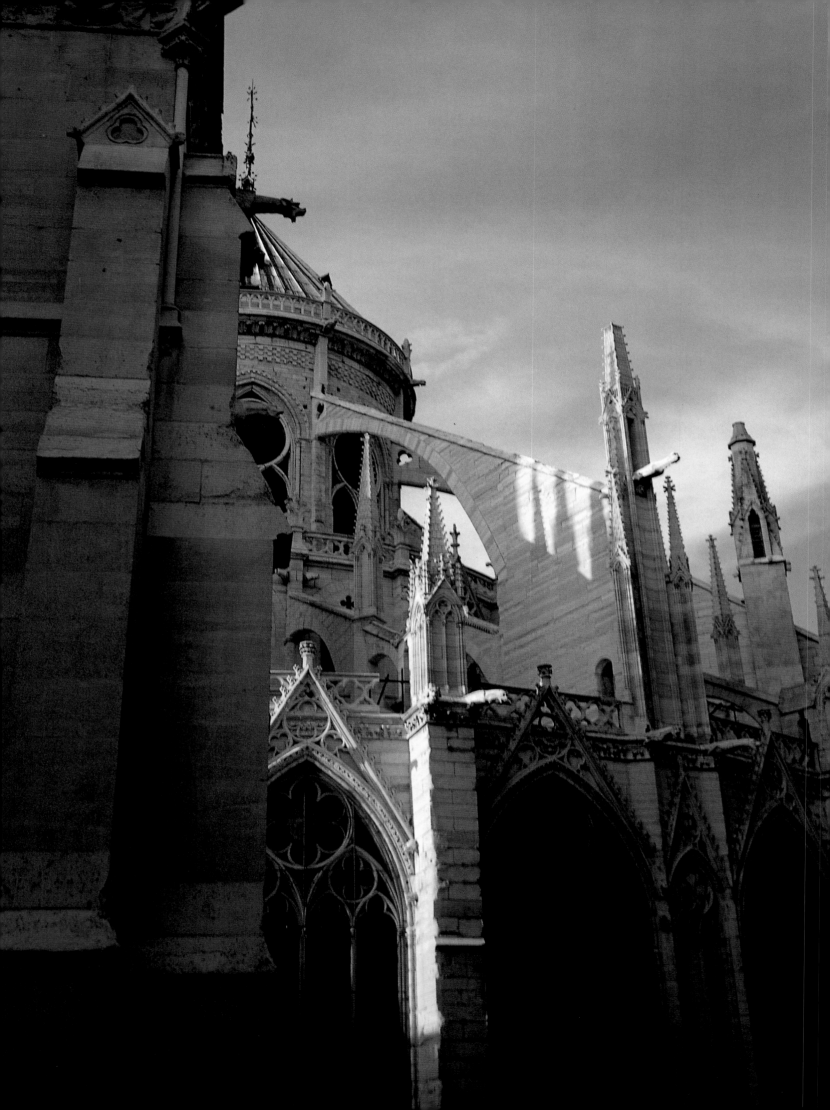

Although by no means the grandest or the best preserved of France's cathedrals, Notre-Dame in Paris defines the essence of the Gothic style for most people. Until 1889, when the Eiffel Tower was completed, Notre-Dame was the tallest structure in Europe, and it still remains a vital symbol of the faith and creative energy of the city. It is situated on a small island in the Seine River said to have been founded by a Gallic tribe known as the Parisii. The cornerstone was laid in 1163 by Pope Alexander III, who had been welcomed by the French king after the Emperor Frederick Barbarossa had forced him into exile. The building reflects, above all, the vision and determination of Maurice de Sully, a priest of humble origin who had become the seventy-fourth bishop of Paris three years earlier. Sully realized that the city needed a cathedral worthy of its status as one of Europe's greatest centers of learning and as the seat of the country's power.

Once the necessary quantities of stone were found and transported to the building site to be cut and shaped by skilled masons, construction proceeded slowly. The chancel (choir and apse) was the first part of the building to be completed, since the bishop reasoned that when it was in place the church could assume its functions. The chancel itself was of an unprecedented size—170 feet long and 157 feet wide—with four tiers of stained-glass windows that flooded the sanctuary with brilliant light. The high altar was solemnly consecrated in 1182.

At the time of Sully's death in 1196, the long nave was nearly finished. On the outside, to support vaults that rose to a height of 115 feet, a series of flying buttresses was constructed. The double aisles of the chancel continued in the nave, but with a notable difference in the character of the supporting columns. In the chancel they were simple round shafts on square bases.  In the nave, the line of columns that separate the two aisles combines plain shafts and colonettes, creating an effect of movement that continues unbroken through the triforium and culminates in the clerestory.

Sully's successor as bishop was a wealthy nobleman who allocated large sums of his own fortune to the cathedral's construction. Such was his largesse that the original design for the west façade was altered to accommodate a larger scale and a more elaborate sculptural program than had been planned. Between 1200 and 1225, the façade was built to the level of the great rose window. The three magnificent portals, set between pairs of buttresses, vary slightly in height and width. Following tradition, the central portal was reserved for the Last Judgment. At the summit of its tympanum, an enthroned Christ, flanked by angels holding the symbols

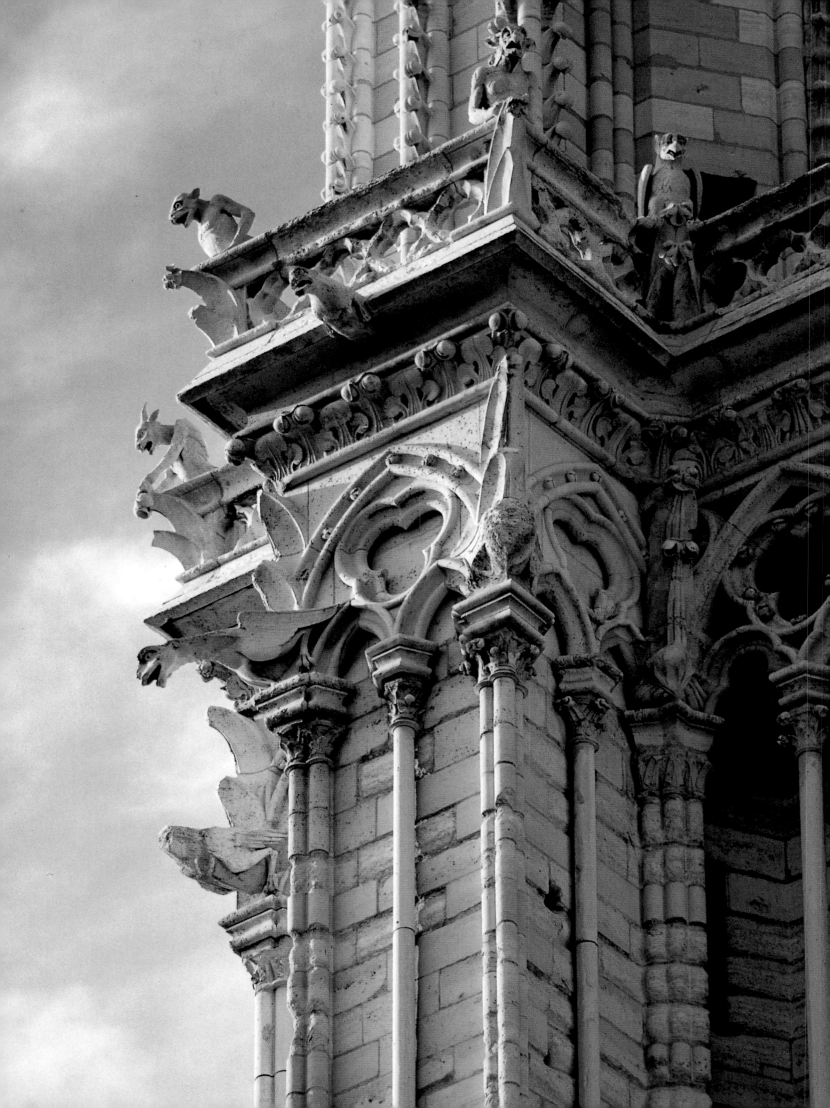

*(continued from page 113)* of the Crucifixion and by the kneeling figures of the Virgin and St. John, presides over the selection of the blessed and the damned. Beneath him, the reward of virtue and punishment of vice are starkly contrasted in the two figures who vie for souls on the scale of justice. The realm of the blessed is evoked through the upright stance and serene gaze of the Archangel Michael, while the twisted hairy body and monstrous leering countenance of the demon leave no doubt as to the awful destination of the damned.

Above the three portals, extending the entire length of the façade, is the celebrated Gallery of the Kings. The sculptures now in place there were commissioned in the nineteenth century to replace those destroyed during the Revolution. The originals had been erroneously identified as rulers of France, not Israel.

After 1225, numerous chapels were installed along the side aisles of the nave in the spaces between the buttresses. The wall of the clerestory was reworked to accommodate tall double lancets and small rose windows, and the huge rose window—the largest of its kind at the time—was installed in the west façade. Stained glass had become a decisive feature of Gothic architecture, providing cathedrals like Notre-Dame with a dazzling array of colored light of jewel-like intensity. During the seventeenth and eighteenth centuries, architectural interventions sought to impose a more classical character on the interior, which was increasingly perceived as "barbarous" and old-fashioned. Many of the beautiful thirteenth-century windows were removed and replaced by sober gray glass with borders of fleurs-de-lis in yellow. In 1771, during an attempt to increase the height and width of the central portal so that it might accommodate the elaborate paraphernalia of royal processions, much of the sculpture was damaged. But the greatest harm to the cathedral—from which it never completely recovered—came during the French Revolution. In 1793, after the executions of Louis XVI and Marie Antoinette and the government's prohibition of any public religious observances, Notre-Dame was transformed into a Temple of Reason. By then, a campaign of vandalism and desecration had already claimed many religious works. Fortunately, the artist Alexandre Lenoir was permitted to store enormous quantities of sculpture taken from French churches such as Notre-Dame in the abbey of the Petits-Augustins, and much survived.

Although its functions were restored by Napoleon's Concordat of 1802, it was not until the 1830s, when the former duke of Orleans became King Louis-Philippe, that people began to pay attention to the decay into which Notre-Dame had fallen. Victor Hugo's inspired characterization of it as a "history in stone" influenced Eugène-Emmanuel Viollet-le-Duc, who was appointed architect for the restoration of Notre-Dame in 1845. For the next twenty-five years he oversaw the implementation of a comprehensive program that determined the building's character. —D.K.

Balustrades and buttresses of the towers of Notre-Dame are enlivened by
sculptures of gargoyles that also serve as waterspouts.

*Following pages:* The Last Judgment is depicted in the tympanum of the central bay.

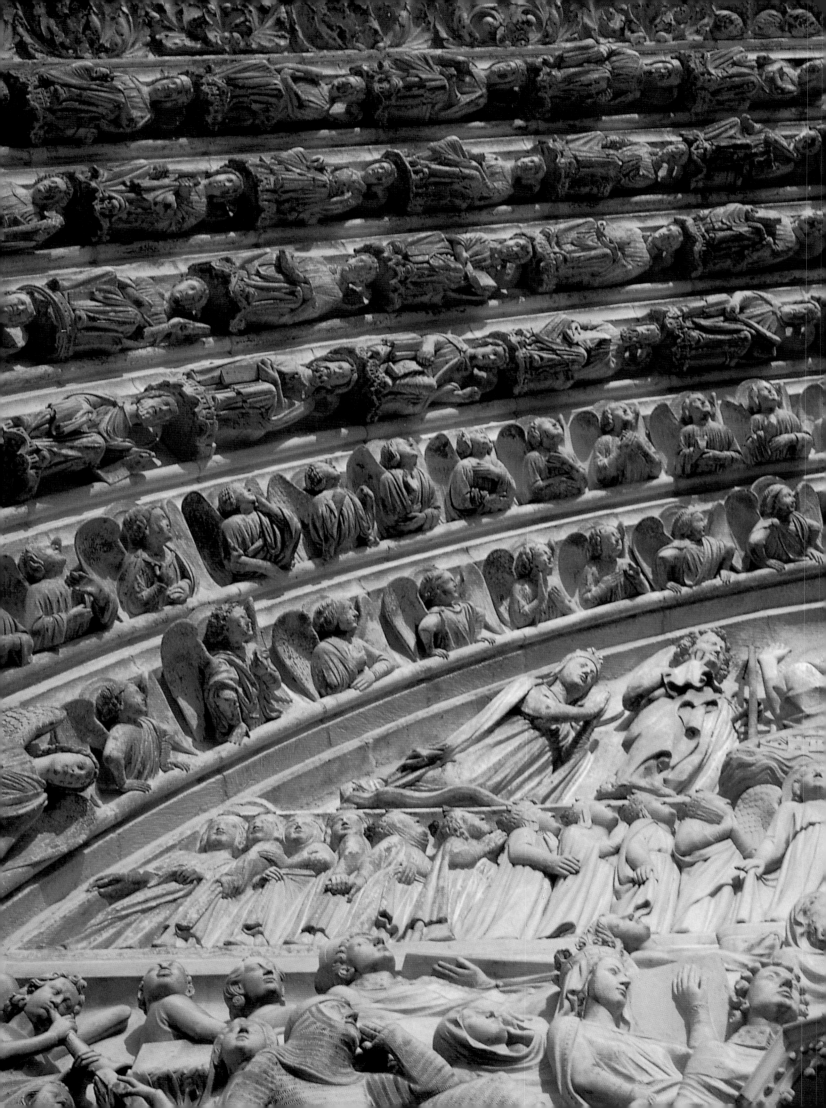

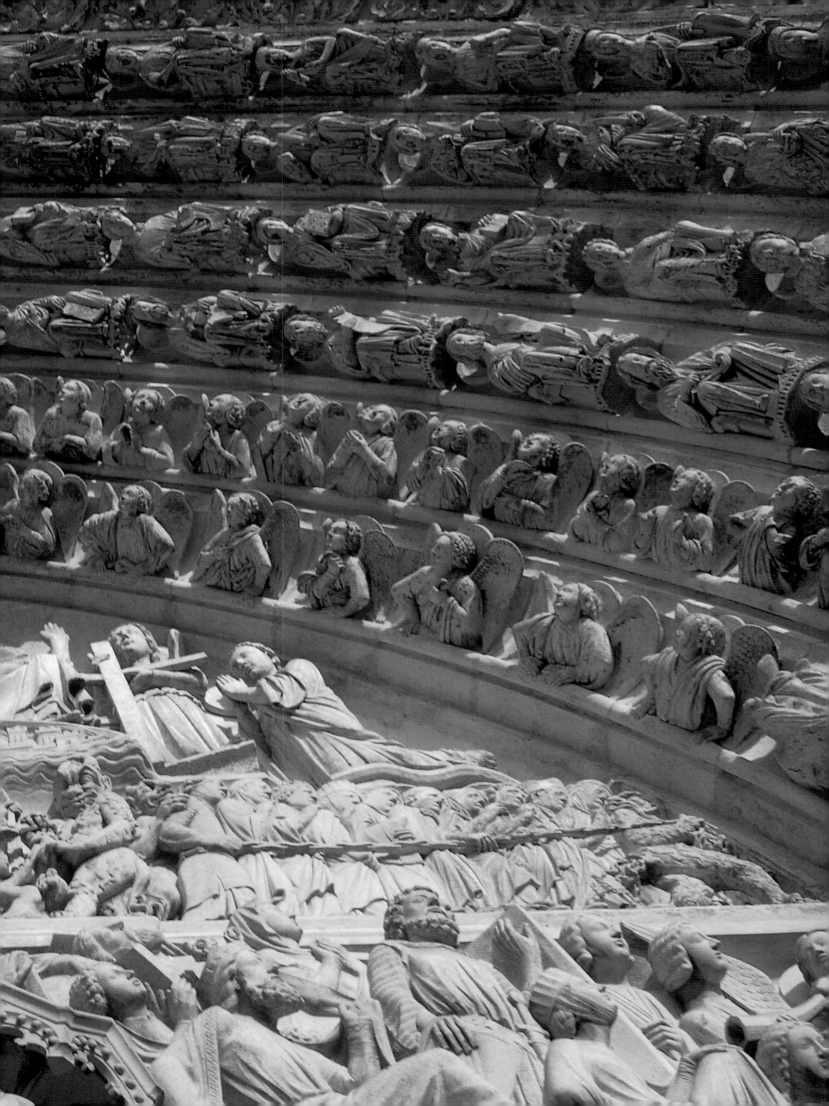

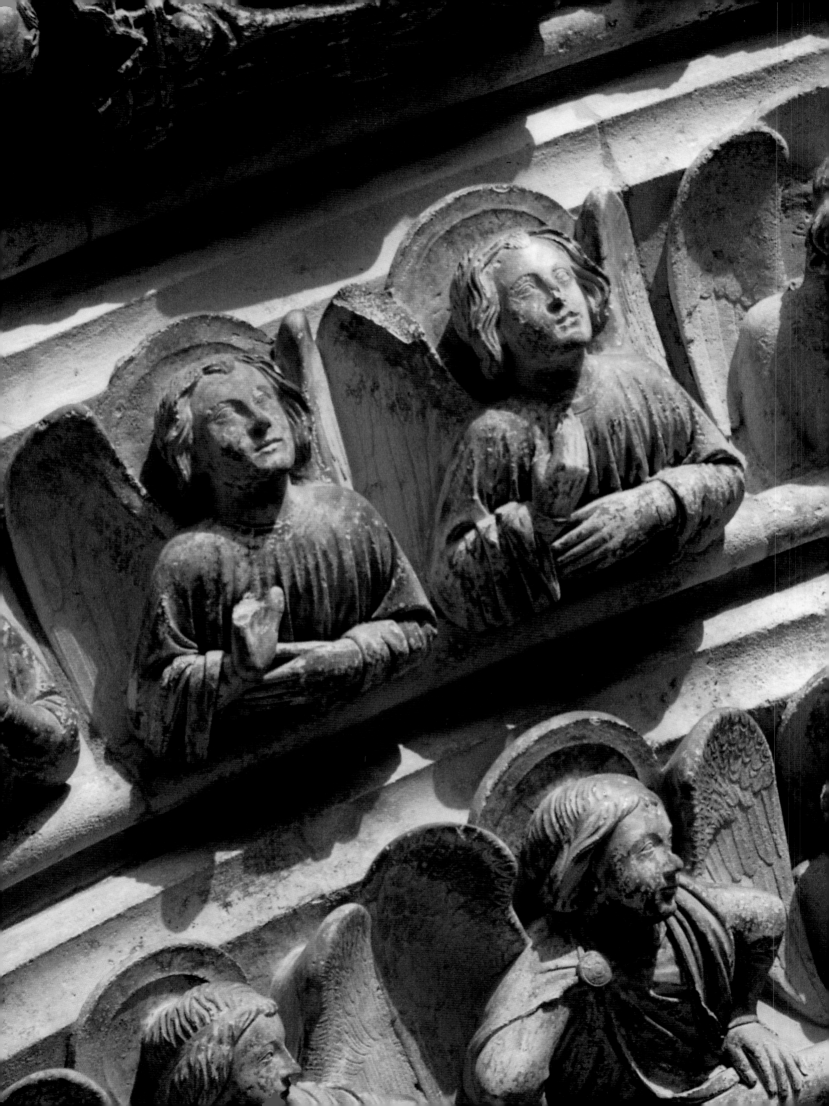

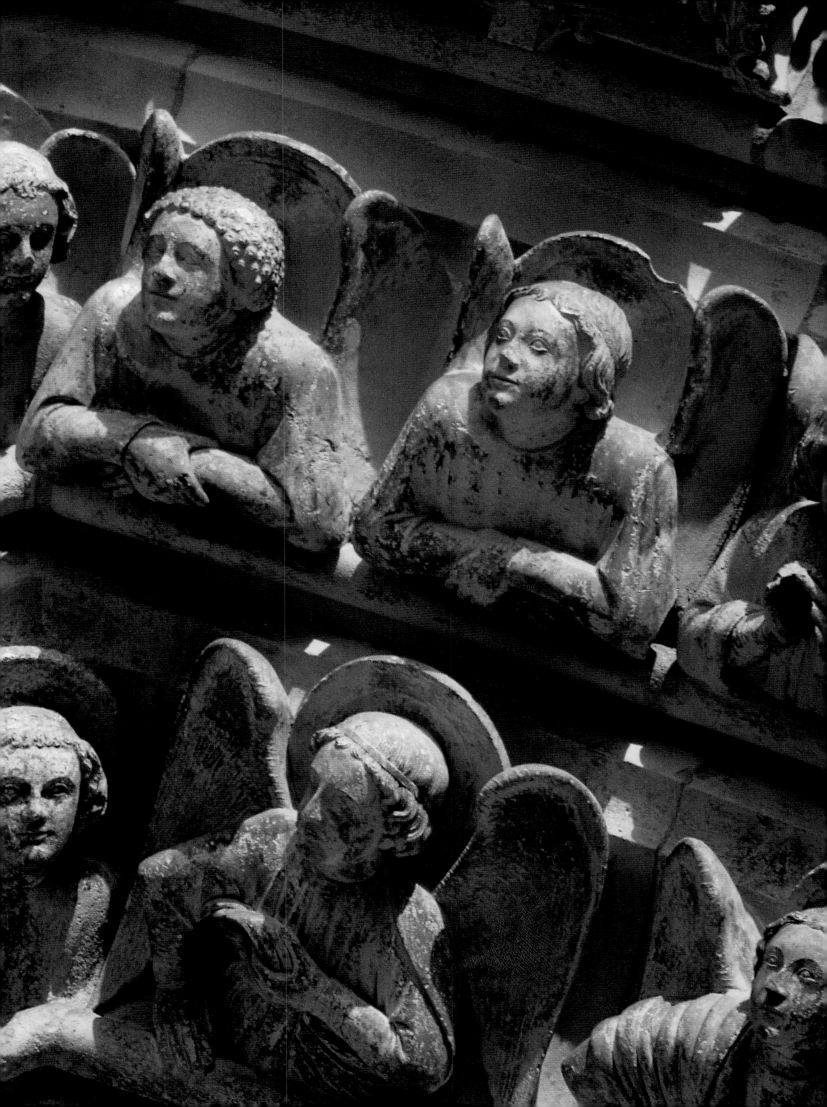

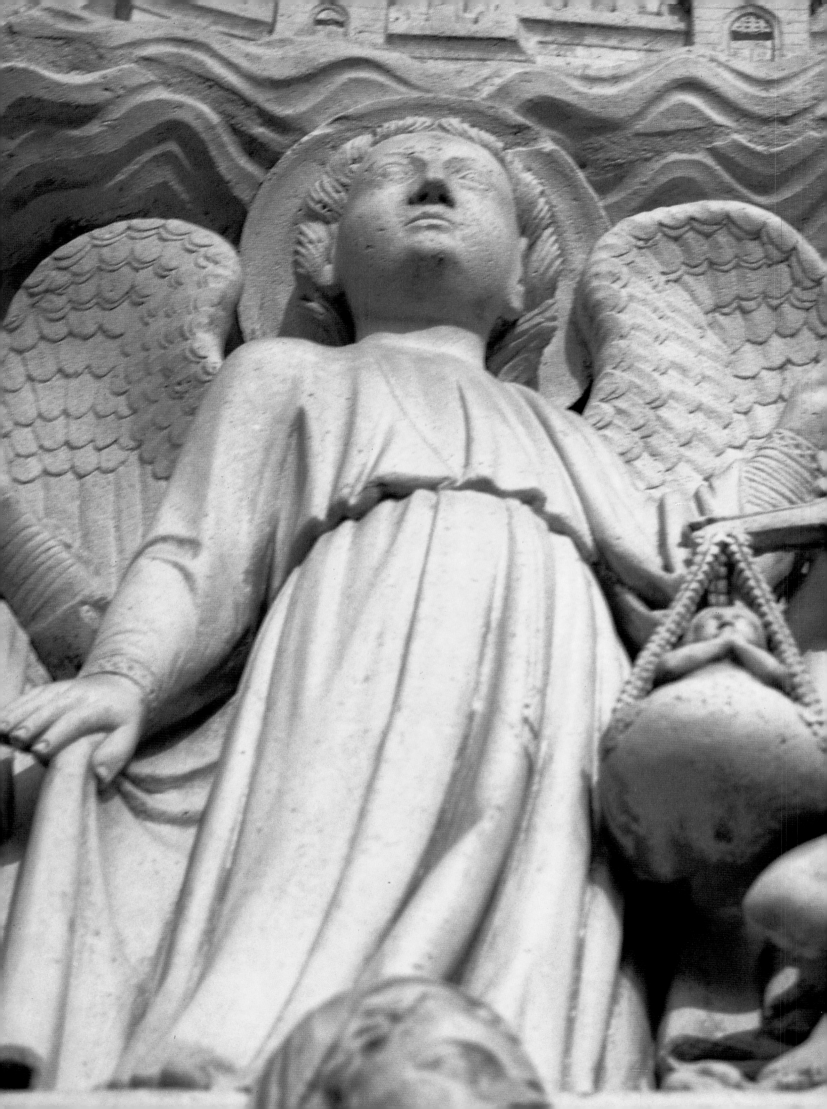

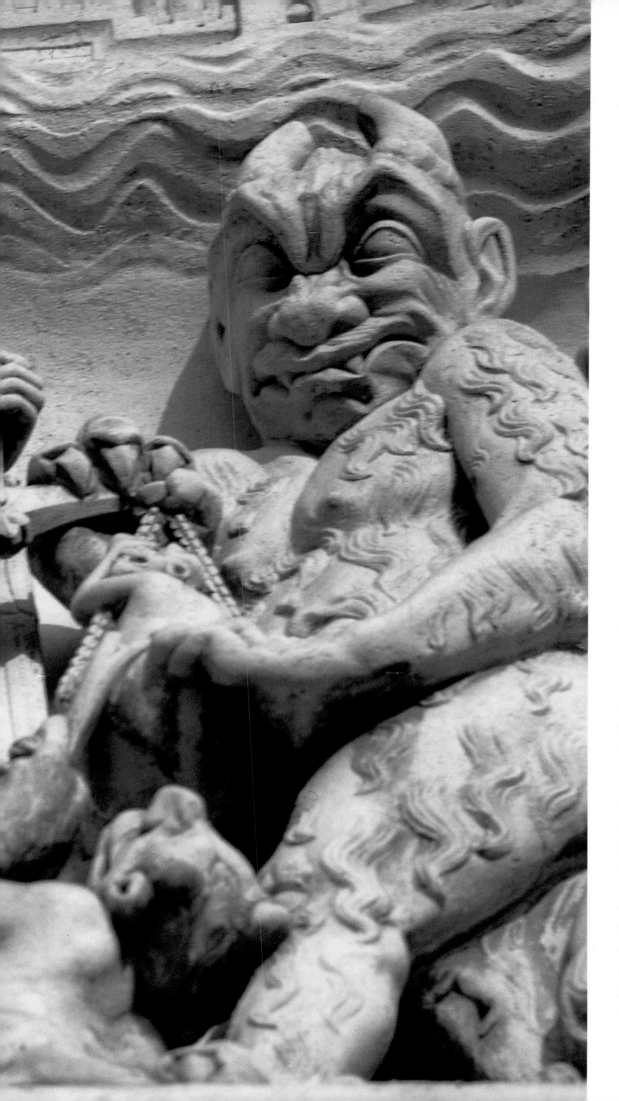

St. Michael and Satan weighing souls in the center of the Last Judgment relief.

*Preceding pages:* Details of the angels around the arch above the Last Judgment.

*Following pages:* The west façade, with two of the four lancets and the rose window. The figures in the Gallery of the Kings at bottom were destroyed and replaced by replicas in the nineteenth century.

121

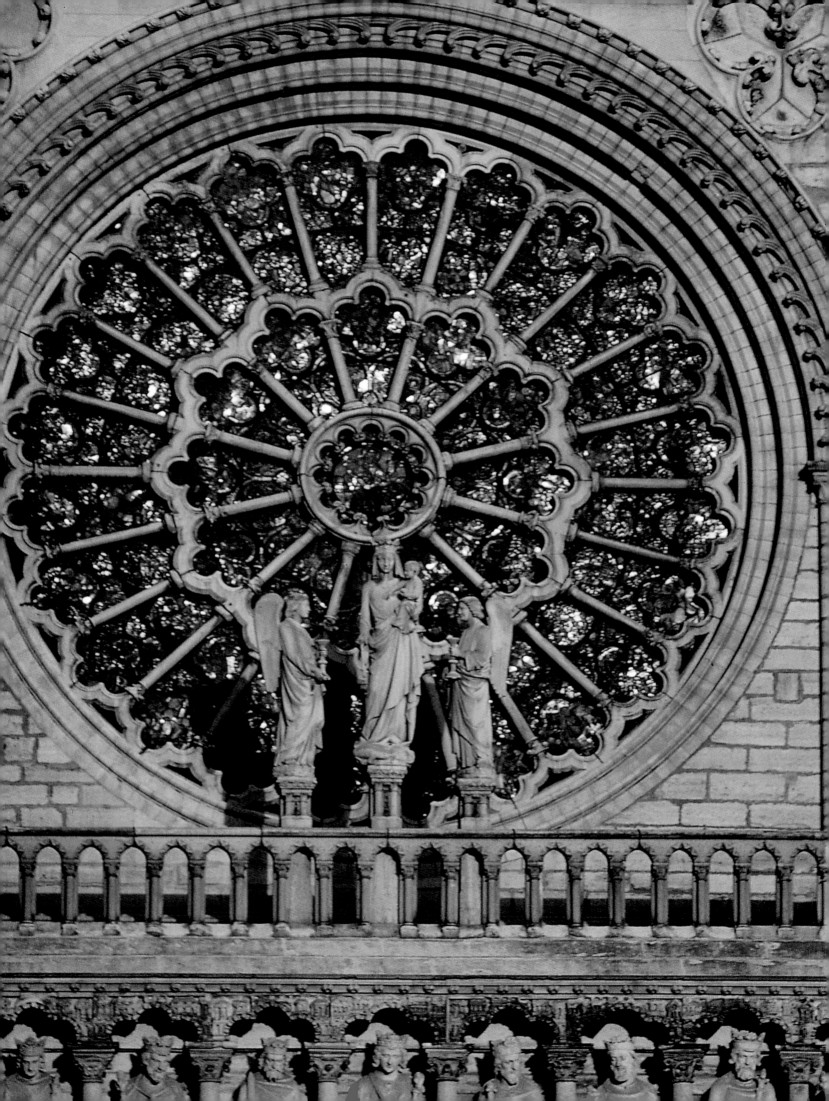

# The Basilica of St. Francis at Assisi

Driving south from Florence toward Rome, through the magnificent Umbrian landscape, you pass close to Assisi. Off the main road, there are intricate ramps leading to a wonder of religious fervor on top of a hill, a church commemorating St. Francis. On a good day and at a good hour, the church will not be crowded. It is a simple structure, so one can admire without distraction the magic of the light, space, and, above all, the frescoes. To me, Giotto, who decorated many of these walls, is perhaps the greatest of all painters. He managed a grandeur of scale, an extraordinary sense of tragedy mixed with sweetness, and an ability to translate the meaning of events through color and the movement of bodies and expression of the eyes. The castles and fortifications he painted combine childlike dreams with sober reality. These are the works of a true believer. Giotto covers the stone walls with prayers more tangible and more rich than any architect could conceive.

Daylight illuminates the paintings in the Upper Church, some of it from a great, high, massive door, half opened onto a pure green meadow. Absolutely unspoiled, without monument or ornament, the meadow is a giant carpet to receive in honor the animals beloved of the saint, and birds that might fly down and rest there. No other church I know has such a link with nature. Here you can stop, meditate, breathe in the mood of deep religious feeling. For me Assisi is the closest thing in Italy to the cathedral of Chartres in France. In both cases, there was a restraining hand.

The charm of driving through Italy is that there is delicious food next to the masterpieces. After visiting Assisi, my wife and I and a friend who was for many years our driver went on to a sort of farm restaurant that had the most refreshing wine and subtle—or maybe we were hungry—peasant food. —A.L.

*Three years before he died, St. Francis decided to celebrate the memory of the birth of the Child Jesus. . . . With the greatest possible solemnity . . . he had a crib prepared, with hay and an ox and an ass. The saint stood before the crib and his heart overflowed with tender compassion. . . . Then he preached to the people about the birth of the poor King, whom he called the Babe of Bethlehem in his tender love.*

—SAINT BONAVENTURE, *Legenda Maior*

During the thirteenth century, the small Umbrian hill town of Assisi, birthplace of Saint Francis (c. 1182–1226), became a pilgrimage center of great importance. Even before the revered monk's canonization in 1228, plans for a church to serve as his tomb were under way. The remains of Francis, who had renounced all his worldly possessions to embrace a life of poverty and penitence, would be enshrined in a huge double structure. The unique character of the building, which is essentially two churches, one constructed on top of the other, derives in part from its site, the lower tip of a steep hill, and in part from its function as both a crypt and a church intended to meet the needs of a new religious order that was drawing people of all economic and social stations. The plan of the building took the form of a tau cross, a symbol that was closely linked with Saint Francis. The broad, aisleless nave of the Upper Church is divided into bays by slender columns that are clustered into piers to create a uniform surface that underlines the massiveness of the walls. The marble throne that dominates the apse reminds us that it was intended to be used as a papal chapel. Since the church had to accommodate large groups of people who were drawn to the vivid and accessible sermons of Franciscan preachers, the area between the apse and the nave is particularly spacious.

Between the thirteenth and fourteenth centuries, many of Italy's foremost painters, including Cimabue, Giotto, Simone Martini, and Pietro Lorenzetti were engaged in the decoration of the Upper and Lower Churches. The walls of the nave of the Upper Church contain frescoes depicting traditional stories from the Old and New Testaments as well as twenty-eight scenes that record major episodes from the life of Saint Francis. Scholars disagree about the authorship of the frescoes: some have suggested that they are the youthful work of Giotto and date them between 1296 and 1301, whereas others believe that they may have been painted by a later follower of the artist or by a series of masters. Whether by Giotto or not, the style of the frescoes seems admirably suited to their didactic purpose. Lively naturalistic details are placed in a space inhabited by solid forms. A particularly touching episode depicts the creation of the first crèche in the church of Greccio, a village southwest of Assisi. As Saint Francis reverently places a statue of the holy babe in a simple wooden crib next to the ox and ass who traditionally were present at his birth, the attention of the spectators—townsmen, women excluded from the sanctuary, and the celebrant of the mass—is riveted on his action. —D.K.

Detail of *The Crib at Greccio*, one of twenty-eight frescoes devoted to the life of St. Francis in the Upper Church at Assisi. The artist may have been Giotto or one of the other masters who worked on the cycle between 1296 and 1301.

*Following page: St. Francis Casting Out the Devils of Arezzo.*

*Opposite following page:* The simple façade of the Upper Church, with symbols of the Four Evangelists framing a small rose window.

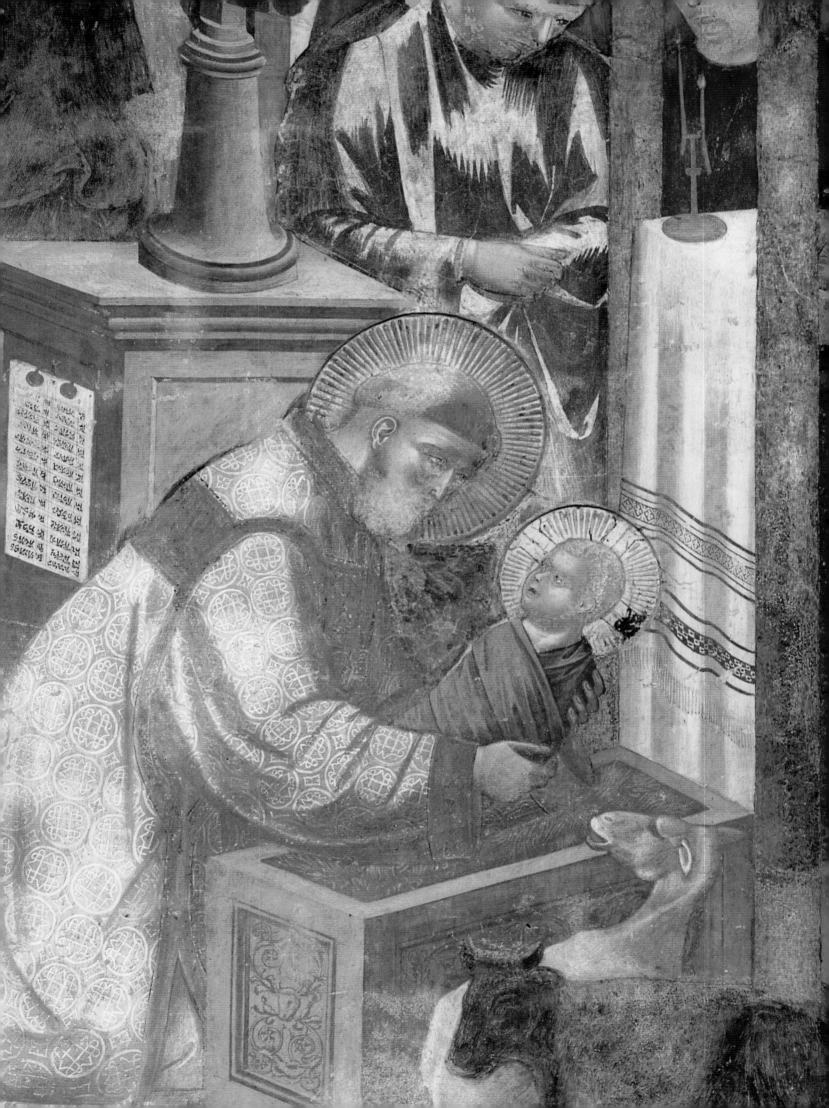

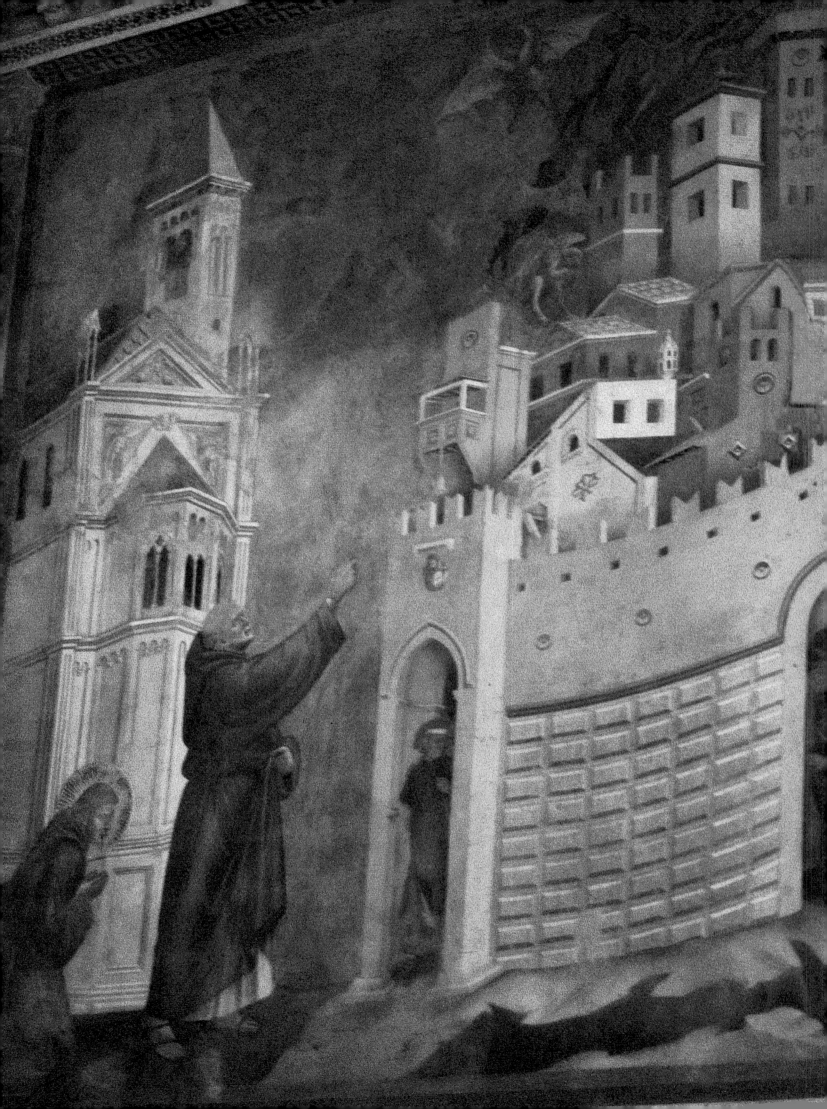

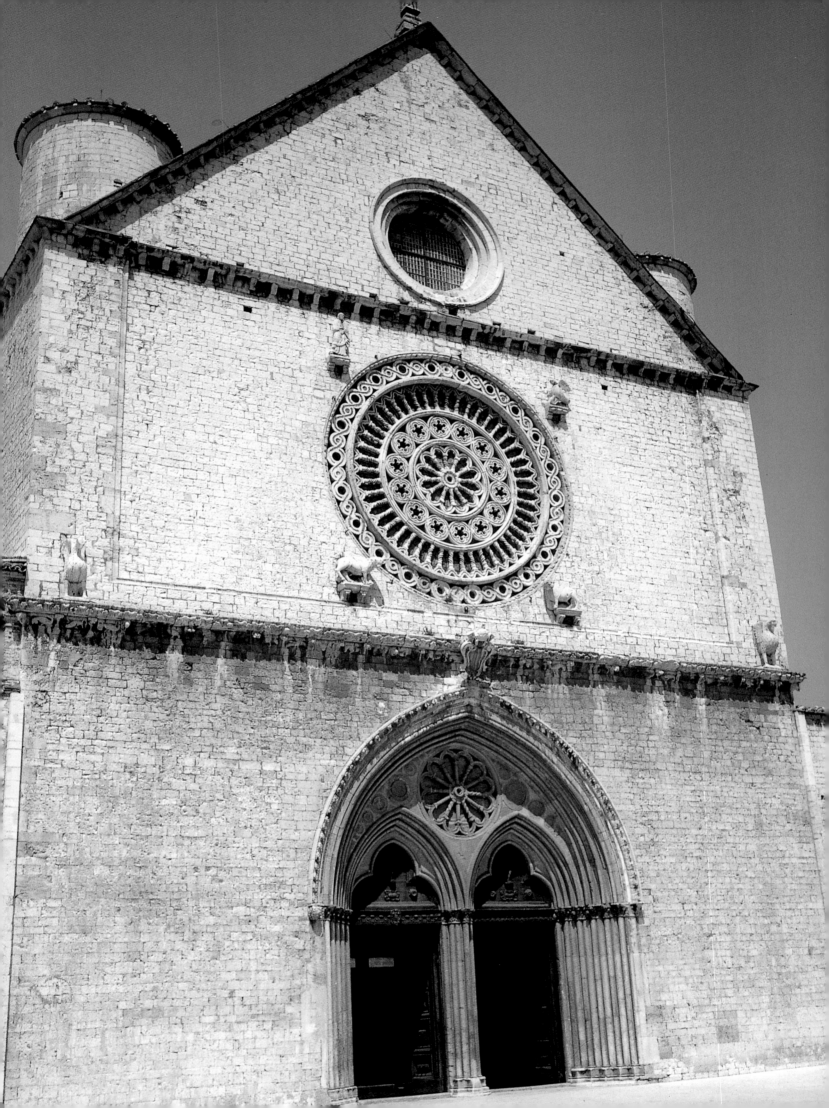

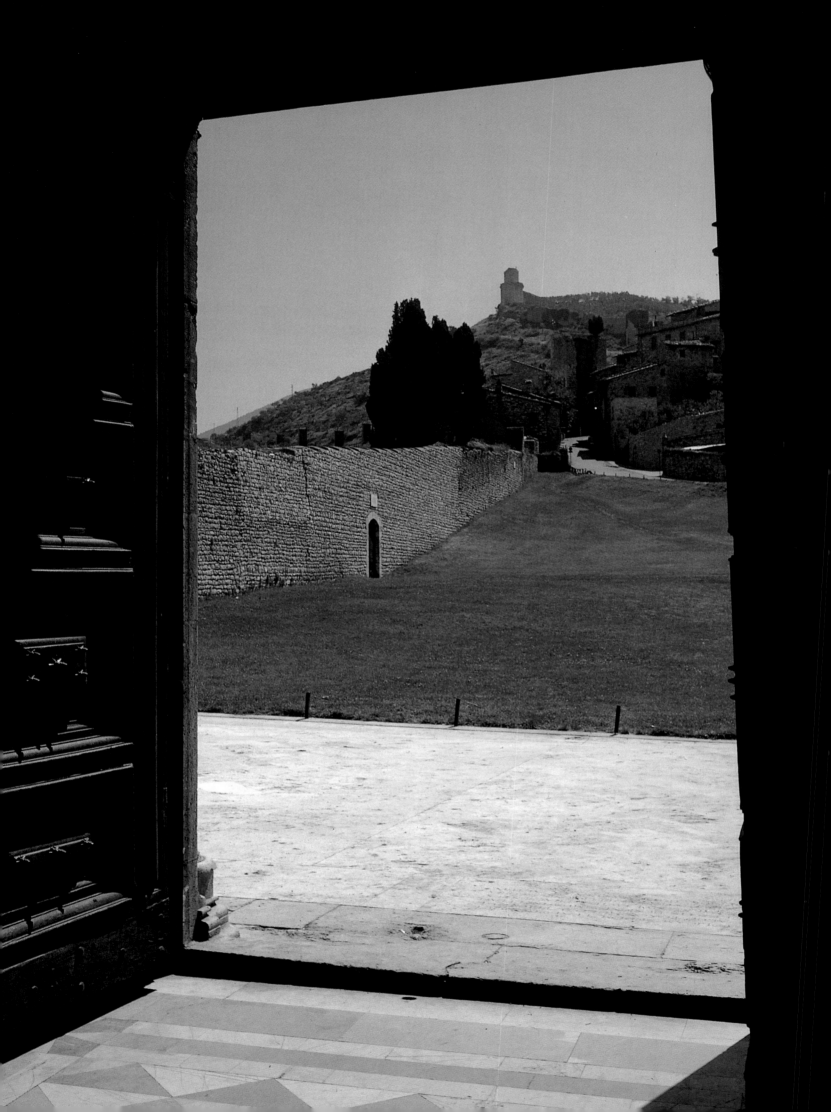

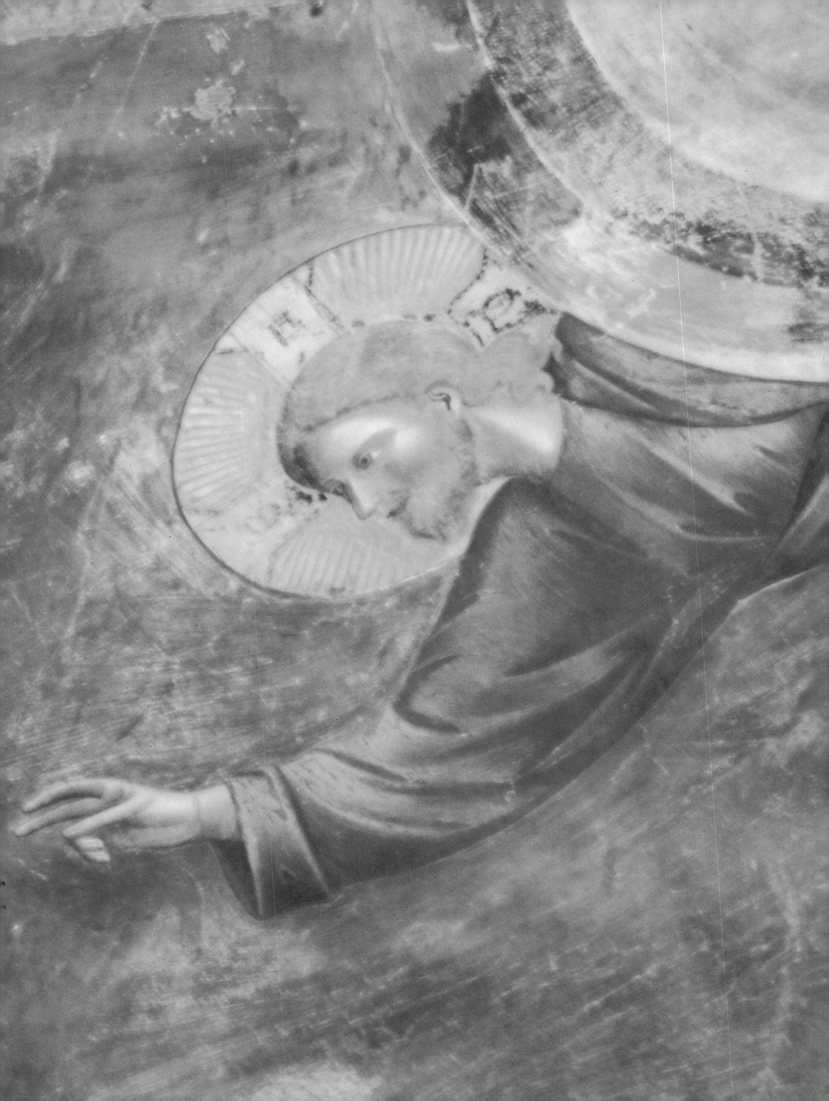

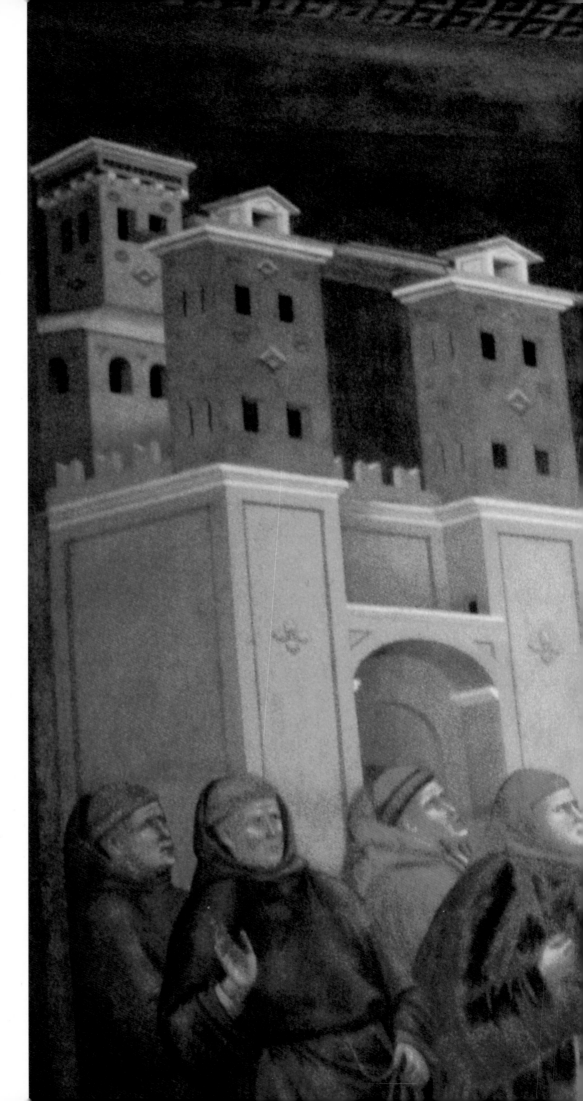

*The Apotheosis of St. Francis.*

*Opposite preceding page:*
View of the Rocca
Maggiore, Assisi's medieval
citadel, from the doorway
of the Upper Church.

*Preceding page:*
Detail of Christ from
*The Apotheosis of St. Francis.*

*Following pages:*
Courtyard of the fifteenth-
century cloister adjoining
the apse of the basilica
of the Upper Church.

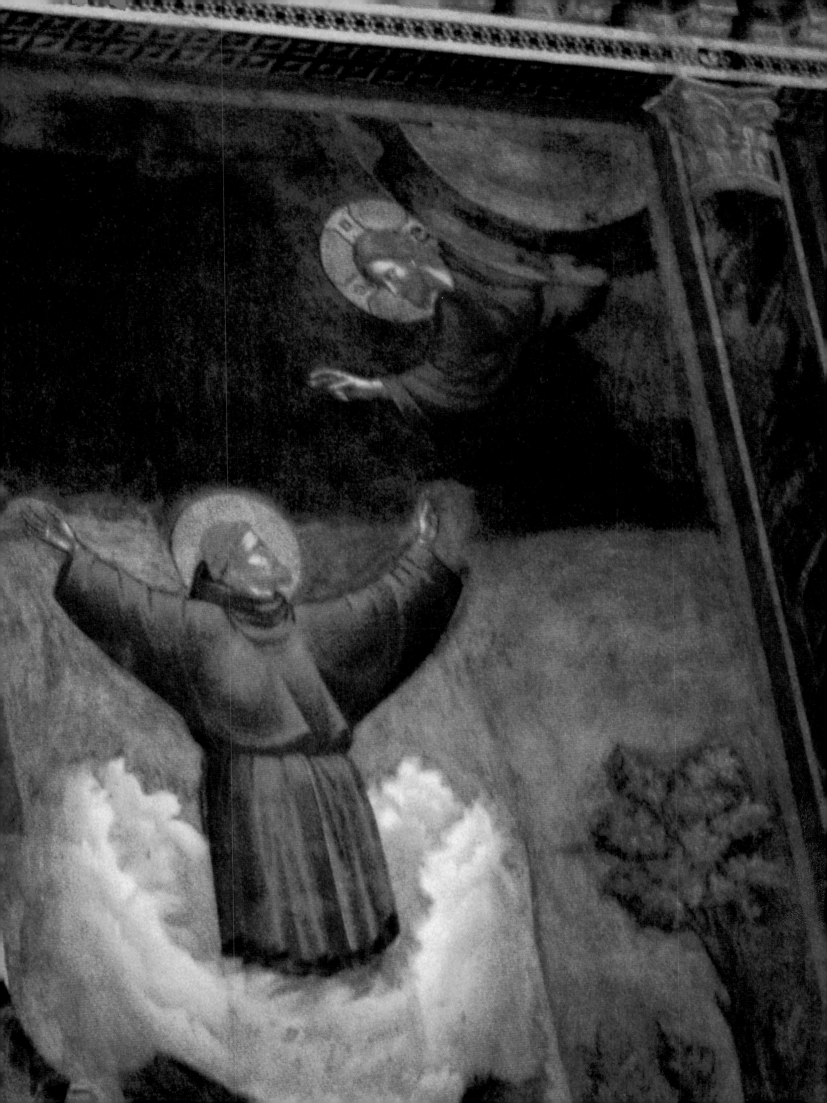

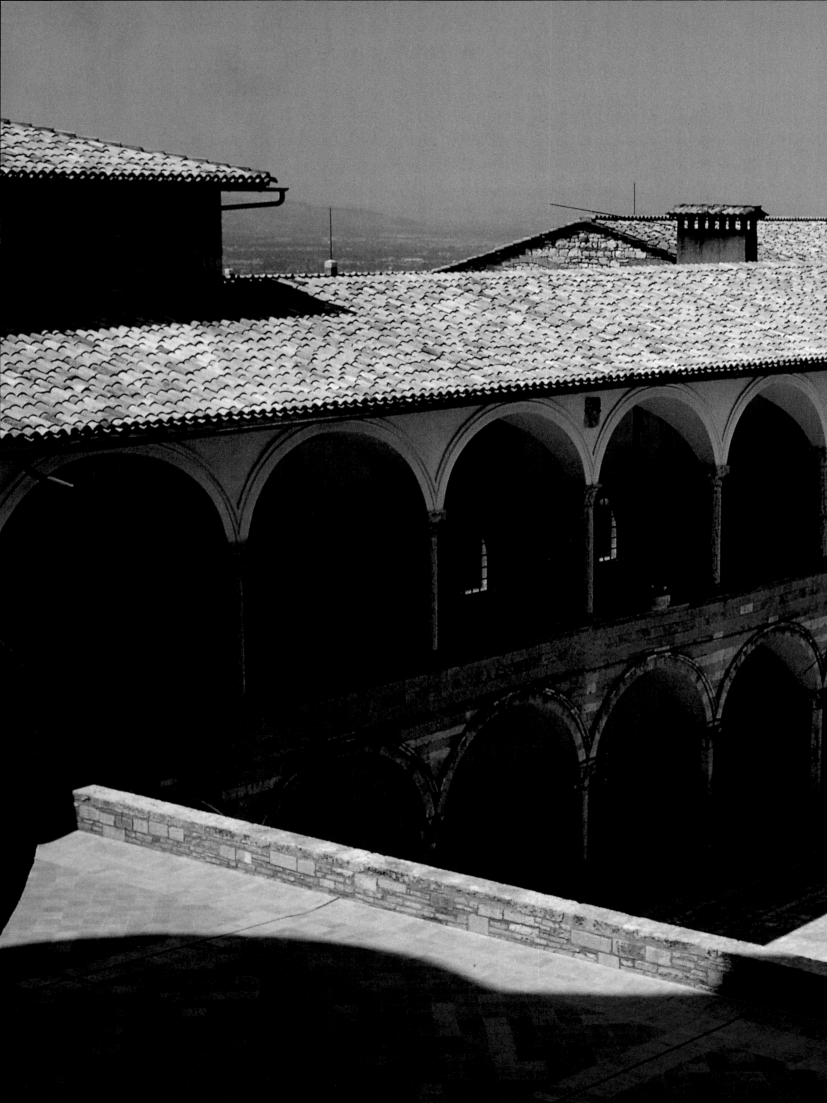

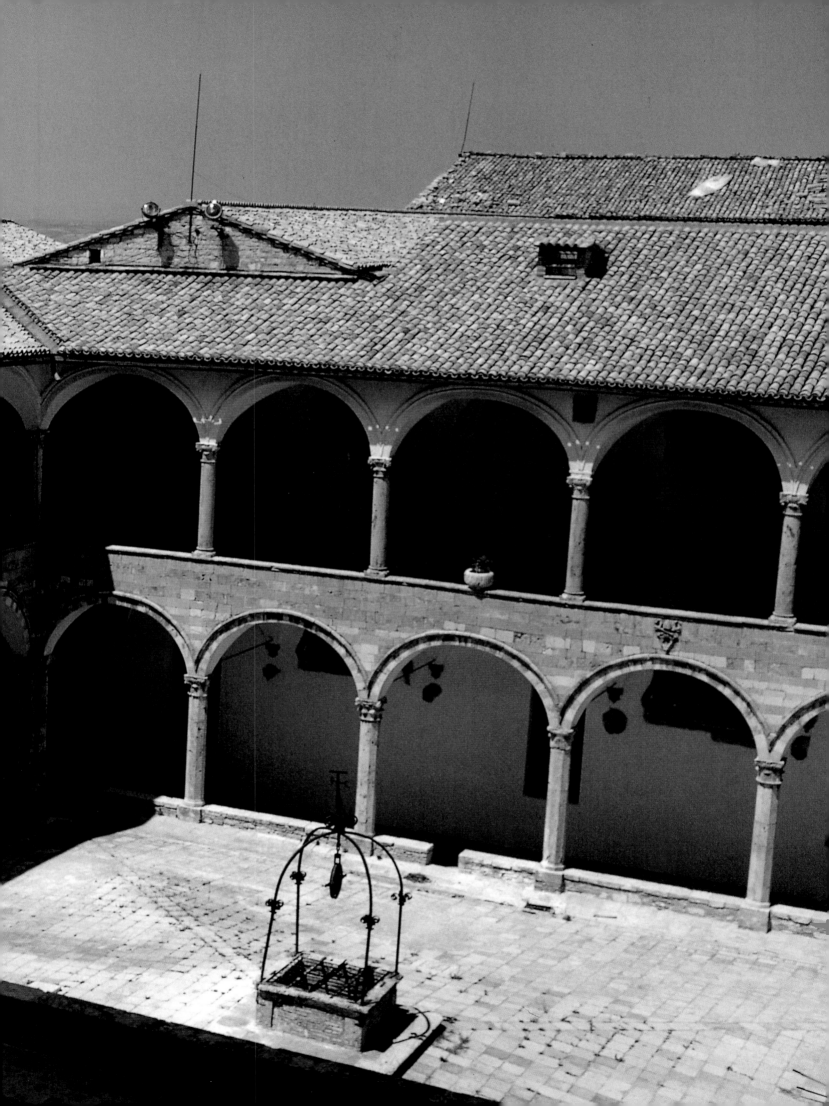

# St. Peter's Basilica

Rome has been dominated since the Renaissance by the magnificent architecture of St. Peter's. The cathedral and its piazza are meant to be the center of Christianity, and to encompass the hundreds of thousands of worshipers that flock here whenever the pope is giving a blessing. The Church is truly triumphant in this place. It is an overwhelming ecclesiastical monument, conceived by its architects and decorators on the grandest imaginable scale, with every pope contributing some touch to its magnificence. The Bernini colonnade that surrounds the piazza in front is itself an extraordinary architectural treasure. And the greatest artist and architect of his time, Michelangelo, was called upon to design the majestic dome that commands the edifice and the whole city. That Michelangelo's grand concept could be realized in that age is a miracle.

It is the interior of the dome that truly dazzles. You walk through the majestic basilica and suddenly there is an explosion of glory. Light falls on the altar below the dome, where Bernini's amazing

*(continued from preceding page)* baldacchino provides fireworks of twisted columns, sunbursts, draperies, bronze, and gold. Frankly, you can forget about meditation here. With all its luster, space, and magic, St. Peter's is not conducive to private worship. The aura of power intrudes on the humility that one should feel before one's God. This is a triumphant, victorious edifice, where one can sink into rapture. St. Peter's celebrates power and glory, and each believer who enters is enrolled in this celebration. Still, when I walk along the Tiber toward St. Peter's I am drawn to the distant silhouette of what was intended as a symbol of faith.

Beyond this splendor there is an island of religious fervor in the Vatican Palace: the Sistine Chapel, also the creation of Michelangelo, who spent years lying on his back to paint the sublime frescos on the ceiling. It is here that I find meditative relief from the vast and overgilded glories of the great church. And in the incredible, tormented vision of the Last Judgment in the painting over the altar, Michelangelo rivals the heroism of his stone. —A.L.

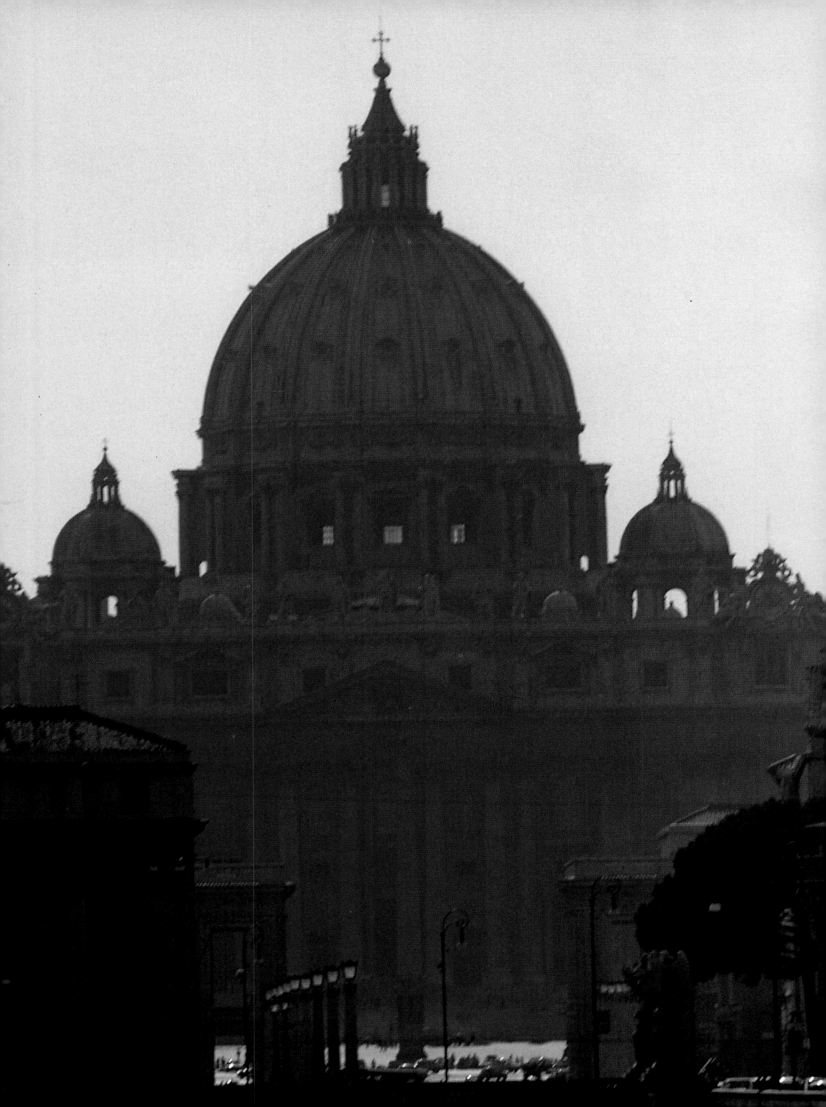

*At last Julius II appeared on the pontifical throne. This pope had a genius for great things. He decided to finish St. Peter's; he knew men, and chose the plan of the famous Bramante Lazzari; he told him to try to make the most beautiful thing in the world and not to think about expense.*

—STENDHAL, *A Roman Journal*, 1829

The magnificent Basilica of St. Peter is linked historically with the cultural and political ambitions of the great della Rovere pope, Julius II, who laid its cornerstone on April 18, 1506. However, the original impulse to create a symbolic structure worthy of the center of Christianity must be credited to Pope Nicholas V (1447–55). It was Nicholas who made the fateful decision to transfer the papal residence from the Lateran Palace, where it had been located for a thousand years, to the Vatican Palace on the opposite side of the Tiber. Nicholas also planned the renovation and expansion of the fourth-century Church of St. Peter, site of the apostle's tomb and papal coronations.

Julius II considered reconstructing the badly deteriorated old church but decided instead to demolish it and replace it with a colossal structure that would convey his grand vision of a militant papacy. He entrusted the design to Donato Bramante, who had been engaged since 1504 in transforming the medieval Vatican Palace into a more splendid edifice. Bramante produced several floor plans, the most striking of which combined a Greek cross surmounted by an enormous dome, a formula that had come to symbolize divine perfection during the Renaissance. The deaths of Julius and Bramante in 1513 and 1514 called a temporary halt to the construction of St. Peter's, but Bramante's inspired plan would remain the point of reference for subsequent papal architects, including Raphael, Baldassare Peruzzi, and Antonio da Sangallo. In 1546, the seventy-one-year-old Michelangelo returned to Bramante's initial conception, providing a dynamic Greek-cross plan surrounded by a barrel-vaulted and squared ambulatory with four small domes at the corners. Michelangelo designed a majestic hemispherical dome to rise above the crossing, with massive walls and piers to provide support. Never before had interior space been so clearly articulated by the exterior, nor the relationship between heaven and earth so exquisitely symbolized in geometric forms.

At Michelangelo's death in 1564, only the drum of the great dome had been built; its completion was supervised by his associate Giacomo della Porta, who maintained the basic design but gave it a somewhat taller profile in relation to the rest of the structure. Michelangelo's plans for the nave and entrance portico were never executed. The Church's liturgical priorities and its concern with accommodating increasing *(continued on page 143)*

The dome and lantern of St. Peter's Basilica, designed by Michelangelo but erected by Giacomo della Porta between 1564 and 1590.

*Preceding page:* Long view of St. Peter's, with Bernini's sculptures on the Ponte Sant'Angelo in the foreground.

*Following page:* Interior of the colonnade of St. Peter's Square, which was conceived and executed by Gianlorenzo Bernini between 1656 and 1667.

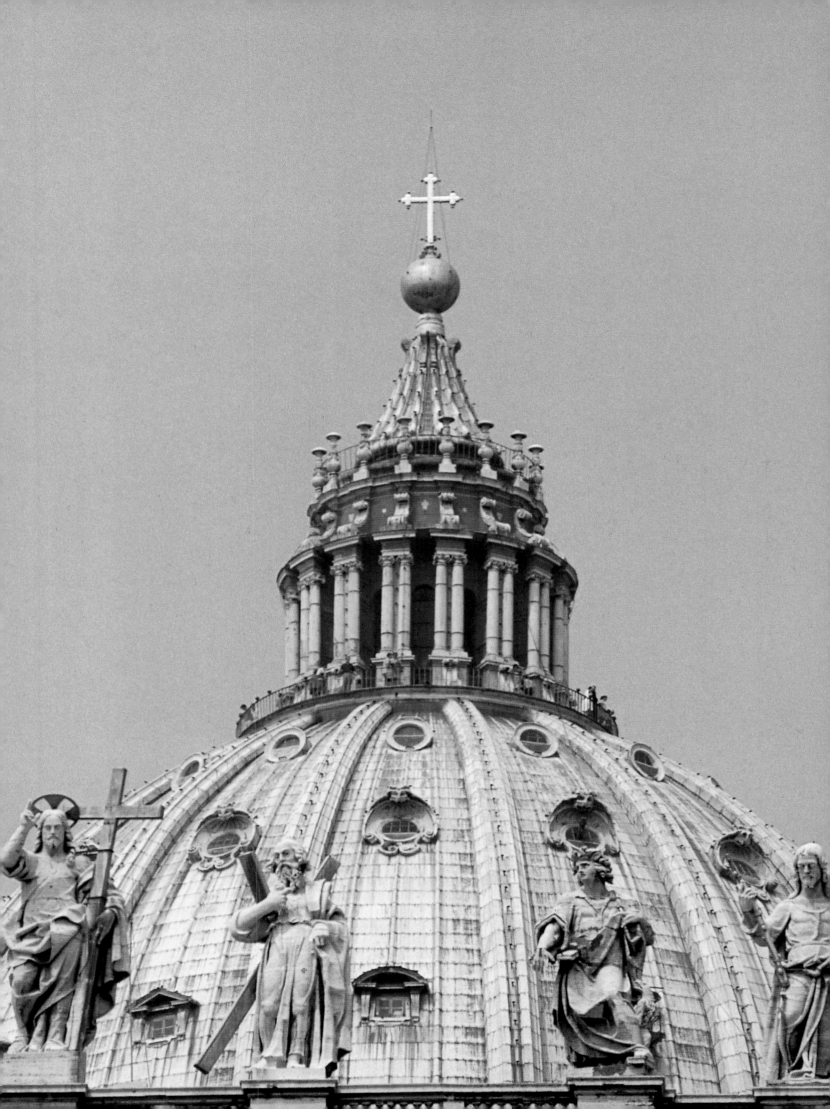

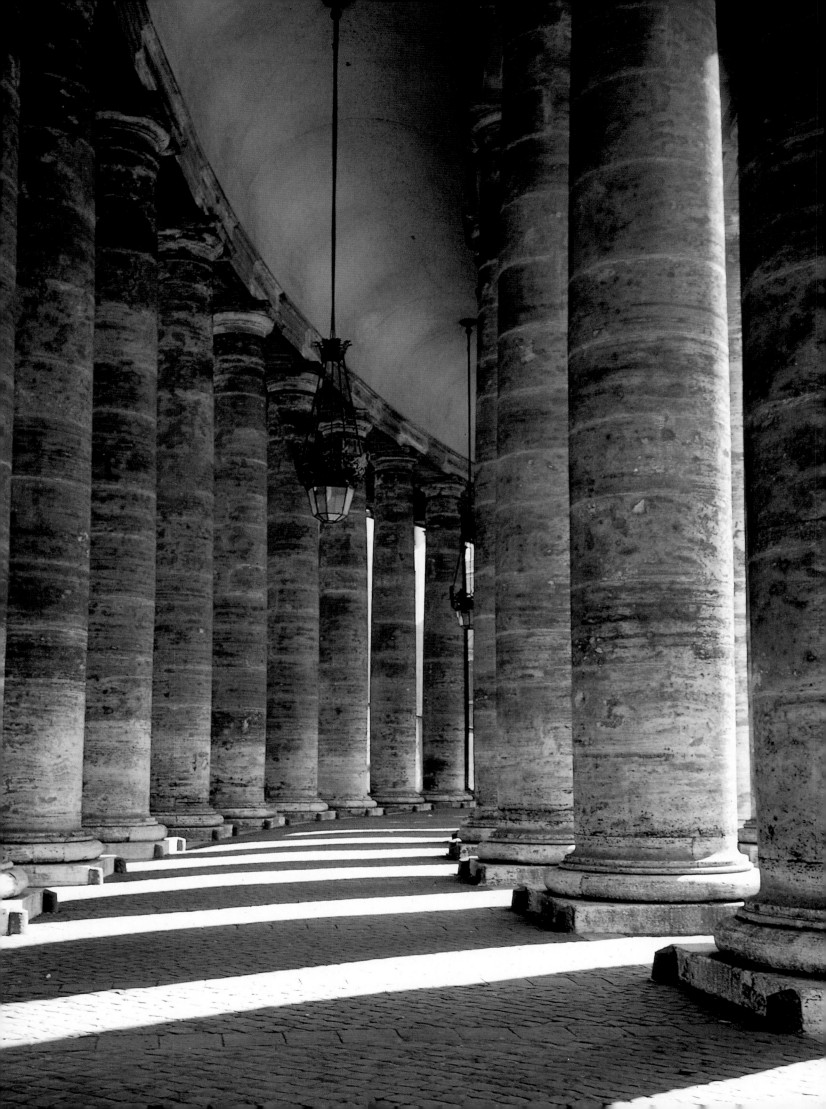

(continued from page 140) numbers of the faithful dictated the changes enacted by Carlo Maderno (1603–29), who abandoned the Greek-cross plan, extended the nave some two hundred feet, and reintroduced the Latin-cross plan that had been proposed by Raphael. Maderno also designed the façade, with its elaborate stagelike portico and prominent benediction loggia.

In 1623, the newly elected Urban VIII gave an audience to the young but justly celebrated sculptor Gian Lorenzo Bernini during which he was reported to have said, "It is your great fortune, Cavaliere, to see as pope Cardinal Maffeo Barberini. But much more is it ours that the Cavalier Bernini lives in our pontificate." Over the next forty years, Michelangelo's great contribution to St. Peter's would be equaled, and in the view of many, surpassed, by Bernini's stunning achievements as a sculptor and architect. His first commission in 1624 was to create a baldacchino, or canopy, to cover the high altar above the apostle's tomb. This was a daunting test of Bernini's creative genius, but one that he faced with enthusiasm. Rising to a height of ninety-five feet, his gilded bronze monument is a dazzling fusion of architecture and sculpture. The design of the spiral columns was inspired by the twisted columns of the old St. Peter's, which were believed to have been brought from Solomon's Temple in Jerusalem to Rome. On top of the four columns he placed shimmering angels. Just below, putti display the symbols of papal power. If the baldacchino functions as a symbol of the regenerated Church of the Counter-Reformation and as a reminder of its early history, it also serves as a monument to the pope who commissioned it. Virtually its entire surface is decorated with bees, suns, and vines, heraldic emblems of the Barberini family.

Bernini's presence resonates throughout the interior of St. Peter's: he redesigned Michelangelo's piers under the dome and introduced niches for colossal marble statues. He created an extraordinarily complex ensemble of bronze, gilded stone, polychrome marble, stucco, and stained glass to surround the *Cathedra Petri,* the symbolic throne of the Vicar of Christ and his successors, and he provided Popes Urban VIII and Alexander VII with magnificent tombs. Bernini succeeded both in unifying the interior of the vast basilica and in affirming its symbolic and ceremonial character as a sacred theater. Yet there are those who would argue that his greatest achievement, and the truest measure of his genius for orchestrating space, was his integration of the basilica's façade with its surrounding square. In 1656, he began to clear away the various buildings that were scattered around the irregular area in front of St. Peter's to prepare for an approach that would be worthy of the grandeur of the architecture and accommodate the large crowds that gathered for the papal benedictions given on Easter Sunday and other solemn occasions. Seeking to modify the excessive width of Maderno's façade, he designed two arms that form a trapezoid opening into a vast oval space. The colonnade that encloses it consists of four rows of simple Tuscan columns, crowned by a plain Ionic entablature, and surmounted by a balustrade on which stand one hundred and forty marble figures of saints. Arriving in the stately piazza, with its towering obelisk and flanking fountains, pilgrims and tourists are immediately enveloped in an atmosphere of ceremonial grandeur. Bernini pointedly likened his colonnade to the maternal arms of the Church, "which embrace Catholics to confirm their belief, heretics to reunite them with [her], and unbelievers to enlighten them with the true faith." —D.K.

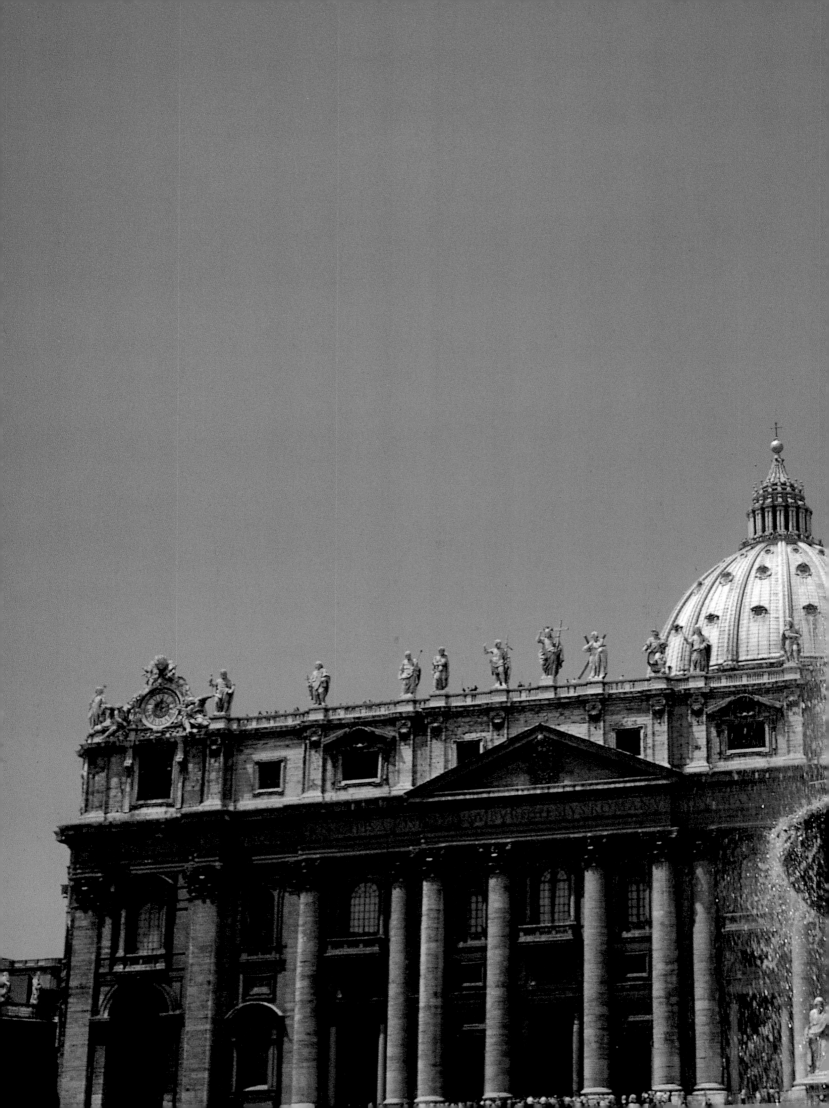

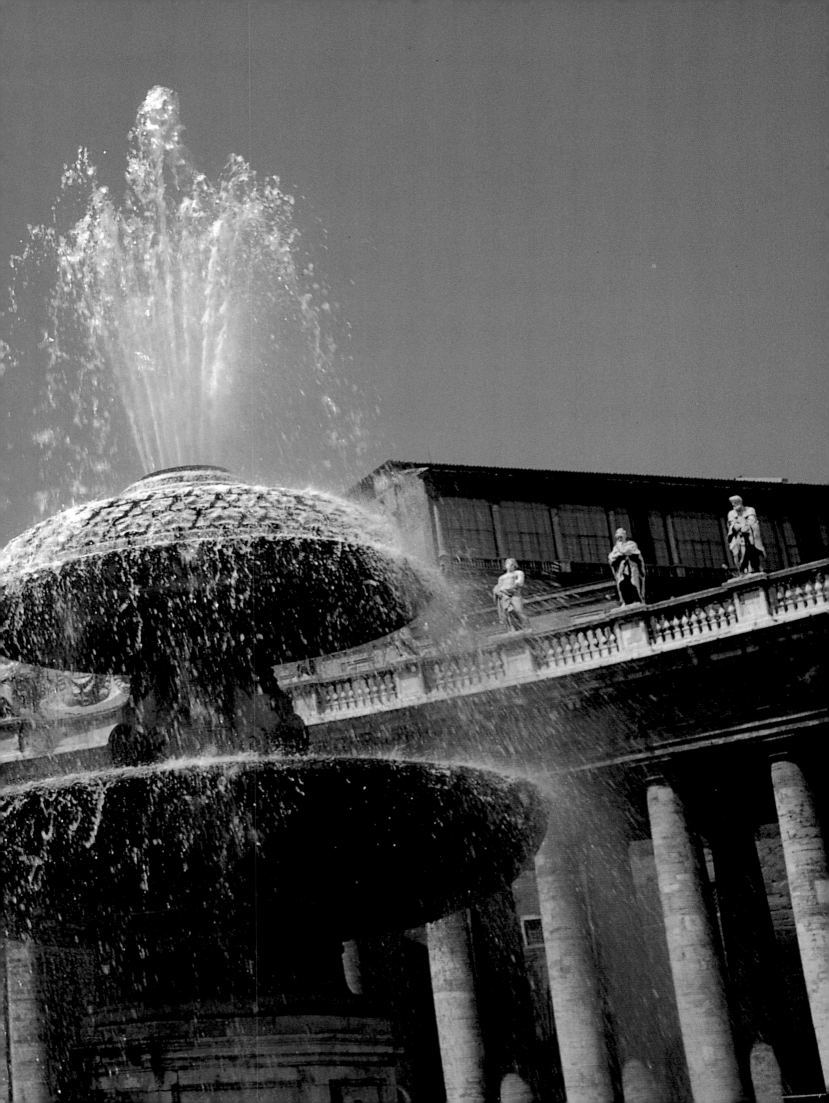

Marble and bronze sculptures of St. John the Baptist, Christ, and St. Andrew on the balustrade of the portico.

*Preceding pages:* Panoramic view of the façade and a section of Bernini's colonnade.

*Following pages:* Bernini designed the baldacchino, or canopy, over the altar above the Tomb of St. Peter. Angels hover on top of gilded bronze columns, and the heraldic emblems of the family of Pope Urban VIII cover the surface.

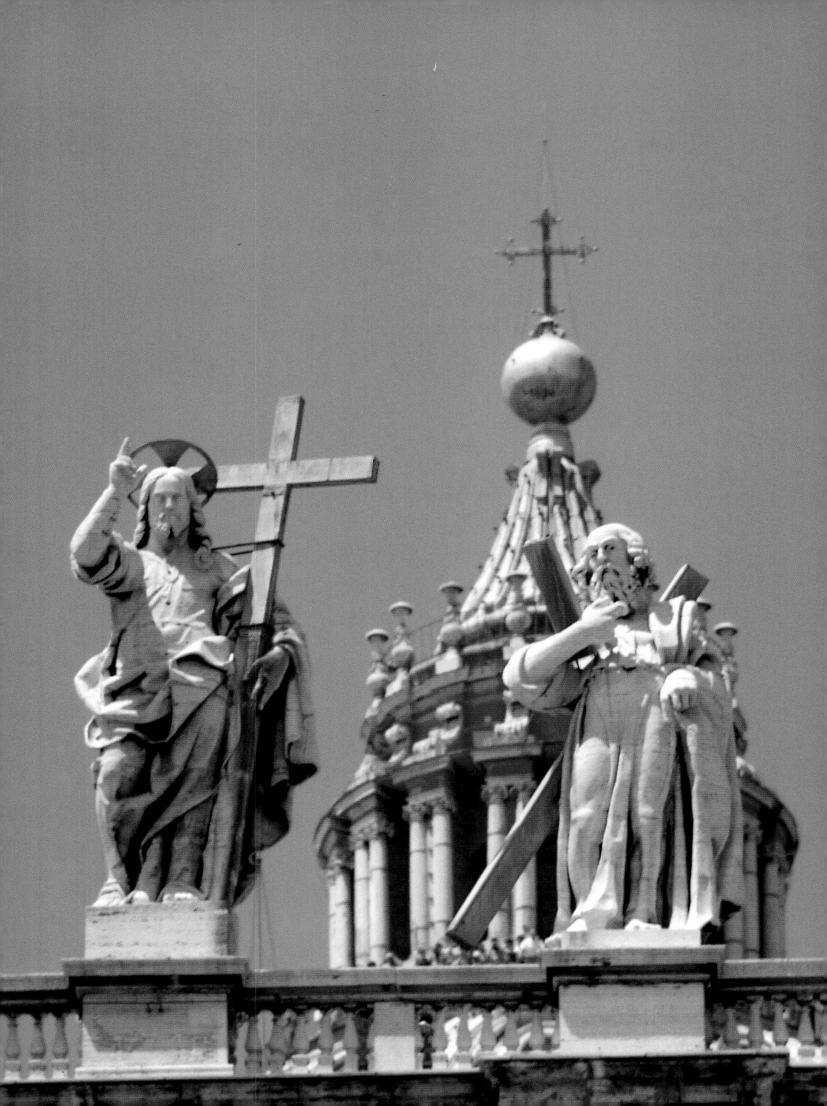

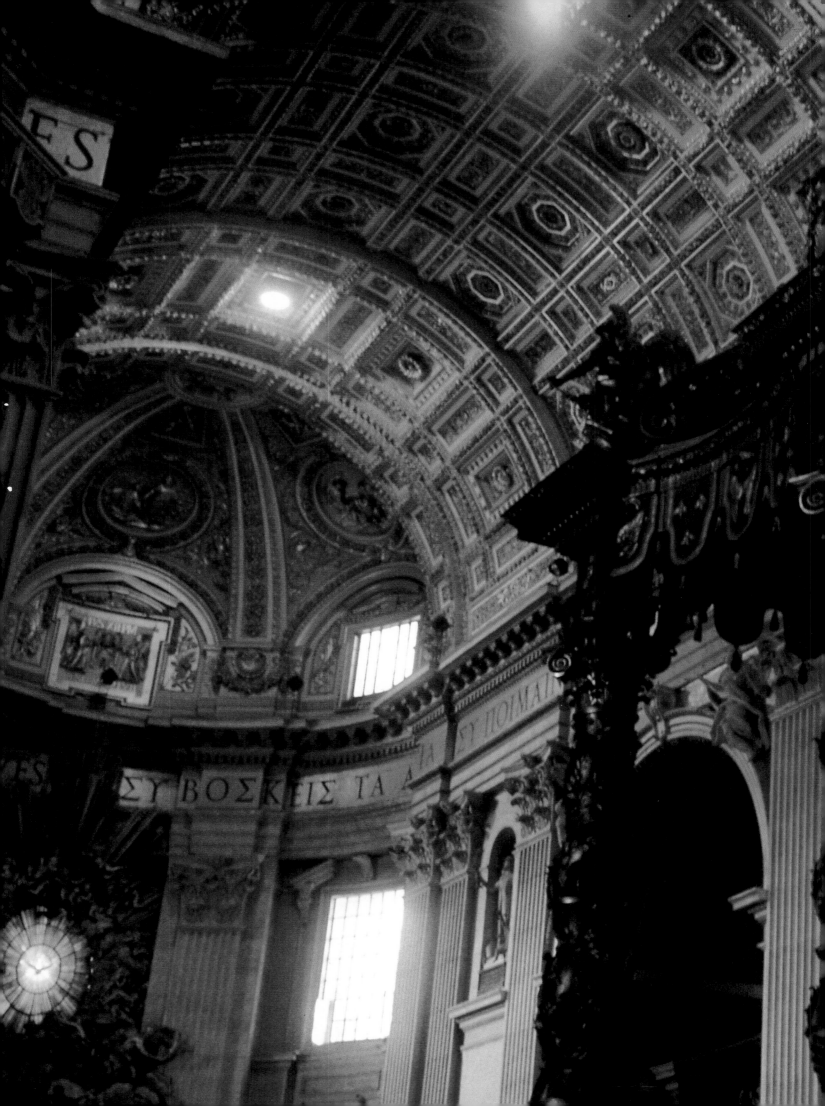

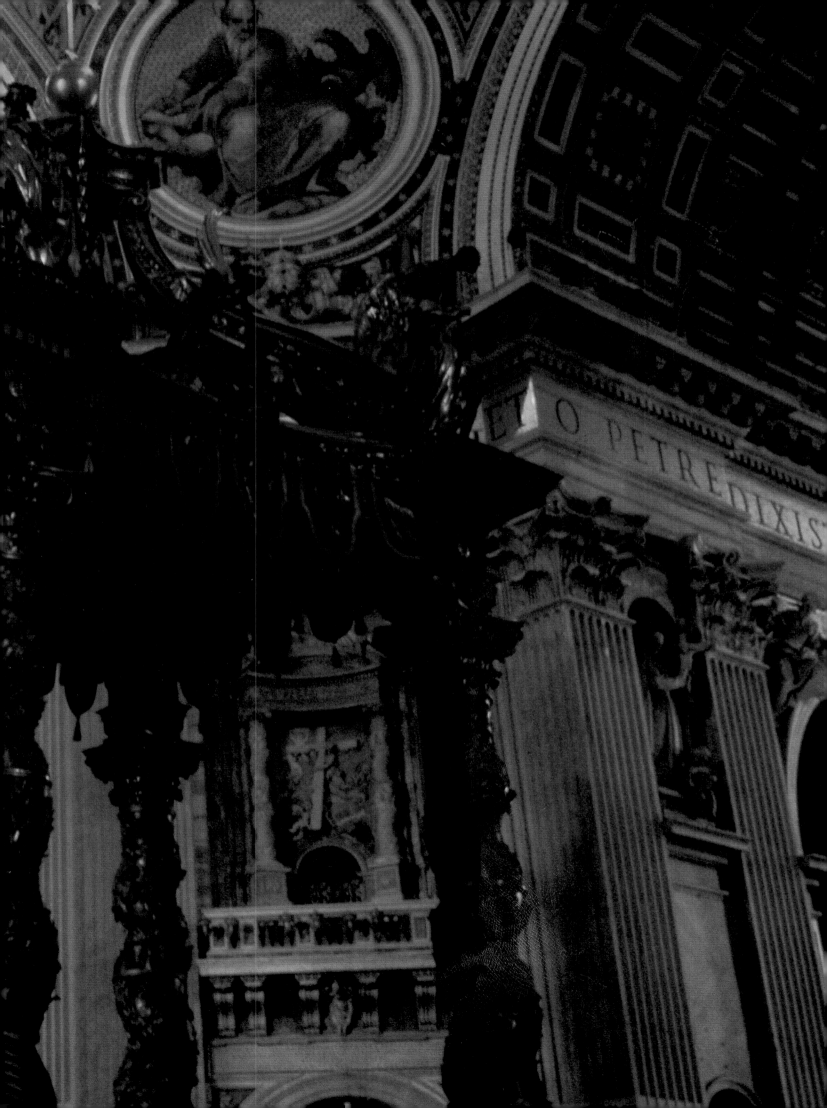

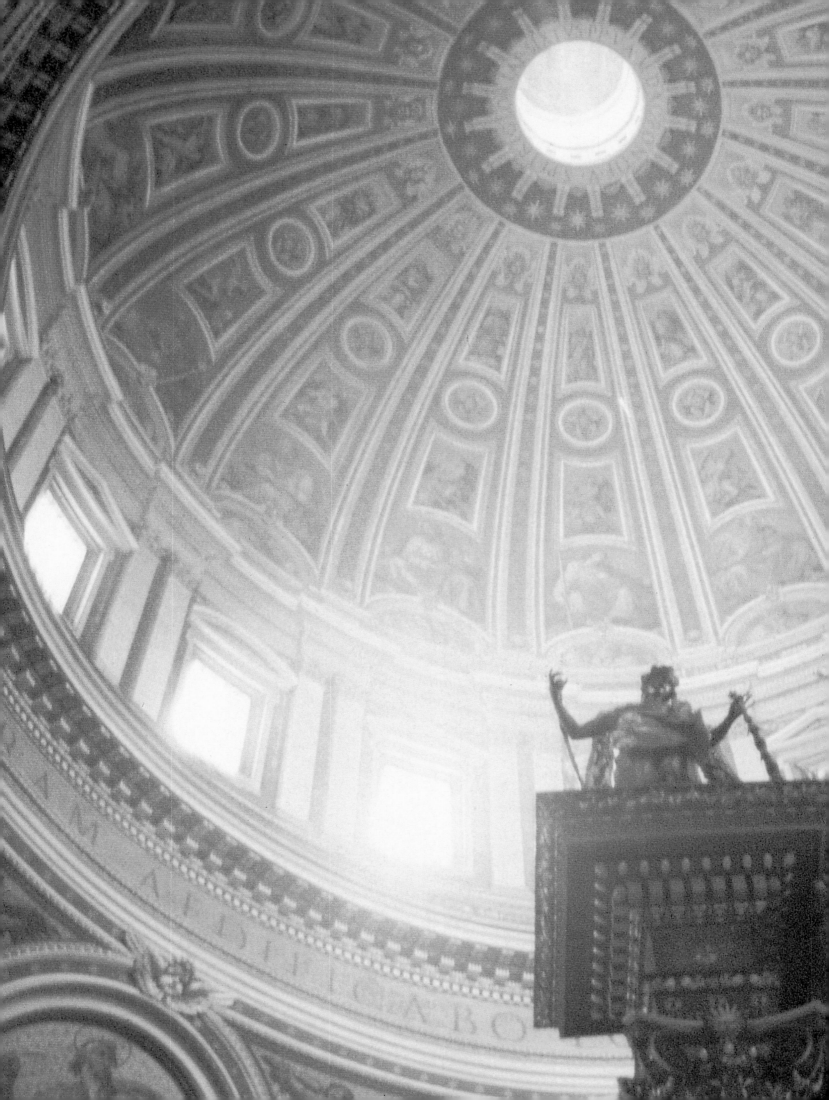

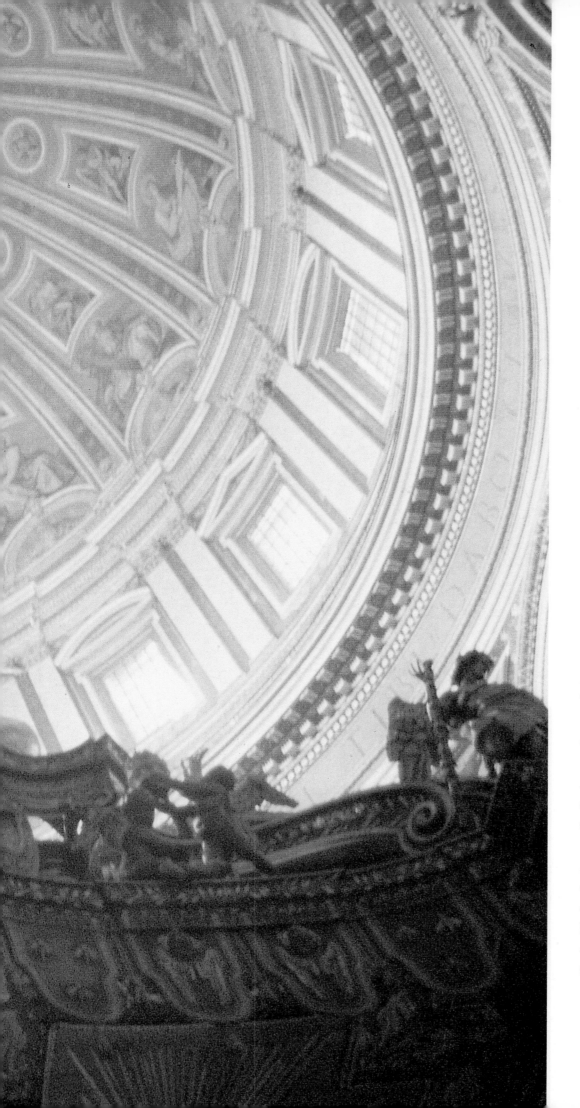

The dome of St. Peter's,
seen from the base
of the baldacchino.

*Preceding pages:* Close-up
of the baldacchino's
spiral columns.

*Following pages:* The nave
of St. Peter's, which is
over two hundred feet in
length, leads up to the tomb
of the apostle, covered by
the baldacchino.

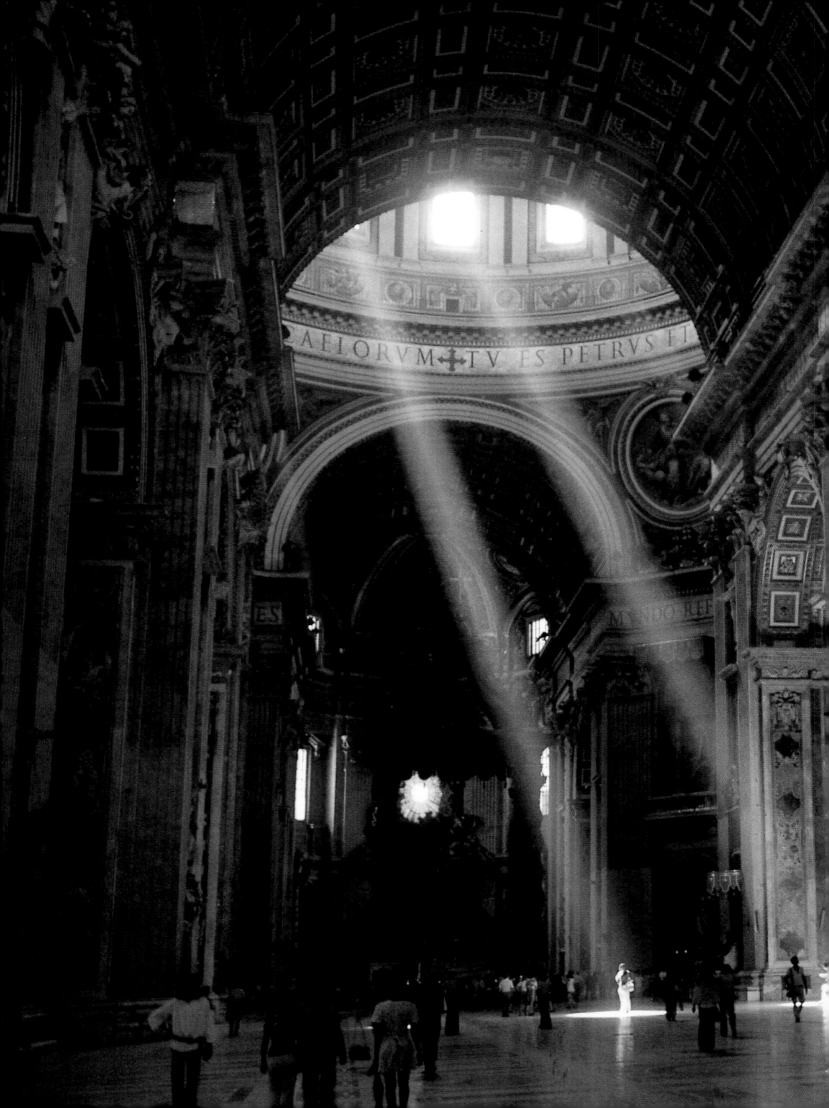

# The Duomo in Orvieto

We were on our way to visit friends in Todi when we discovered the extraordinary cathedral in Orvieto. Among the many treasures here are bronze figures on the façade of such vitality that they seem to spring right out from the walls. The bull and other monsters of the *Apocalypse*, and, over the central portal, the *Nativity of Christ* sheltered by a magnificent baldacchino—these sculptures seem to me as modern as any work by any sculptor in my time. Their glory is so striking that it dominates the whole cathedral. In contrast to the façade, the rest of the exterior is covered in parallel and alternating bands of black basalt and pale travertine. It is an unusual and curiously delicate marvel of stonework. Inside the cathedral, the fresco of the Last Judgment by Luca Signorelli in the small chapel is unforgettable. The torment of the half-buried bodies is terrifying. Orvieto is a treasure, not as visited by tourists as it should be. —A.L.

The façade of the
cathedral of Orvieto
was begun in 1290
and completed c. 1600.

*Following page:*
White travertine and
gray basalt create
horizontal bands on
the exterior walls.

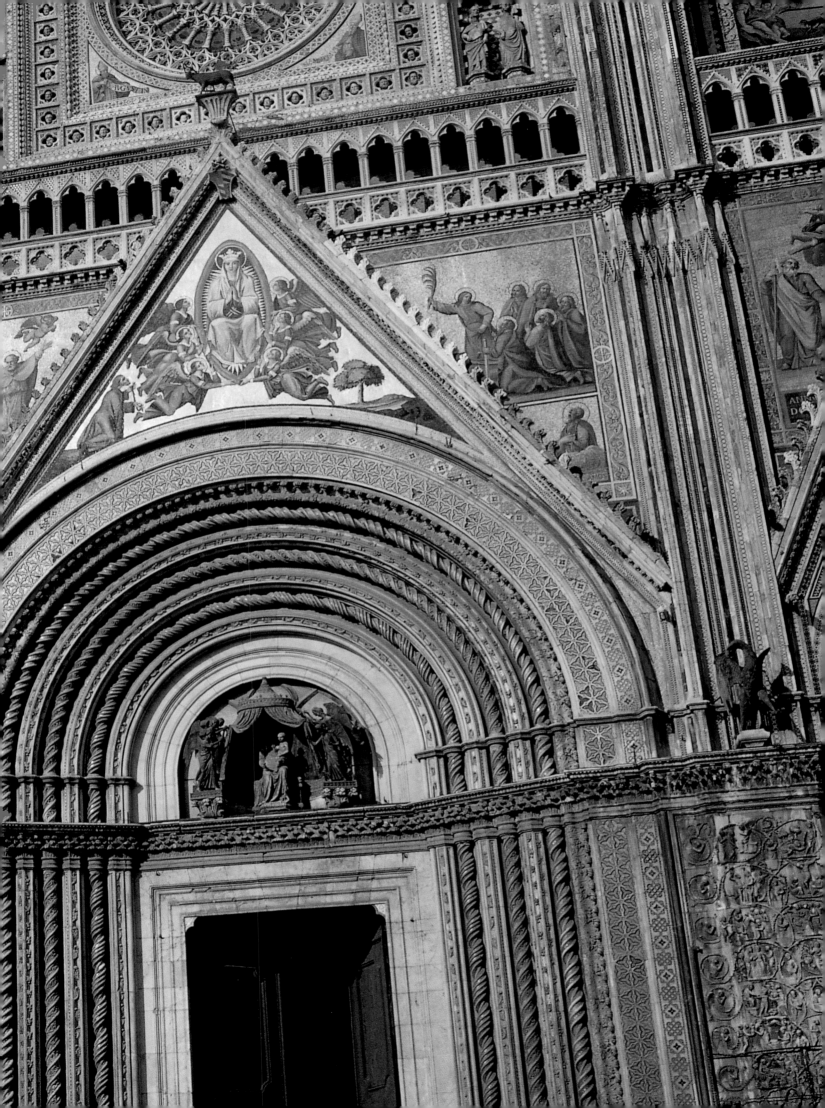

*I am the true vine and my Father is the gardener. He cuts off every branch in me that bears no fruit, while every branch that does bear fruit he trims clean so that it will be even more fruitful. You are already clean because of the words I have spoken to you. Remain in me and I will remain in you. No branch can bear fruit by itself, it must remain in the vine. Neither can you bear fruit unless you remain in me.*

—JOHN 15:1

Set on a high plateau overlooking vineyards and fields of sunflowers, the small city of Orvieto traces its roots to the seventh century B.C. when it was founded by the Etruscans. Visible for miles, its rugged profile is dominated by one of the most impressive cathedrals in Italy, a remarkable synthesis of late Romanesque and Gothic elements. The origin of this immense structure is linked with a miraculous occurrence in a church in nearby Bolsena. During the celebration of mass, a consecrated host began to drip blood on the altar cloth. In 1264, Pope Urban IV, who was temporarily residing in Orvieto, proclaimed the feast of Corpus Christi, acknowledging the validity of the miracle and ordering the construction of a church to house the bloody altar cloth.

The early building history of the cathedral is barely documented, although it is believed to have begun in 1290. It is known that the Sienese sculptor and architect Lorenzo Maitani was appointed its *capomaestro* (chief master) in 1310, and that he worked there until his death in 1330. Maitani is usually credited with supervising the construction of the walls of the spacious nave and the timbered roof, and with designing the ornate, three-gabled façade, which resembles that of Siena's cathedral. He also is regarded as the principal sculptor responsible for the four great marble reliefs that flank the entrance portals with subjects drawn from the Book of Genesis, the Tree of Jesse, the Life of Christ, and the Last Judgment. Work on these narrative scenes proceeded from the bottom, and some of the upper portions of the panels remain unfinished. Initially, Maitani and his collaborators composed their scenes in continuous strips similar to the arrangement found in the second-century columns of Trajan and Marcus Aurelius, but in the second register the artists introduced a huge vine motif in the center of each panel. The branches impose a decorative symmetry and also separate the individual components of the narrative. These shallow reliefs abound in lively details, and the delicate but highly expressive carving of bodies and faces reflects the increasing naturalism of early fourteenth-century religious art. —D.K.

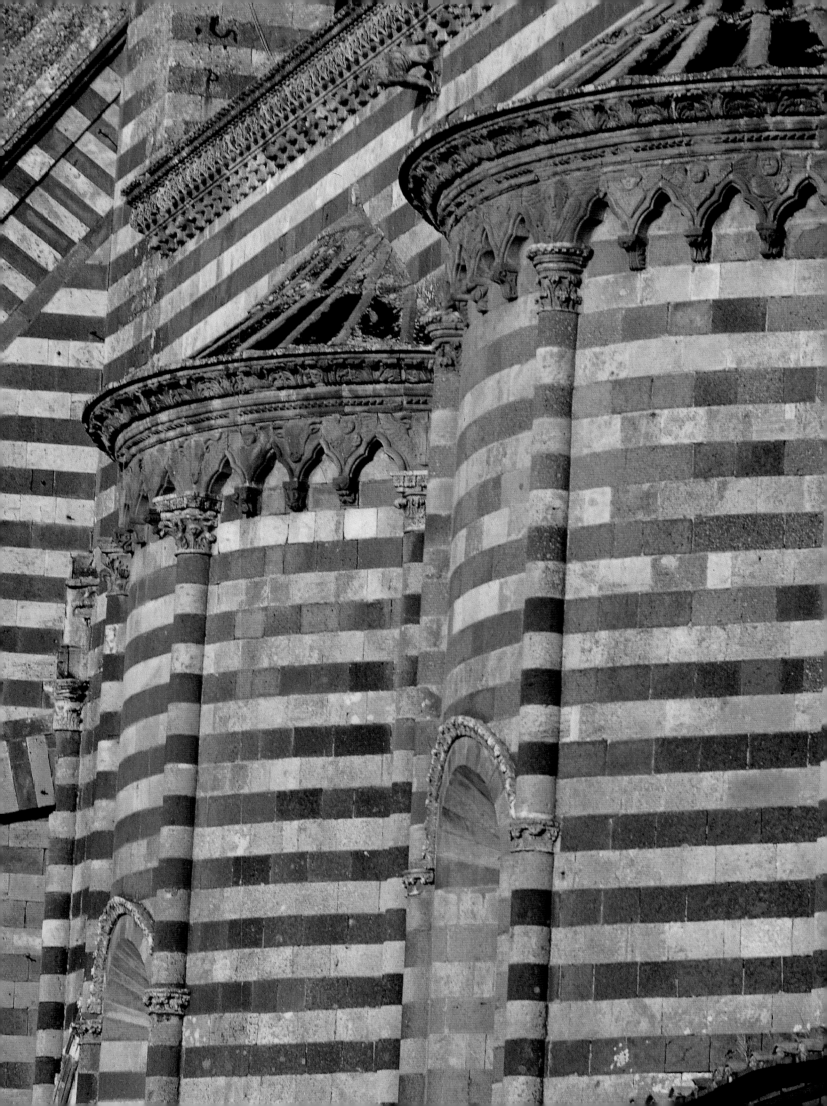

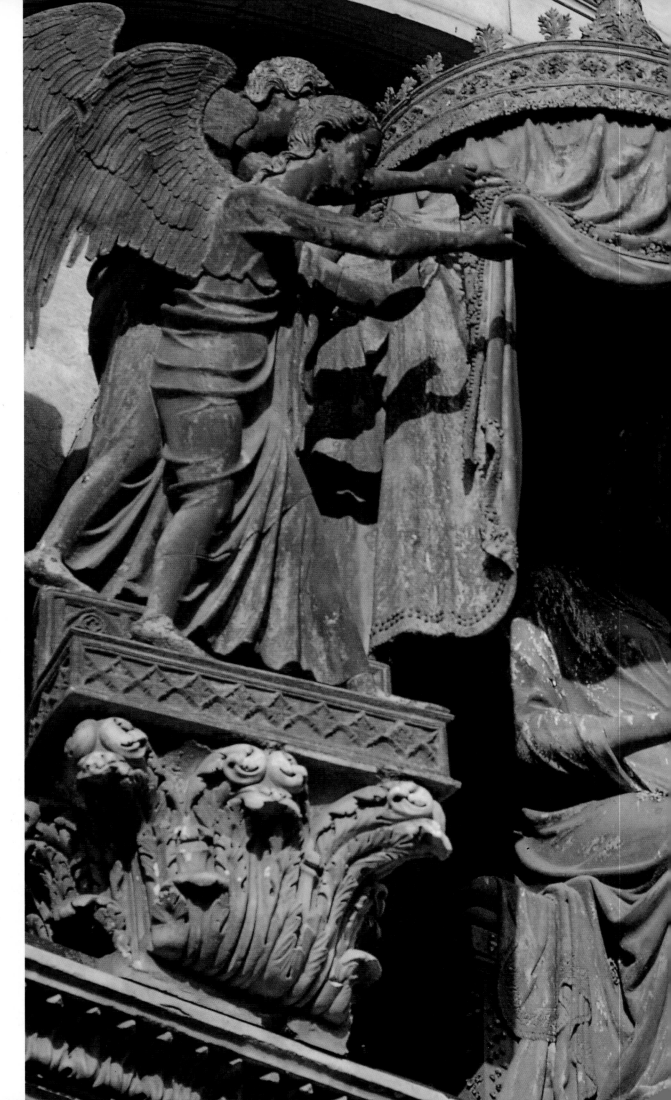

A bronze group of the enthroned Virgin and Child with Angels executed between 1320 and 1330 and attributed to Lorenzo Maitani is placed above the main entrance to the cathedral.

*Following pages:* Symbols of the Evangelists Matthew and Luke sit over the portals.

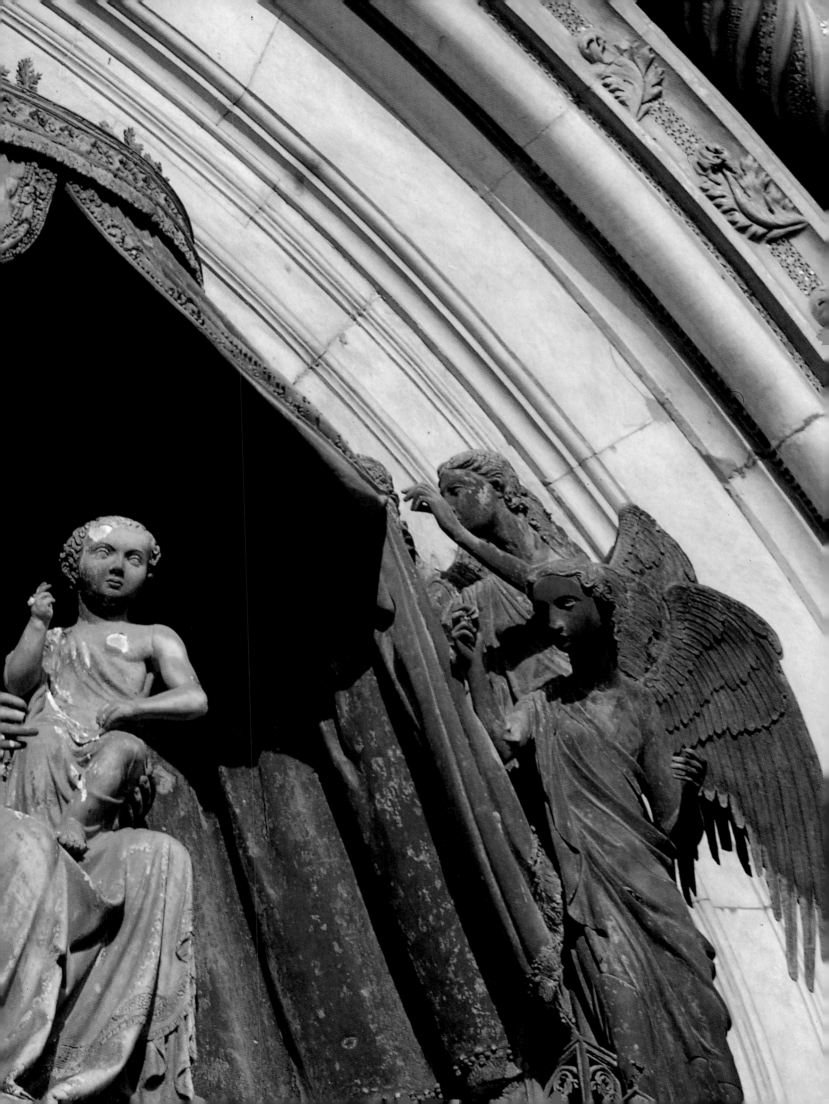

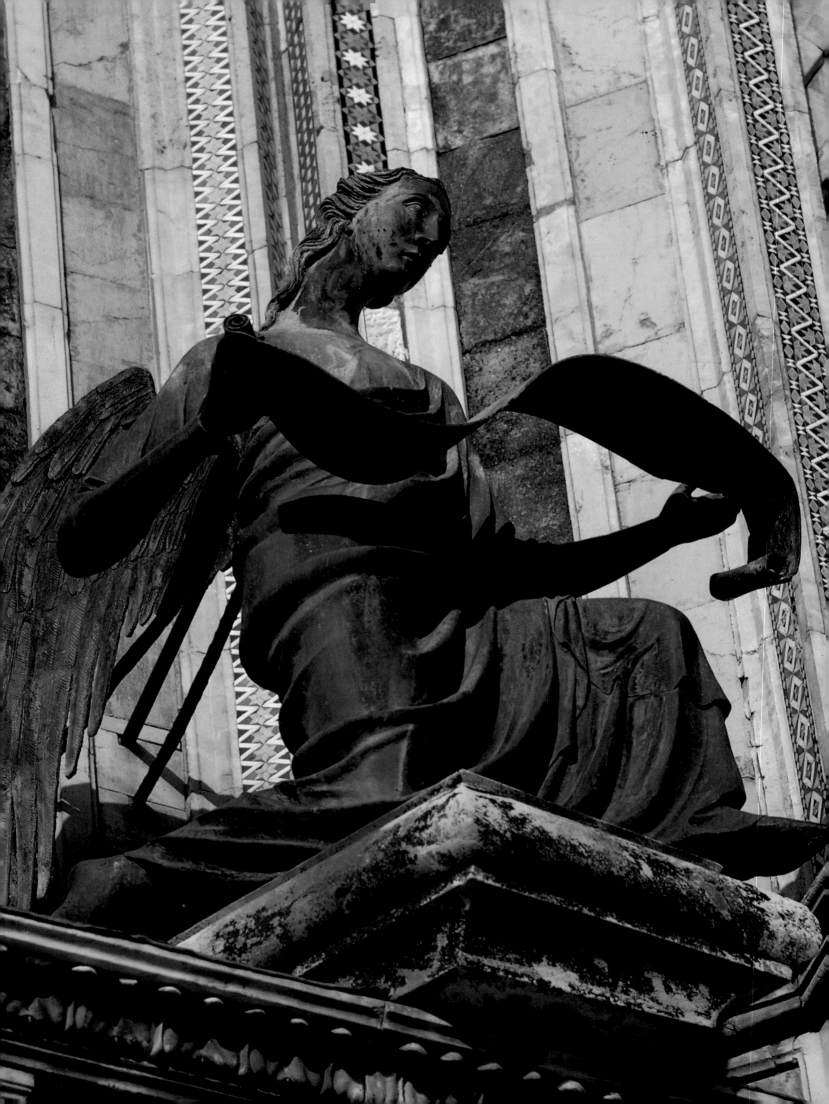

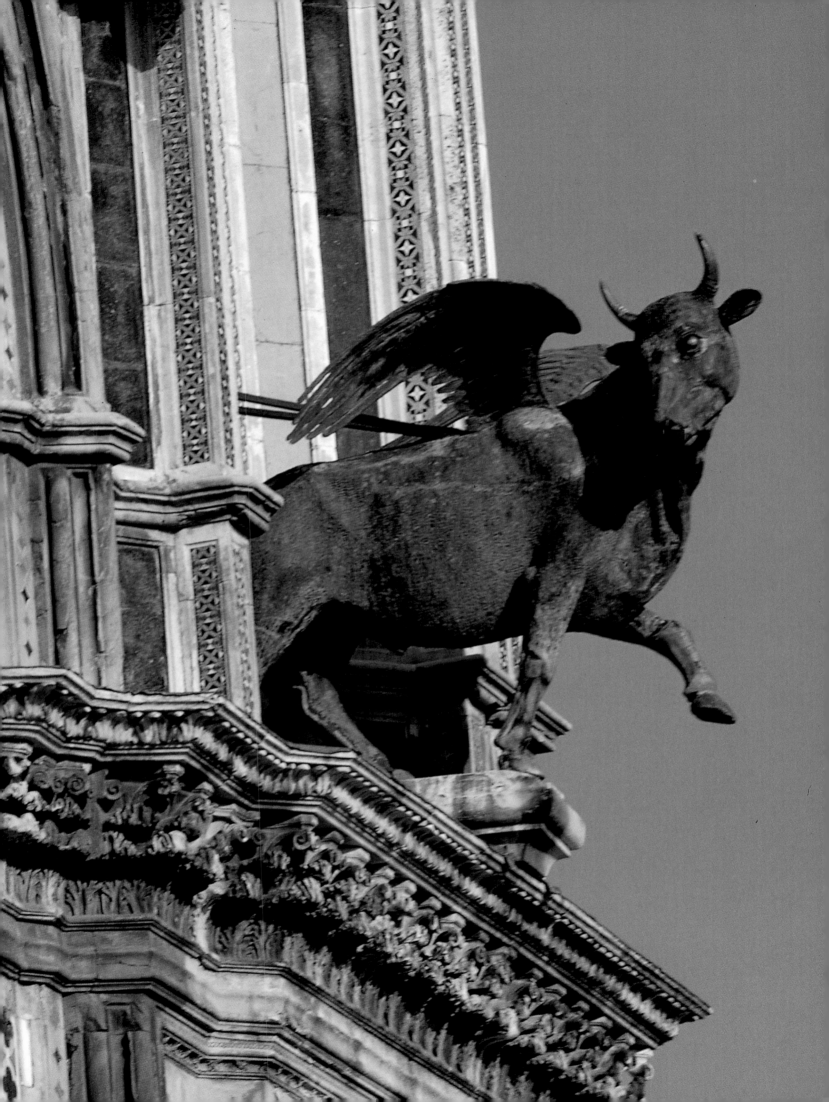

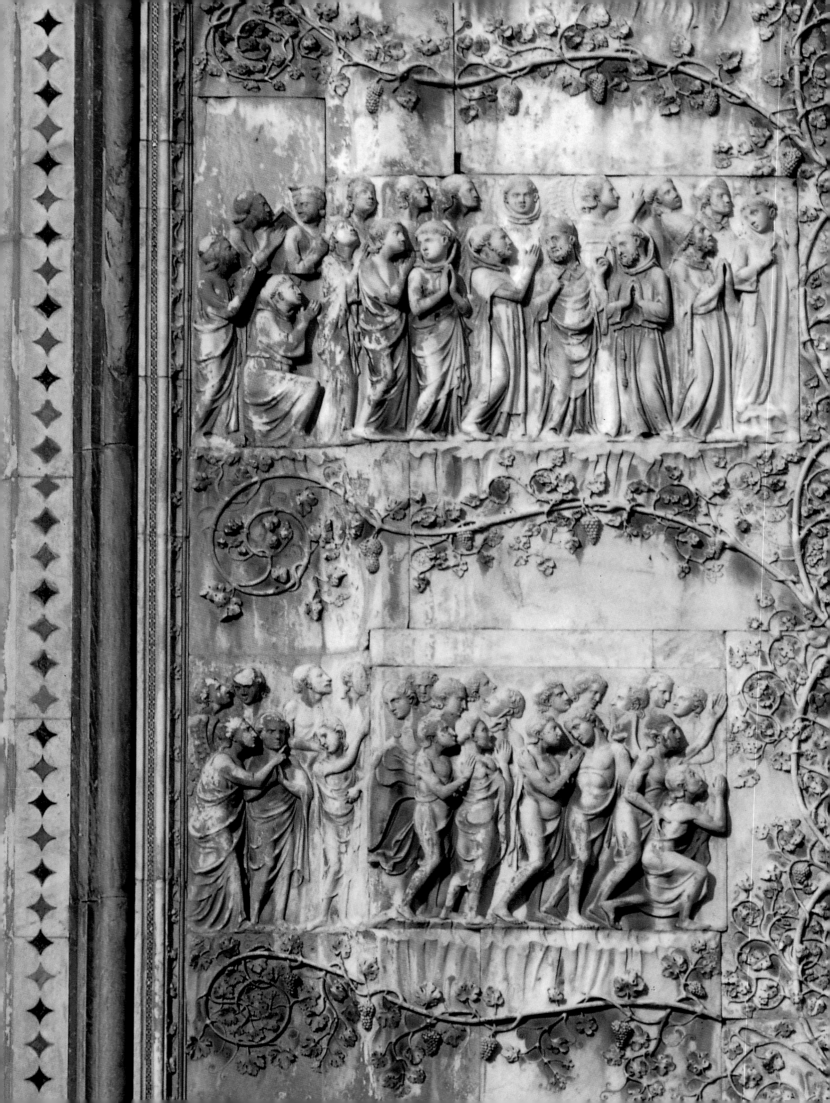

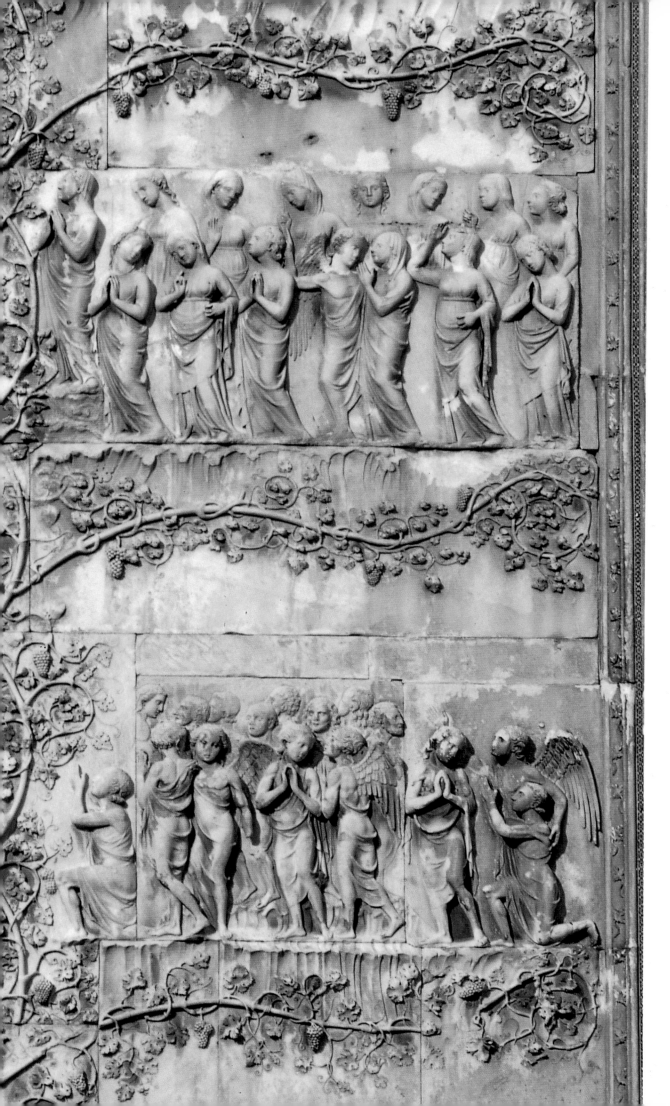

A section of
one of the four
thirty-foot marble
reliefs that flank
the portals of
the façade of the
cathedral. This is
a scene from the
Last Judgment.

# The Medici Chapel

Before he began work on the architecture of St. Peter's, Michelangelo was engaged in creating the Medici Chapel in Florence. The artist was a sculptor before he was an architect, and here the sculpture is extraordinary. You see two sides of Michelangelo. He had to restrain himself when making the calm, classic portraits of the Medici princes, but he could let go to create the figures at their feet. *Dawn* and *Dusk* and the incredibly expressive *Day* and *Night* provide a moving contrast between the serene and the violent.

I have always admired the unfinished *Slaves* that I felt were Michelangelo's freest work, but somehow that freedom is pushed further in the figures of *Night* and *Day*. Some popular guidebooks denigrate the female forms as having no real femininity, calling them male bodies with breasts attached. I find this criticism unforgivable. As you look at these bodies charged with emotion, there is a tragic difference between *Night* and *Day*. But for Michelangelo feminine bodies had as much strength as male bodies. It was just a different strength, a strength that was more contained, less obvious. Go to the Medici Chapel and contemplate these contorted human forms that only the power and the vision, and maybe the belief, of a great artist could create.

Stone has always been one of sculpture's great mediums, but the work in this chapel conveys another dimension of majesty and inspiration than that expressed by much of the other work in this book. The torment and the agony that Michelangelo was able to chisel out of inert matter reveals an individual's sacrifice. There is nothing comparable in Michelangelo's oeuvre to the contained violence of the *Night* and *Day* figures, although perhaps the Last Judgment in the Sistine Chapel carries some of the same power. But Michelangelo was most able to express his striving and his greatness in stone. No one else in the world has managed to endow marble with such an awesome quality. —A.L.

Detail of Michelangelo's *Virgin and Child*, which faces the altar in the Medici Chapel in Florence. Statues of two Medici dukes, Lorenzo and Giuliano, are on the walls on either side of the Virgin, with their faces turned toward her in contemplation. The child is a robust, naked boy clinging vigorously to his mother's breast.

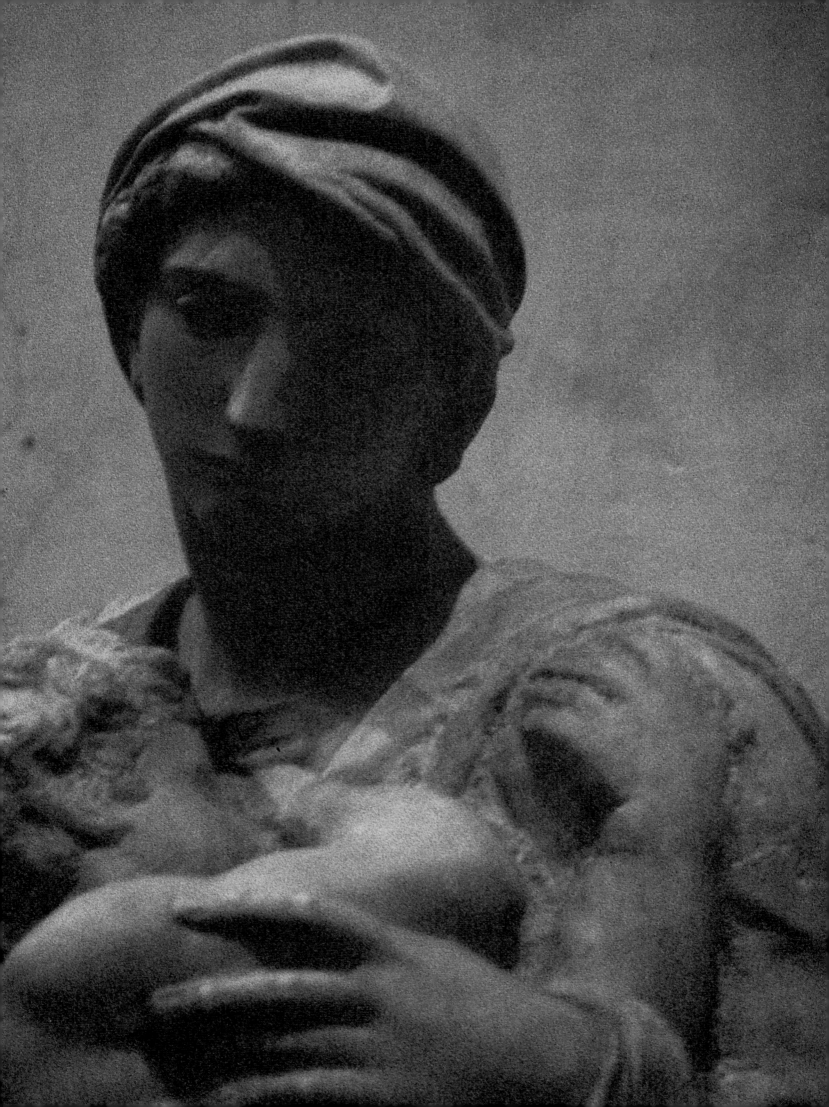

*Then there are the four statues of Night and Day, Dawn and Twilight, most beautiful, and sufficient of themselves, if art were lost, to restore it to light. The other statues are the two armed captains, the one the pensive Duke Lorenzo, and the other the proud Giuliano.*

—GIORGIO VASARI, *Lives of the Artists*, 1568

In 1515, Giovanni de' Medici returned triumphantly to Florence as Pope Leo X. Almost immediately, he and his cousin, the future Pope Clement VII, initiated a series of projects in the family church of San Lorenzo. Michelangelo returned from Rome to preside as chief architect and undertook the design of the church's façade. His work was interrupted some four years later when the pope asked him to create a family mausoleum in the New Sacristy, now commonly referred to as the Medici Chapel. This chapel was to honor the pope's father (Lorenzo the Magnificent) and his cousin's father (Lorenzo's brother, Giuliano) as well as their recently deceased namesakes, Lorenzo, Duke of Urbino, and Giuliano, Duke of Nemours, who had played important roles in restoring the family to power. Although intended to mirror Brunelleschi's Old Sacristy on the opposite side of the church, Michelangelo's design included a more dynamic and explicitly sculptural treatment of the wall surface. Surviving drawings indicate that he had planned to place frescoes in the lunettes above the tombs so that the chapel would have integrated elements of painting, sculpture, and architecture.

Only two of the tombs were completed, and they face each other on opposite walls of the chapel. The shallow central niche of each tomb contains an idealized image of the deceased wearing a Roman military costume that emphasizes his service as a soldier of the Church. Michelangelo intended the figures to complement one another. The alert Giuliano was to represent the active life and the brooding Lorenzo the contemplative life. The heads of the

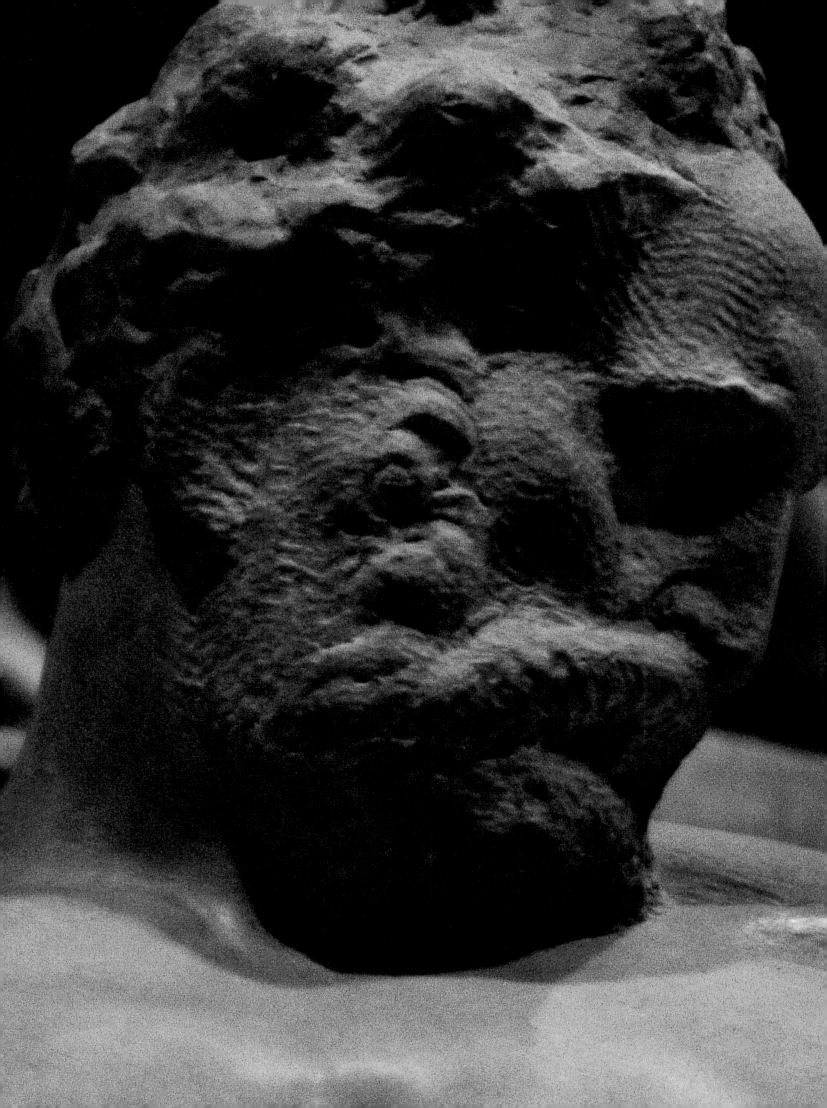

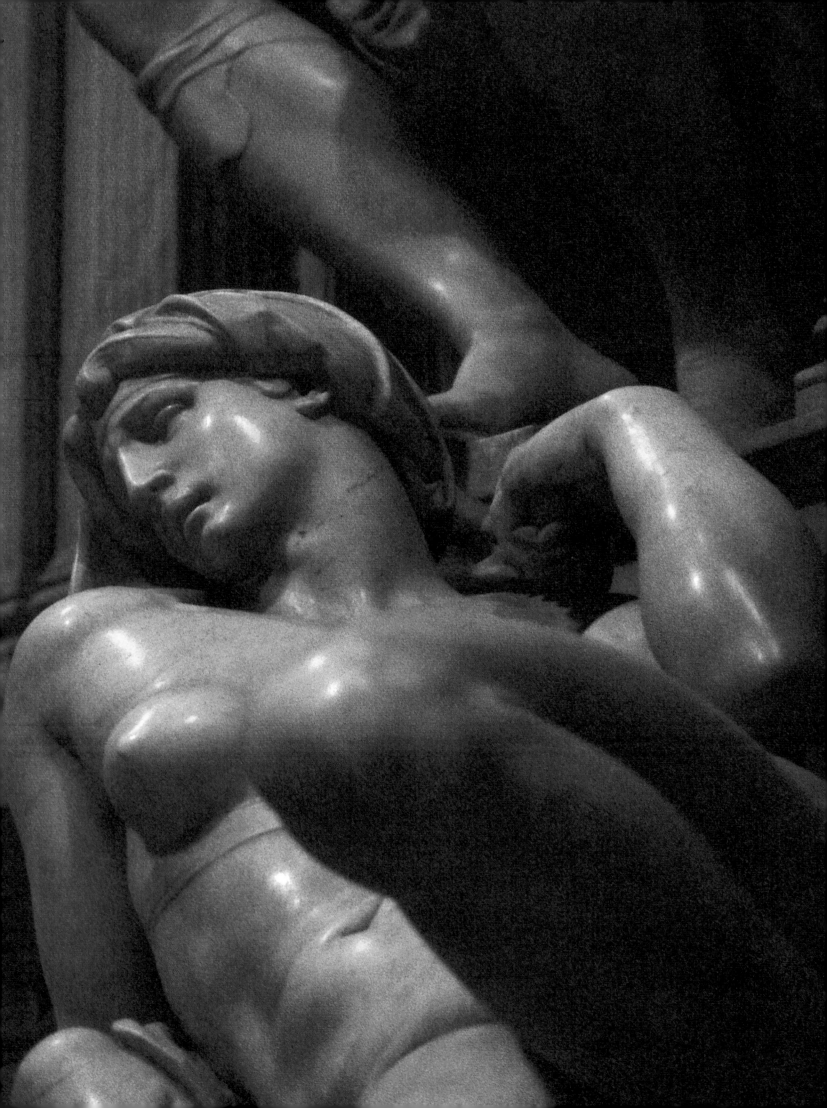

(continued from page 172) young patricians turn to face the wall where the remains of Lorenzo the Magnificent and his brother were to have been placed, but their gazes are now directed at the *Virgin and Child*, a traditional funerary image and one that also may symbolize the Church, which had embraced the Medicis when they were exiled from Florence.

Below the dukes, on the carved lids of the sarcophagi, are recumbent figures: *Day* and *Night* for the tomb of Giuliano, *Dawn* and *Dusk* for that of Lorenzo. Some scholars have discerned the artist's own features in the weary face of *Dusk*. Notes written by Michelangelo on a sketch for Giuliano's tomb illuminate its allegorical significance:

> *Day and Night speak and say: We with our swift course brought*
> *to death the Duke Giuliano; it is just that he take vengeance upon*
> *us as he does, and the vengeance is this: that we having slain him,*
> *he thus dead has taken the light from us and with closed eyes has*
> *fastened ours so that they may shine forth no more upon the earth.*
> *What would he have done with us then while he lived?*

The taut musculature of *Day* with his roughly worked, unfinished face, and the powerful limbs and creased flesh of *Night* demonstrate Michelangelo's genius for conveying the expressive range of the human body. The figure of *Night* is accompanied by familiar symbols, such as the star and crescent on her diadem and the owl that is perched under her leg. The large mask beneath her shoulder is probably an allusion to Death, since Sleep and Death were regarded as the children of Night.

The decoration of the chapel proceeded very slowly, and in a letter written by the artist in April 1526, he provided an account of what he had accomplished and what he planned to do: "I am working as fast as I can, and within a fortnight I shall begin work upon the other Captain; after that the only important works remaining to be done will be the four rivers." Michelangelo never began the figures of the river gods that were to have been placed under the sarcophagi. In 1534, when Clement VII summoned him to Rome to paint the fresco of the Last Judgment in the Sistine Chapel, he left the extraordinary ensemble unfinished. The arrangement of these heroic and deeply moving sculptures was entrusted to the artist's pupils in 1554. —D.K.

Two figures, one male and one female, lie across each of the tombs
in the Medici Chapel. *Dawn (detail on opposite page),* an athletic young woman with
an anguished expression, reclines on the tomb of Lorenzo de' Medici, below a pensive,
helmeted statue of the duke. The male figure on Lorenzo's tomb represents
*Dusk (detail on preceding page)*. The model is a man of middle age,
with muscles that sag. He seems to be contemplating the end of the day.
The unfinished face resembles that of Michelangelo.

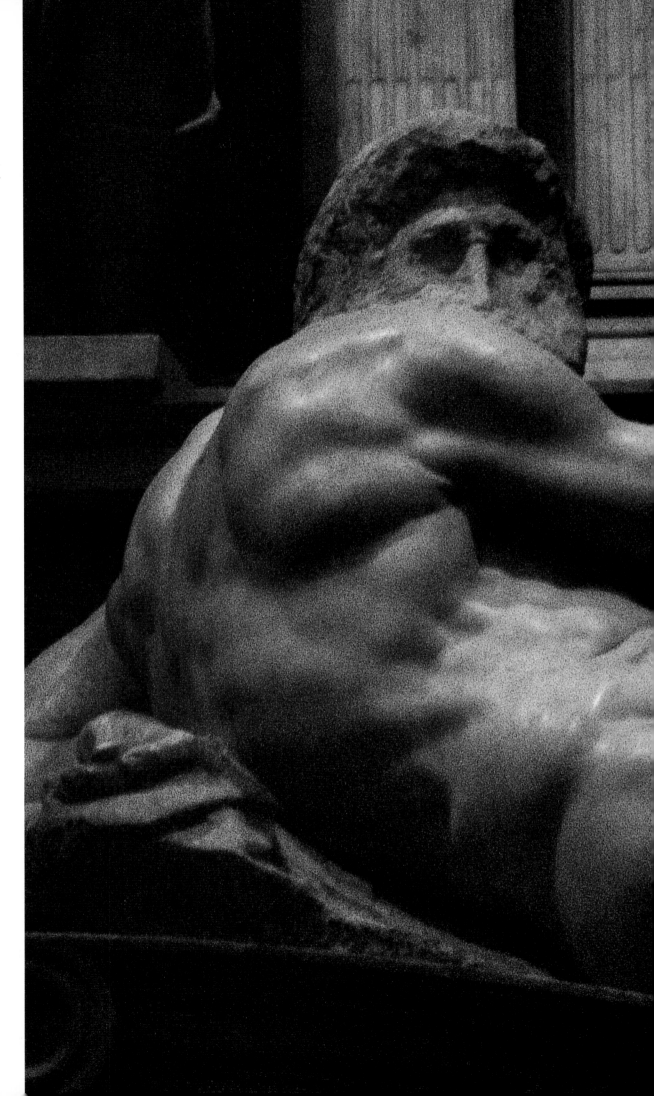

Below the calm, sensuous statue of Giuliano de' Medici, a muscular, energetic male nude representing Day reclines across Giuliano's sarcophagus. The vigor of *Day* contrasts with the contemplative figure of *Dusk* on the opposite wall. The face of *Day* is roughly blocked in, and the drapery across his right thigh would probably have continued through what is now unfinished marble below his knee. The female figure on Giuliano's tomb, *Night (detail on following pages),* is also a powerful physical form, but she appears to reflect some of the artist's inner anguish. A menacing mask disturbs her sleep.

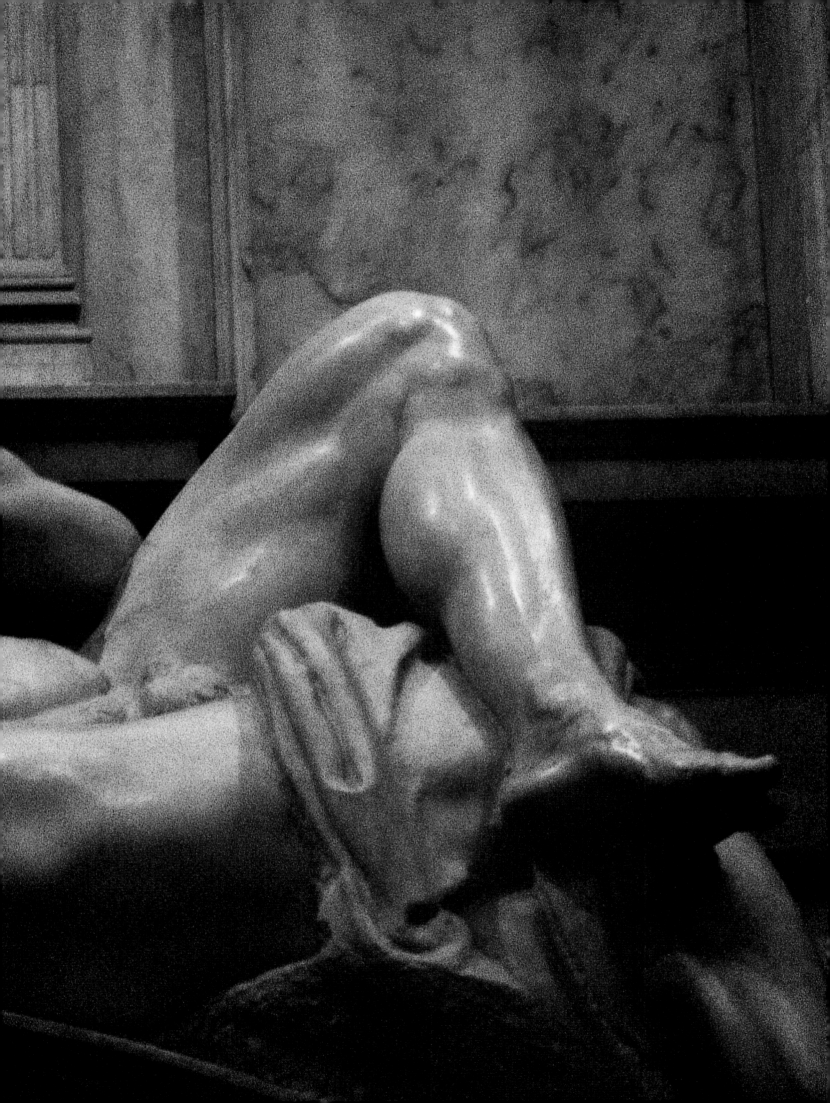

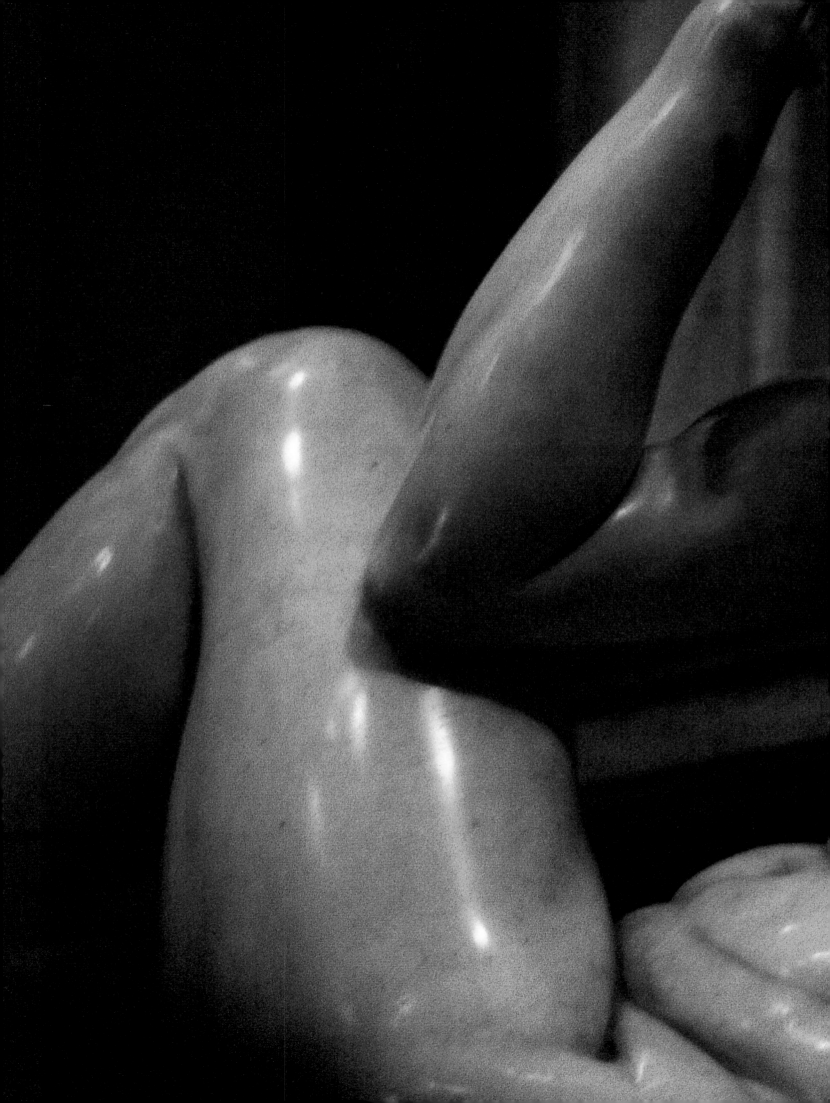

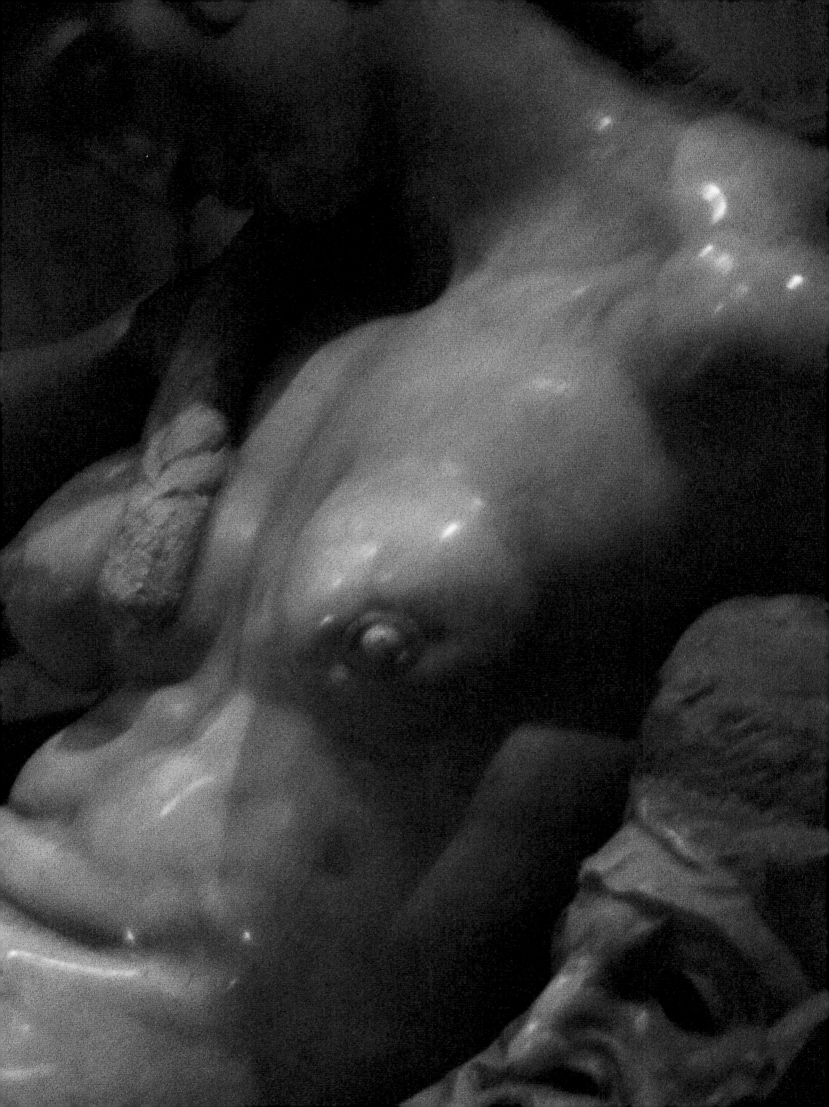

# Matisse's Chapel of the Rosary in Vence

Perhaps it seems strange to put Matisse's chapel in the same volume with the great cathedrals. But, in my mind, it carries an extraordinary power, much like that of Michelangelo's Medici Chapel. There are so many inventions in the chapel, both graphic and optical, that I felt it should be included as a possible vision of future religious art. Here, practically on his deathbed, Matisse broke through painting with his magical cutouts. In his hands a seemingly childish way of expressing an artistic feeling became a magical instrument for visual and sensuous delight.

I first met Matisse in his apartment on boulevard du Montparnasse in Paris. He was already ill, and it was very difficult to get an appointment, but I wanted to photograph him, and by luck, I was permitted to visit. With deep admiration for this great artist I waited in the living room for him to come out. Suddenly the doors opened. Matisse walked in. He had on a short, full jacket to disguise his medical problem, and this gave him a stature and a girth that for the great painter seemed natural. He sat majestically,

*(continued from preceding page)* like a French king, in an upright armchair. I did not want to tire him, so we cut the photography short. But some trust must have been established, because when the chapel was being built, Matisse suggested that I be the first and only photographer let in when it was finished.

When I went to Vence in 1964, I was met by a very sweet nun, dressed in black, who led me into this jewel. Everything was designed by Matisse: the crucifix, the figure of Christ, the altar cloth, the vestments. Every detail. The little sacristy door seemed cut from one of his still lifes. The stained glass, a whole wall of solid, modern stained glass, had been designed boldly, so that the yellow and blue created an optical green. And another color was somehow born also, a kind of violet that played on the stones, the tiles, the whitewashed walls. It was an inspiring effect.

After overly ornamented churches, after the grandeur of cathedrals, here came a genius who was able to express his faith with the simplest, most primitive means that he had at hand. In a way, it brings us back to the menhirs of Carnac, where the simplest means express such majesty and mystery. The miracles of light and drawing suggest what the imagination can offer. In its humility and abstract simplicity, the chapel provides a place where an individual can meditate deeply and worship. Michelangelo's Sistine Chapel, with its wondrous panels high up, is somewhat out of our reach. Here, in this chapel by Matisse, all is human scale. The phantasmagoria of light, color, line, and texture creates a visual wonderland. When one contemplates the details—the windows, or the drawing on the tile—one is overcome with awe for the genius of art, and these stirrings are laid symbolically at the feet of the Almighty. —A.L.

*Do I believe in God? Yes, when I am working. When I am submissive and modest, I feel myself to be greatly helped by someone who causes me to do things which exceed my capabilities.*

—HENRI MATISSE, *Jazz*, 1947

The Chapel of the Rosary in Vence owes its existence to Matisse's warm friendship with Sister Jacques-Marie, a Dominican nun. When she conceived the idea of placing a stained-glass window in a shed that served as the chapel for a nursing home run by her order, she consulted Matisse and he gradually became enthusiastic about executing designs for the windows as well as for a new structure to house them. In a notebook begun in April 1947, Matisse provided a humorous third-person account of his recent and surprising involvement in religious art: "This is really sensational, when you think of who Matisse is. Who would ever have thought that this artist, whose work seemed irremediably closed to the supernatural, would get excited about such a task."

Since all of Matisse's previous art was devoted to sensuous subjects, the likelihood of his undertaking a religious commission must have seemed remote indeed. However, the idea of the chapel gradually took shape in the following months, and Matisse, who had just completed *Jazz*, a stunning book of cutouts, came to envision its interior as "the visual equivalent of a large open book." Long conversations with a young Dominican novice, Brother Rayssiguier, helped to clarify Matisse's ideas about the architecture of the chapel, which emerged as an L-shaped structure (a simple rectangular nave with a smaller projection that was reserved for the use of the nuns). As in *Jazz*, black-and-white forms confront colored forms in the chapel's interior. Looking at the black-and-white ceramic tiles of the *Virgin and Child* on the side wall and *The Stations of the Cross* on the end wall of the chapel, one is immediately aware of the delicate colored reflections from the stained-glass windows opposite them. The styles of these monumental tile "drawings" are strikingly different: in the first, the faceless silhouettes of the Virgin and her son are defined by lyrical, graceful curves, while the second is characterized by a harsh, angular shorthand that evokes the pain and violence implicit in its theme.

The painter originally had conceived "the Heavenly Jerusalem" as the subject of the principal stained-glass window, but the design was never developed beyond the maquette stage. Instead, he created the vibrant *Tree of Life*, whose stylized forms, executed in shades of blue and yellow, were apparently inspired by a cactus plant. Matisse planned the surfaces of the chapel to be smooth, with no visible evidence of construction. He wanted visitors to be enveloped by light, and in a letter to Brother Rayssiguier he wrote that: "We'll have a chapel where everyone will feel hope. However burdened with sins—they'll leave them at the door the way Muslims leave the dust of the streets on the soles of their sandals at the doors of mosques." —D.K.

Simple arches define the shapes of the fifteen stained-glass windows
in the nave and transept of the Chapel of the Rosary.

*Preceding page:* Matisse designed a distinctive cross-tipped metal spire
for the tiled roof. A small bell hangs from the base.

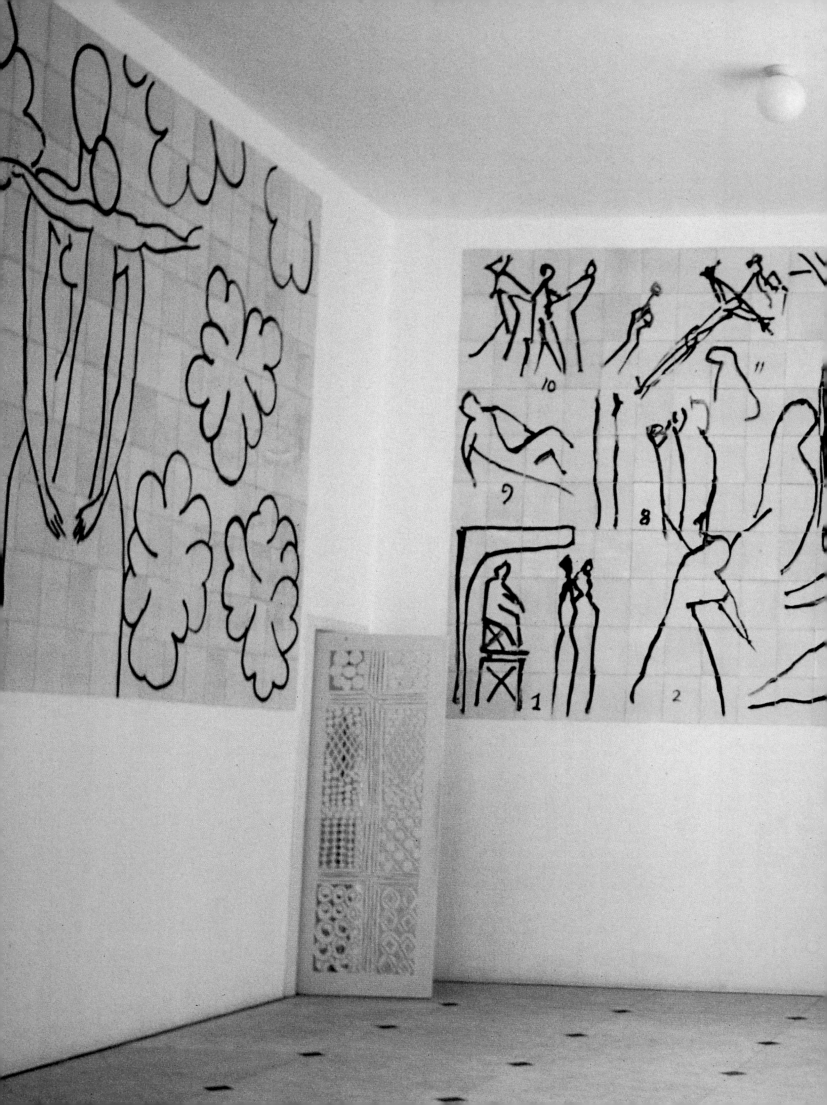

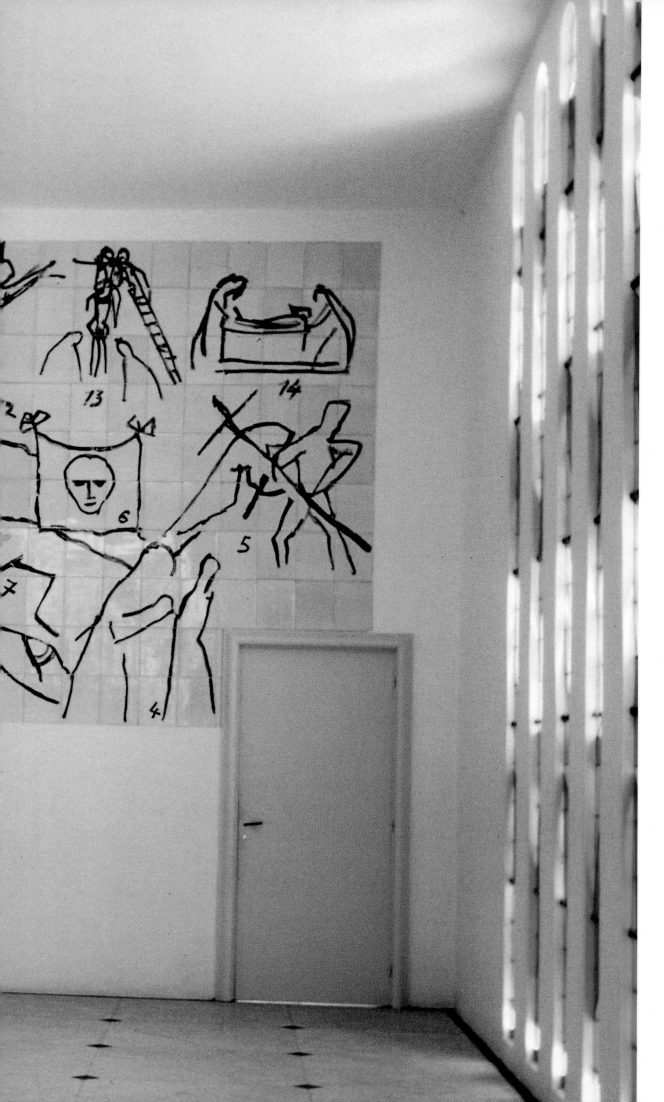

Large black-and-white murals made from ceramic tiles adorn the north and east walls of the nave. At left is the *Virgin and Child*, and in the center is *The Stations of the Cross*, with all fourteen stations in one composition. The carved wooden door between the two murals leads to the confessional. The six *Tree of Life* windows at the right filter light onto the white marble floor.

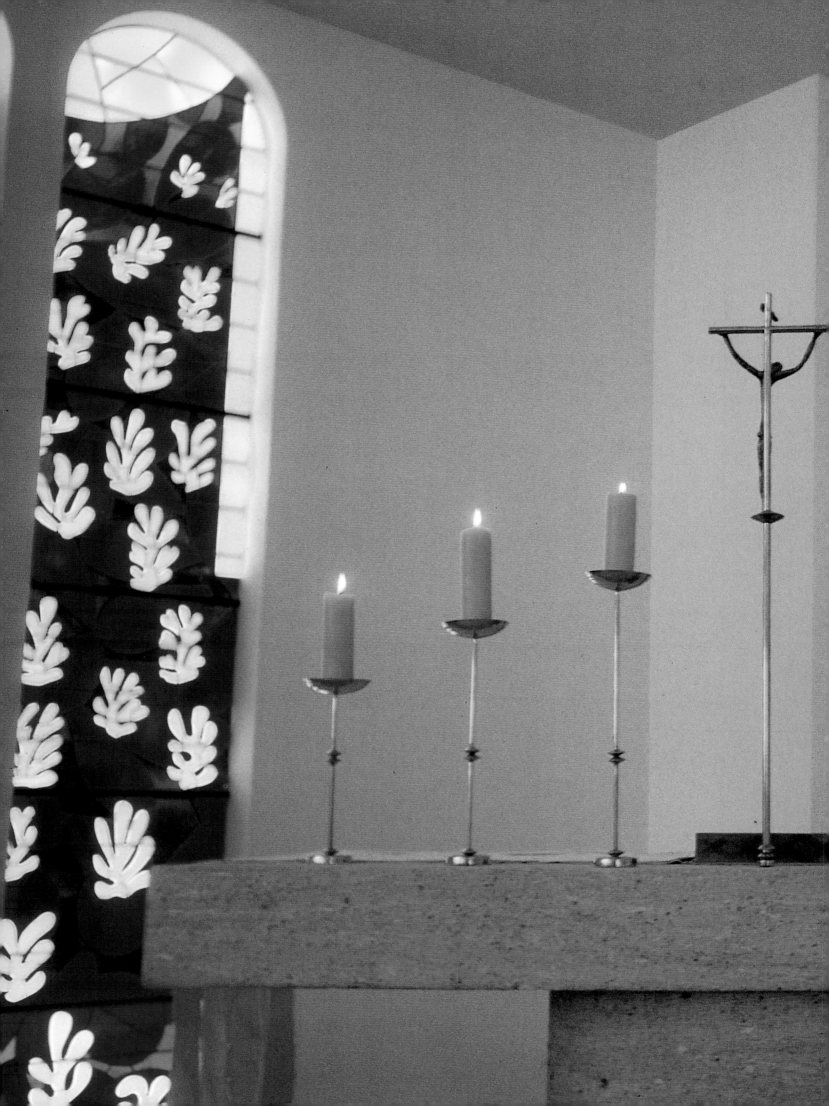

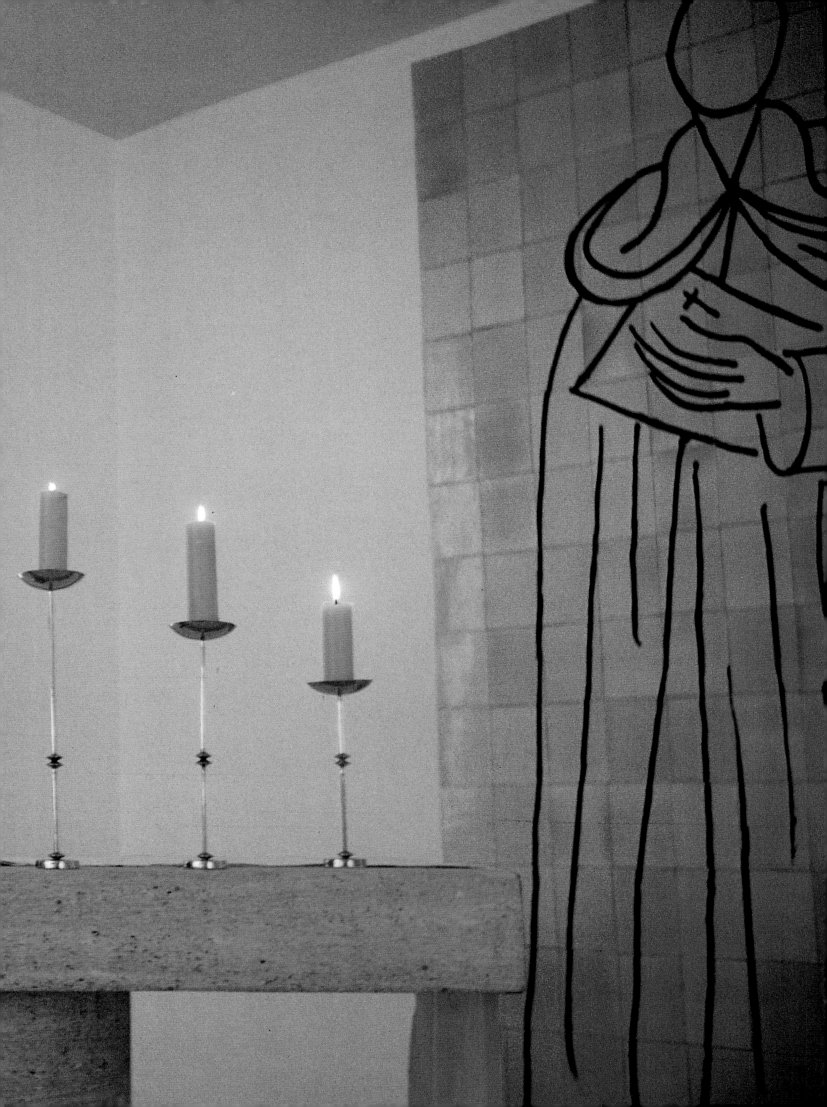

Nine *Tree of Life* windows fill the wall of the transept reserved for the nuns. Each window is about a foot wide. The nuns sit in the stalls below the windows, facing the altar.

*Preceding pages:* The two windows behind the altar have a much more complex design than those that form the wall of the nave and transept. The stone altar is adorned by six slender brass candlesticks and a delicate crucifix. The figure in the mural at right is St. Dominic. Matisse made the drawings for the murals directly on the tiles before they were glazed.

191

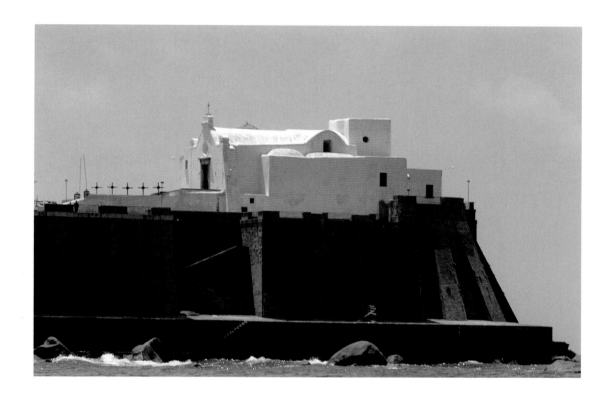

IN SOUTHERN ITALY ON A PROMONTORY THAT REMINDS ME OF SOUNION, the fishing village of Ischia erected a chapel. Each black cross stands for a ship lost at sea. This chapel is moving in its simplicity, and I think it makes a fitting conclusion to my attempt to convey the sense of humility that comes from belief and prayer. For it is this, more than the glorification of great temples and splendor, that impelled me to make a book paying tribute to those whose toil and love went into the construction of testaments to their faith in the Holy Being.

# Acknowledgments

My gratitude to S. I. Newhouse, Jr., chairman of Condé Nast Publications, who has supported my every creative effort. To Harry Evans, president and publisher of Random House, for his faith and enthusiasm. My thanks to Sharon DeLano, the editor of this book. Her wise and perceptive advice has helped me a great deal. To Crosby Coughlin, my friend and collaborator, for his unflinching belief in this project—from the research archives to the printed pages. The layouts and typographies are also his. He has been creative and tireless. To Professor Diane Kelder, my appreciation for her remarkable knowledge and culture, and for her understanding of this project. And last, thanks to my dear friend Denise Otis for her sensitive editing of my texts. And to my assistant Susan Peters for her constant help.

*Endpapers:* Medieval stonecutter's marks used to identify
which stones a particular worker had squared off.

*Frontispiece:* The interior of the Parthenon, looking east.

Copyright © 1997 by Alexander Liberman

All rights reserved under International and Pan-American Copyright Conventions.
Published in the United States by Random House, Inc., New York, and simultaneously in
Canada by Random House of Canada Limited, Toronto.

Library of Congress Cataloging-in-Publication Data is available.

ISBN 0-375-50021-9

Random House website address: http://www.randomhouse.com/

Printed by Amilcare Pizzi, Milan

24689753

First Edition